God's Art

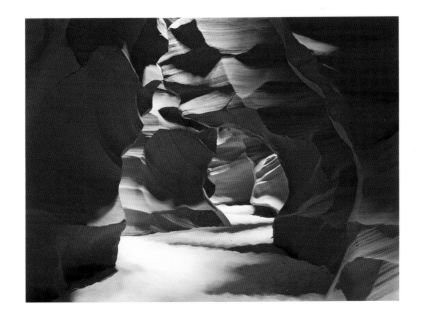

By

Greg Smith

Grand Canyon Publishing

God's Art

By

Greg Smith

Published by:
Grand Canyon Publishing
Post Office Box 8550
Mesa, Arizona 85214-8550

Orders at: WWW.gregsmithbooks.com

ISBN 0976715406

Library of Congress Control Number: 2005924533

Everyday Living/Religion/Art

Printed in Korea

Dedication

This book is dedicated to the memory of my parents,
Betty and Earl Smith, who gave me life,
and the freedom to pursue my destiny.

Table of Contents

Acknowledgements

The process of writing a book is solitary, lonely, utterly self-defining, and will always be so. But the experience is influenced by others, sometimes a loved one, by friends and inevitably by many people who are only known in passing. My debt in writing this book encompasses family and friends and to one or two institutions that have shown unwavering support for this ambitious and revealing activity – the writing of God's Art.

My parents, Betty and Earl Smith, did not live long enough to see the publication of the book, but will never be forgotten for their considerable and constant faith in the accomplishment of this task.

To my wife Phyllis who has tolerated my absences for thirty-five years while I journeyed to the far corners of the world searching for the meaning behind this book, and life, I offer my love and gratitude. Perhaps the next thirty-five years will find us journeying together.

To the many reviewers and thoughtful people who spent hours reviewing and considering the concept and content of this book before it became a reality my deepest gratitude. These wonderful people include: Charlotte Smith, Terry Bowes, Pamela Davenport, Calvin Coolidge Wilson, Giancarlo Traverso and Douglas Smith.

My sincere thanks to Wilson A. Bentley (1865-1931), affectionately known as "Snowflake" Bentley, for his pioneering work in photographing snowflakes. Mr. Bentley's work is found in this volume and his legacy as a self-taught scientist and photographer has brought joy and fascination to generations of people throughout the world through his images of one of God's most delicate artistic wonders.

My thanks to Ray Miglionico and the Jericho Historical Society in Jericho, Vermont for making the exceptional images of Mr. Bentley's work available to me, and to the world, that they may be treasured and appreciated for generations to come.

To the citizens of the United States and Europe who had the foresight to fund and build the greatest instrument for the study of the art of the universe ever conceived: the Hubble Space Telescope. The beauty and scale of the visible universe has been brought to Earth by this incredible device and it has changed the way we imagine beauty and art to exist beyond the dimensions of our imagination.

To the Space Telescope Science Institute for doing an incredible job of processing the images from the Hubble Telescope and creating a wonderland of information and art work for the whole world to see and enjoy. Many of those images are found in the chapter on Celestial Art in this book.

For those of you who venture to read and consider this very modest depiction of God's limitless universe of artwork, my sincerest thanks.

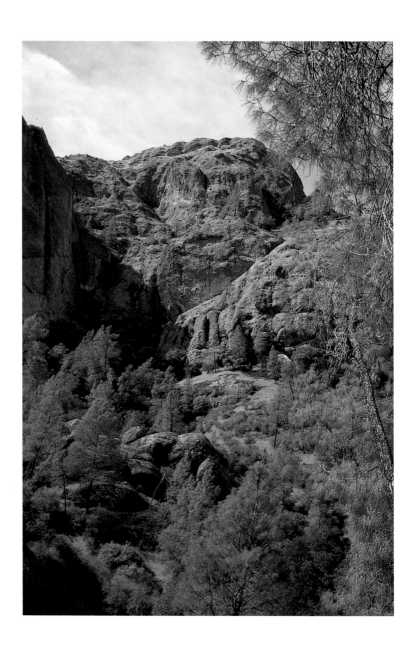

The Pinnacles,
Central California

Introduction

"The Art of God"

We are surrounded with human expressions of our lives, our landscape and the emotions that affect us in great ways, and small. What we miss so often is the great and wondrous of the world that God has created for us. The tactile, the visual, the aromatic and the sounds of our lives that emanate from the universe of God are so seldom seen, felt or heard as expressions of the greatest and most constantly present stimulus in our lives: the Art of our Creator.

If you are alive, you are affected by the natural, the plant in the garden box, the rain from the sky, the rock vaults of mountains and the hum of the wings of a bird. Where do these startling and beautiful creations come from? What force, what brush, what sculptor's knife molds and shapes and inspires this limitless array of beauty; and can it be accomplished without divine guidance? That question will be answered a thousand ways by a thousand souls, and not one will know the answer for certain. But the patterns, colors and sublimity of our lives are testament to the hand of an infinite master, a creator of such genius and creative inspiration that we can only wonder at the power and magnificence of this limitless universe.

This world of wonder is not limited to the extraordinary; it is not just visible as a majestic horizon or a sky-full of multi-tiered clouds at the peak of a summer's thunderstorm; the art of God is everywhere. It resides in the graceful peel of a tree's bark, and the fine layerings of a thousand years of wind blown sand. Time like all things divine is not an element of limitation, but rather one of enhancement. The mountain peaks and sanded landscapes are testament to this seemingly timeless etching and molding, piling up, and wearing away that yields an ever-changing visual display of art that is truly evolving. The extraordinary nature of this art is its range of animate and inanimate elements; characters and settings that blend together to provide mortals with grandness and minute revelations of the mosaic of God's realm. It is there for everyone to see, if we would only look.

Life becomes richer for the experience, for the effort to go beyond our

preoccupation with ourselves, to a deeper, simple and even occasionally complex view of these expressions of wonder, tranquility and exultation. Is all this creative; is it indeed art? That too remains in the eye of the appreciative observer, and the seeker after the source. Can the twists of an abandoned snakeskin, the ice patterns in a frozen pond, and the genius of mineral crystals be happenstance? Perhaps. Randomness will always be explanation enough for some. But the true essence of creation is seen by those who look at the sublime and magnificent creations of God's universe and see both order and inspiration in a universe full of wonder and art. Not the inspiration that finds expression in the hands of man, but the original art of God.

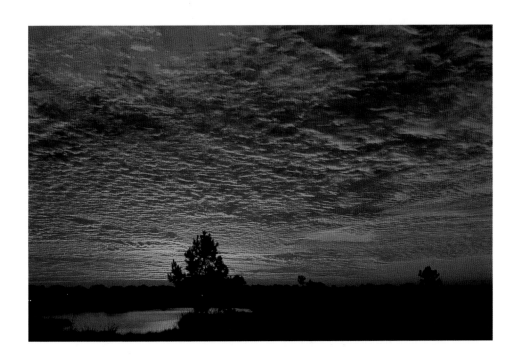

*Bear Creek,
Houston, Texas*

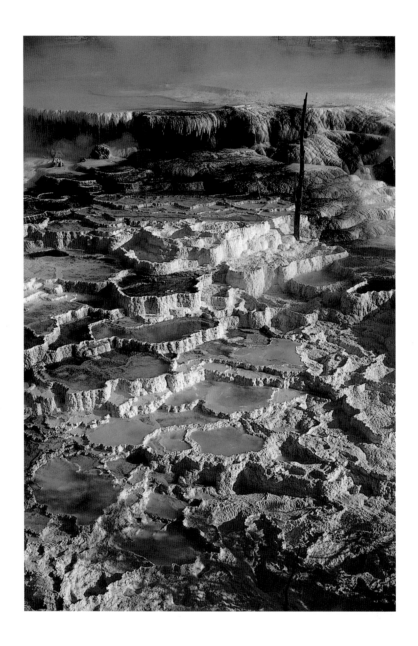

Mammoth Hot Springs
Yellowstone National Park

In the Beginning

"Our object in life should be to accumulate a great number of grand questions to be asked and resolved in eternity – now we ask the sage, the genius, the philosopher, the divine, but none can tell; but we will open our queries to other respondents, we will ask angels, redeemed spirits, and God."
-John Foster-

When we look out into the world, we see a nearly infinite number of colors and patterns, shadows and light…and ourselves. The sand of the earth, the blue of the sky, the reflection of the water – everything offers a glimpse of the universe near and far, and all of it somehow adds up to the sum of each of us. I have come to the conclusion that I am not a random bit of water and dust, a collection of toads and fireflies, but a creature of design, of thought and purpose. It is not through the rigors of science or the paths of tongue twisting Latin and philosophical discourse, but faith and instinct that have led me to believe that I am a small sample of universal planning, of sensitivity, and even the odd bit of hope. This self-image doesn't sit well in any category; it is not science, it is not strictly philosophy. It may only be discussed one afternoon a week after church, but it is what I think I am, and this is the story of how I arrived at this rather simple conclusion: that God's very existence is presented to us in the most incredibly simple but glorious form – as Art.

When I was very small, I spent the evenings looking at the heavens as most all of us do at some point, wondering what all those clusters of stars were all about, and even staring into the orb of the moon looking for the face of the resident who was supposed to be living there. I saw tadpoles in the ponds in the peat bog next door, and was fascinated at the gelatin that begot the green toads many days later – it was squishy and slipped through my awkward and inexperienced fingers as I experimented with the little dots that were to become the multi-chorused evin' song, serenading me through my bedroom window in a few short weeks. The backyard yielded many-petaled yellow

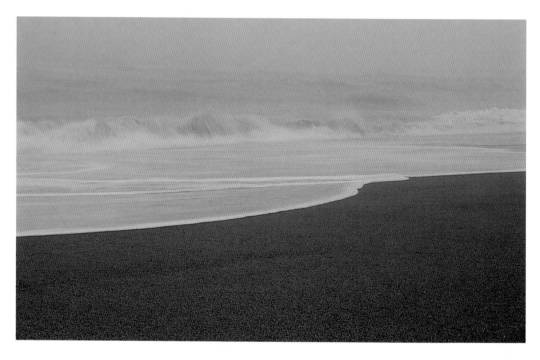

Pacific Coast, California

flowers and thick green grass, tall straight trees and climbing vines, but not once did I question how I was related to all those fascinating elements of the outdoors.

Life is unencumbered for children with the whys of things until later. Fireflies and lightning and the color of the sky are not science questions, they are part of the universe of the backyard and exist beyond the probing dissection of reason and explanation. The irony is that this view of the universe as a cohesive sum of colors and patterns, liquids and sands, and hot and cold is one of design. And no matter the intellect or instruments or skill that is applied to pick it apart or lay it bare, it is ever

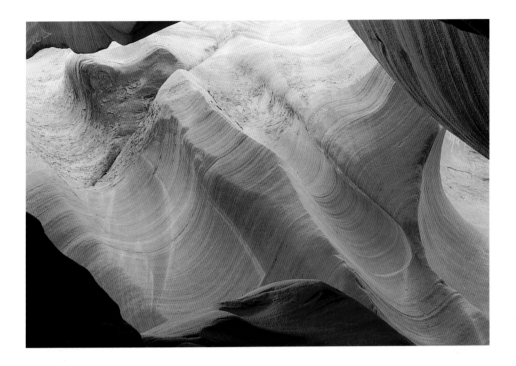

Antelope Canyon, Arizona

elusive and out of reach of all this inquiry and probing – perhaps by design, but surely so that the eventual question of "why" becomes more important than "how."

We are asked to believe through the less than humble word of science that all that exists in the heavens and even here on this smallest of celestial bodies was formed at the crack and peal of the beginning of time; perhaps in the form of a cataclysmic explosion. The first irony is that without ears to hear and an atmosphere to vibrate there wouldn't have even been a sound; but that is never a problem when we search for the how and what of things. Perhaps the question of "who" might be asked. Who decided to start the clock, to grow the universe, to create an almost infinite realm of fire and ice, of color and shape, of light and darkness, of life and lifelessness? Not "who" we are lectured, but rather the very force of chance. Why is that not sufficient? Why are we not able to accept that this wondrous, seemingly endless universe popped out of a

nutshell in a void of inky blackness by chance? It could be that it was simply, well, necessary to relieve the pressure of that random desire to evolve, that same influence we are told that is responsible for driving the engine of all creation.

The night sky, for example, is far more intriguing now than it was many years ago, not just for me but for all of us. We can now see numberless fantastic celestial bodies in more dramatic and creative shapes and colors than we could have ever conceived of before. The rings and dust of countless colorful stars and galaxies appear to us through our lenses and scopes and show us a dimension of distance and time that is

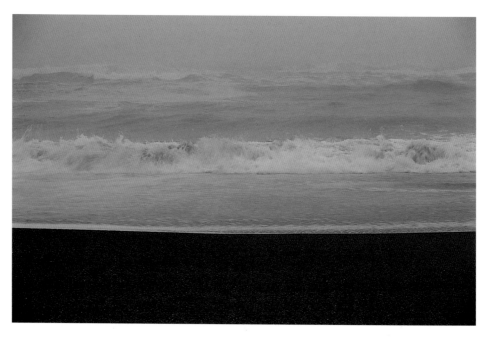

 Pacific Coast, California

beyond our reason and comprehension. Not long ago in our small history, these bits and sparkles of colored light and night-sky beauty were unknown to us. But time has drifted on and we now claim the knowledge to reason why all this has come to pass.

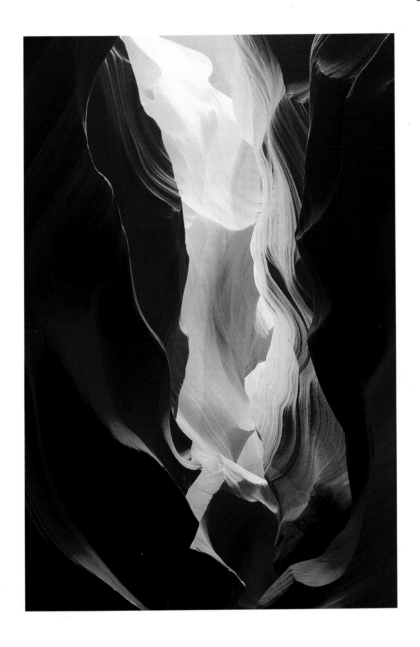

Antelope Canyon, Arizona

After the wonder of childhood, and the insatiable curiosity of youth and later life, a certain skepticism settles in, and that nagging, never-answered question of "why" begins to find its way under the covers like a cat on a cold winter's night. Why is the sky blue, why is Jupiter orange and the sunflower such a satisfying yellow? After all, why is anything painted with a cosmic brush other than black and white? What value is the palette of the universe? Once the top blew off Pandora's box sending out a universe of energy and light and matter, one question that arose was "why all the colors?" No one was there to see them; no one needed to tell the color of one star from another, the color of one element from another, the Pacific from the Atlantic or the blossom of the rose from the petals of the daisy. Why so many elements?

What was first – the light gases of helium and hydrogen, or the heft of gold and lead? Who needs water? Why did this randomness evolve into oxygen, and by coincidence blend the two hydrogens and one of these random oxygen atoms to fall as rain? What a coincidence – not just colors, but elements that combined in "natural" ways to scramble up atomic structures and the very essence of life – what a concept; life, that is.

The beginning of most anything is measurable, even our rather small part in this bigger neighborhood. Yet in searching for our roots, we seem to find comfort in believing that if we can use Greek symbols and Arabic numerals we can somehow explain the entire story and all its ramifications, and yet at every hilltop we find another range of mountains. Should we temper the search or abandon it all together as an unattainable goal, a distance too far to travel; we could no more do that than stop breathing. Searching and explaining are as integral to our nature as creating a faster form of movement or a more complex form of communication. It is in our essence, our genes, but is it just a random element of evolution as we are often led to believe, or is it a sort of survival tool that when combined with other undeveloped tools, could lead us into a more meaningful and limitless future than we can conceive of now?

Faith and instinct add a dimension to life in the here and now and the past and future that are beyond the reach of probes and math, and the process of scientific inquiry. But they are part of the greater realm of not just who we are but of what is out

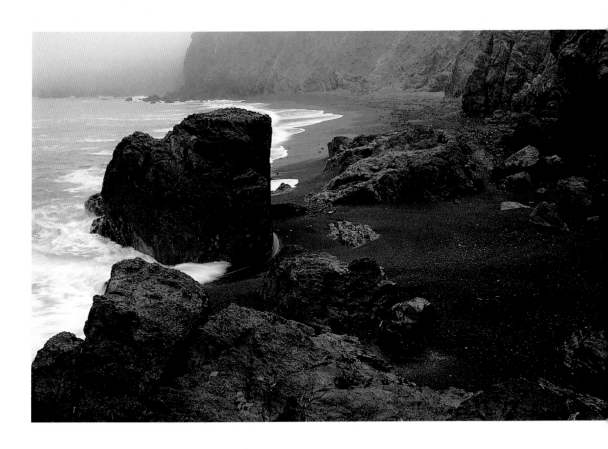

Pacific Coast, California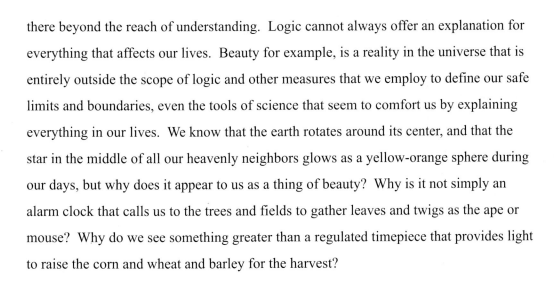

there beyond the reach of understanding. Logic cannot always offer an explanation for everything that affects our lives. Beauty for example, is a reality in the universe that is entirely outside the scope of logic and other measures that we employ to define our safe limits and boundaries, even the tools of science that seem to comfort us by explaining everything in our lives. We know that the earth rotates around its center, and that the star in the middle of all our heavenly neighbors glows as a yellow-orange sphere during our days, but why does it appear to us as a thing of beauty? Why is it not simply an alarm clock that calls us to the trees and fields to gather leaves and twigs as the ape or mouse? Why do we see something greater than a regulated timepiece that provides light to raise the corn and wheat and barley for the harvest?

Why after all are we able to see and feel and mourn, not just for ourselves but even for this earthly bounty of random plants and animals and rocks and oceans that, we are told, developed out of some evolutionary crap shoot? This gift from God is called sentience, the most wonderful and limitless gift of all. It is the exultant and the quiet, the entire range of every expression, feeling and emotion that we possess. Sentience takes us beyond the logic-bound limits of black and white and allows us to soar into rainbows and splash into ocean waves. It is the tantalizing hope and spirit of everything just out of reach; the cold of the snowflake, the heat of the midday sun.

Sentience is a gift that permits us to see beauty in all things if we choose, or to turn away and perceive only what can be translated into clinical and logical terms. For all that we will ever divine in the cosmic closeness and distance of our lives, this gift of sensitivity and the ability to perceive life beyond survival and chance is the true essence of our very existence.

Olympic Peninsula, Washington

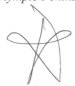

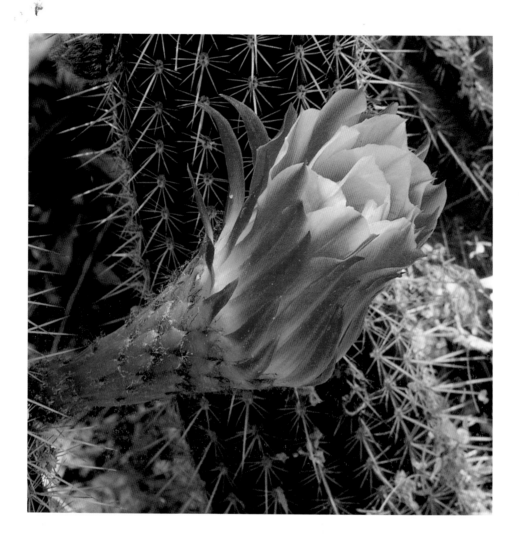

Cactus Blossom
Sonoran Desert, Arizona

Seasons

"Divinity is not playful. The universe was not made
in jest but in solemn incomprehensible earnest. By a
power that is unfathomably secret, and holy and fleet.
There is nothing to be done about it, but ignore it, or see."

-Annie Dillard-

Earth's tilt is just an anomaly, another irregularity in the universe. But because of this cocking of the Earth's gyroscope, we are presented with seasons – Winter- Spring, Summer, Fall. Variety; but to what purpose? All things do not require a purpose in time or space, they can be random and pointless, and that is true of our home place as well. And yet we are still pestered with this quandary, we search for an explanation for this kilter of 23° of tilt. Do we occupy a world of random chance, and trial and error? Does the Earth tilt because of cosmic design, or is it simply one of the infinite number of conditions that we inherited as we evolved in this isolated random world. Faith and instinct, or logic and random circumstances – both provide explanations but from exceedingly different perspectives. The one comes from within and is by agreement, intangible and removed from logic. The converse is slotted to fit the questions of what and how, but never why.

What is the effect, the benefit of this titled perspective on the universe? Every person who ever lived in the north and south has been treated to a greater view of the night sky. The trophies of the night, the moon, the stars, the comets, and those wonders called eclipses would not be shared by so many. Variety would be more static; the cold sun of the north's winter would be as perpetual as the warm sun of perpetual spring or fall in the mid-latitudes, a sort of "Sprall." The cycles of plants and animals, the flowing human emotions in all of us, the colors of leaves dying and spring buds renewing would never alter our moods and our art filled canvases. The sense of birth, life, death and renewal would be reduced and even lost as if the natural mirror of our very existence

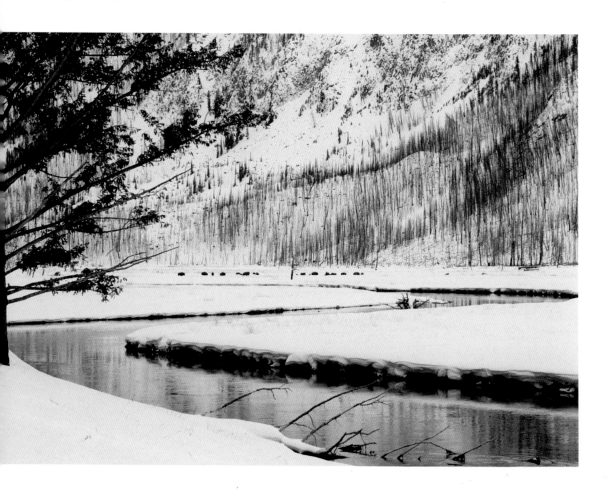

Yellowstone in Winter

was never there. Cycles are as significant to our sense of beauty as they seem to be to our frail, physical lives.

Philosophy would be void of many anecdotes and paradoxes; our imitations of this seemingly unique life cycle would be absent, and the stark and subtle colors and images of change would be lost to the quiet and obscure souls among us who marvel and are made more complete by all of this.

Winter

What do we see in this season of rest, of dormancy and even death? Snow falling is white. With so many colors in our world, why do we not have rainbow snow? Blues

Olympic Coast, Washington

and greens, oranges and mauves; no discernable reason. The sight of blizzards of colors filling the air, piling up in the forest and fields would provide us with an imaginary feast, a real riot of color and accent in this silent, cold, windswept landscape. And imagine the melting. The dripping trees adding drops of color to the slushy blanket of a hundred colors covering the ground; streamlets and brooks forming out of this wondrous kaleidoscope of sparkling liquids would be ever-changing and would add splendor to our sensitive and expressive eyes. The ice forming on the ponds and lakes – the sensory overload of impulses to our brains would be a constant Centennial Celebration – and yet, something would be lost. Subtlety.

Our sensitive, fragile, curious minds would lose the capacity to discern the small, the fleeting, and the pale in our lives. Winter's tilt after all, brings quiet to the world and to our lives – a blanket of whiteness, a visual cleansing that permits us to erase the images and colors of seasons past, to quietly reflect on all the wonders of the rest of this constant seasonal cycle. It is a season for tranquility, for reflection, and a

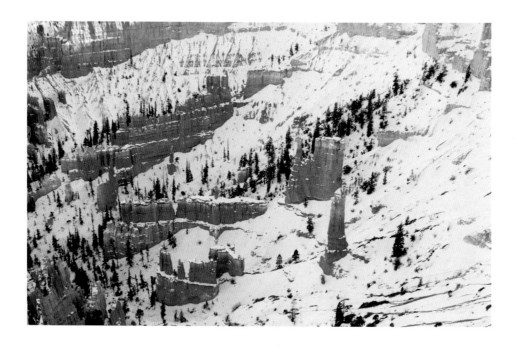

Bryce Canyon, Utah

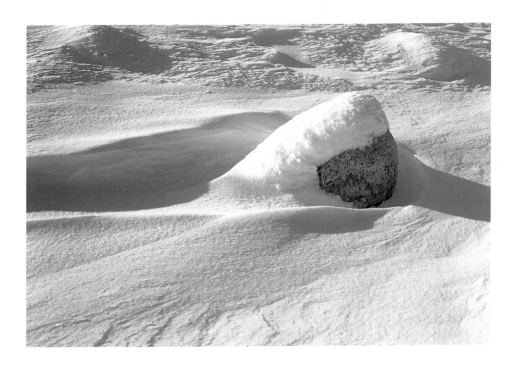

Bradshaw Mountains, Arizona

time to remind us of what our world would be like without color and life and the visual feast we are afforded for so much of the annual cycle of the seasons, and our lives.

Spring

Maybe we just interpret and adopt meaning to explain our lives. Even our capacity to puzzle things out is intended to lead us to the realization that there is always something more beyond our understanding, our reasoning, and the "how" of life. For that, we have spring. New life, renewal, facing into the ever-brighter sun as we have done all our lives. Blossoming and budding, popping and letting loose, colors and varieties of life remind us of what we are surrounded by. The colors are there for the seeing – the shy violets and devil's pokers, roses and lilacs and edelweiss. Short ones and tall ones, bold ones and those nearly hidden, and the canopy of trees and bushes show their own flurry of petals and bracts. Buckeyes and dogwoods, laurels and the buxomous Magnolia provide the most brash and persistent reminders of this new life. The blanket has melted into the ground and the brooks and streams are renewed – there

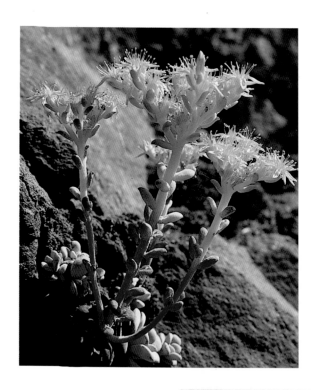

Stonecrop
Olympic Mountains,
Washington

Forest Fire Site
North Rim,
Grand Canyon

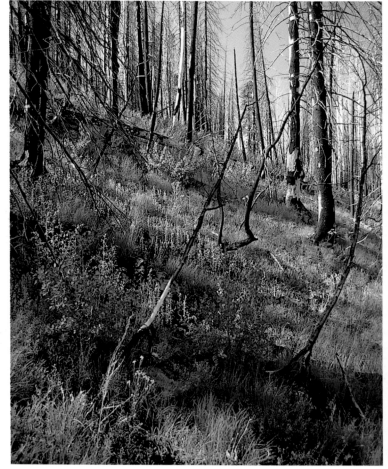

is even a visual strength in all of it. The renewal of color and landscape that we have longed for now surrounds us.

Summer

Heat, hot, close, intense – the mountains of clouds and the strength of cloudbursts – the majesty and grandeur of big scenes and sustained colors, this is summer. The whiteness of cloud tops, and the brooding of cloud bellies, the anticipation of colossal winds and deep greens rising from the plain as grass and hay, all that is the

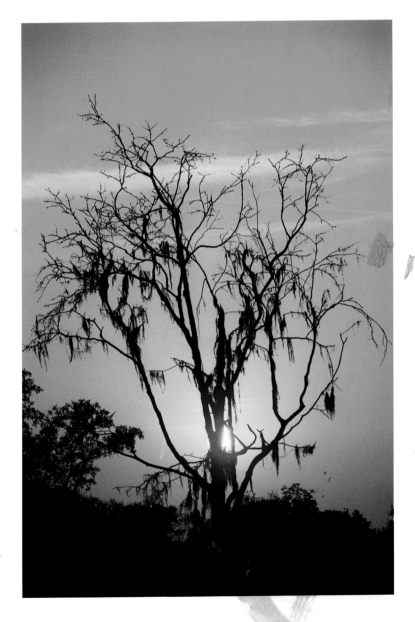

Near Katy, Texas

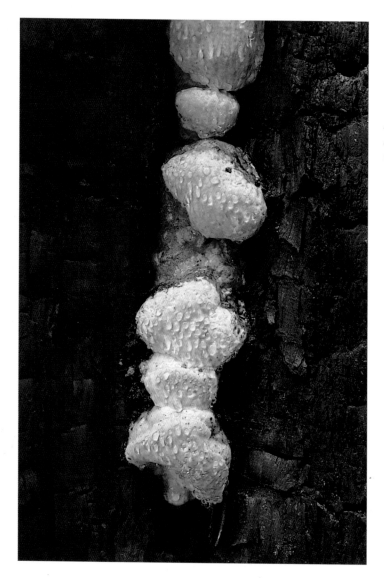

Bracket Fungi
Sequoia National Forest,
California

greatness of this season. There seems to be little about summer that is subtle or quiet. The sound of bugs is intense, and the closeness of the heat of the summer sun is in opposition to winter's cold distance.

Summer – bold, brassy, hot; the closest we seem to get to the sun. We are moved by all this and find ourselves seeking shade. As a season it is like no other, it is what spring has striven for – breaking out into the splendid glory of blossoms, and the strength of virility in animal life. Life itself is coursing at full speed. If we were held in perpetual summer, we would feel the intensity and value the shade and the relief of a

Deep Woods
Manlius, New York

sunset even more. We could not sustain this driving force of productivity and the stamina it takes to flower and bloom and grow and develop the strength needed to meet our destiny. Cold and change would be things not comprehended. Rain and showers would arrive with no fanfare and expectation before the sun returned to the landscape. Trees and plants would be deprived of rest and renewal. Corn in season would be the same staple, shackled by monotony, and forgotten for its sweet climax.

This season of superlatives, of growing and abundance would not have the beauty of spectaculars, of storms raging out of the west, and sunsets burning the horizon's clouds. Intensity is the word for summer, yet late in the season, there is a scramble, a rush to be sure there will be enough for the coming year.

Art is often lost in this business of survival. The strain of concern about crops and sustenance and bounty blurs our view, and we turn with apprehension to storm clouds and days of thick heat. But the majesty and enormity of anvil clouds, pillars and columns that dwarf and diminish us as they rise to dominate the very heavens, provide each of us with the greatest spectacle of our lives. There is nothing that we experience that has a scale that approaches this drama. Yet art is seen by the one who has a vision beyond survival, beyond the limitations of necessity. Clouds, storms, the brazen sun, all of these are part of a holy canvas – always. Their meaning is taken by every soul who

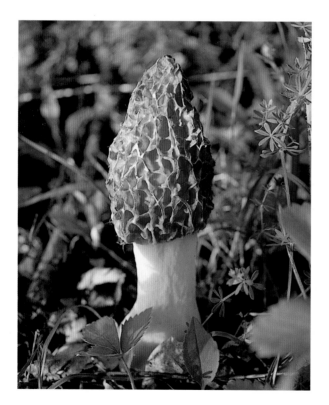

witnesses them, and asks not what or how, but is deeply satisfied with the knowledge of why.

Autumn

The summer turns and slowly dies into autumn; the great harvest when the bloom fades and the fruits are born ripe on the vine and stalk. The leaves gradually fade and the melons fatten, the flowers are straw-like and deep in color. Frost approaches and the motion of life is alternately busy and determined, and then quiet and

Mushroom, Perryville, New York

subdued. Trees offer colors never imagined in the great cycle of seasons, or experienced in the perpetuity of the tropics and middle regions of earth. Husbandry is in earnest as the ground falls asleep. The heavens quiet, and chill stillness seeps into the trees and plants and landscape; then frost. Quiet death descends, and the art of color is heightened to its greatest intensity, not the delicate lines of spring, but the deep pigments of the plant kingdom that give rise to the names of the very colors that grace our lives – umber, orange, yellow, purple and red.

One morning the frost is deep; the day turns to gray, and the silent drift of early snow begins. Not the harlequin fancy of the possible, but the silent white of the end of this intense season of survival. The blanket is the beginning and the end of this eternal cycle. Every facet of life is altered. We go inside and underground to seek comfort and security from the cold and lonely dormancy. Quiet, reflective, muted – moments of spectacular light and breathlessness, but always sinking back to survival – winter.

Round Lake
Central New York

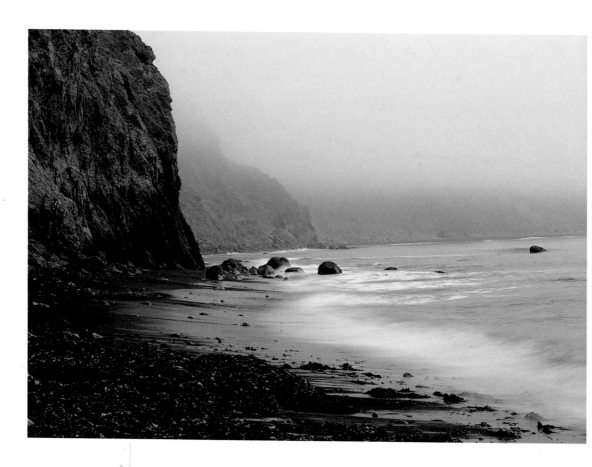

Lost Coast
California

The Setting

"I want to know how God created this world. I am

not interested in this or that phenomenon, in the

spectrum of this or that element. I want to know

His thoughts; the rest are details."

-Albert Einstein-

For one moment we return to the age of Genesis, to life without form in the inky blackness of a void. Life before art, before line and color, symmetry and texture. Life before sentient beings were indeed even a concept. When art was a nonessential part of the rhyme of the universe, before anyone could even perceive the difference, the fineness, the soft and harsh detail. When life was still to be born.

We look across the flat gray sea, and the misty heath and see nothing but sameness and a vague outline of the land and sky. The fog smothers the edges and distorts the fine colors, the soft rain squints the eye of the passing stranger. The detail, the life and color are there, they are simply hidden from view like the beginning of a task when the parts are still not defined, and the final goal is still in question. One imagines life to be this same gray pall lacking in detail with no sharp edges and striking colors, no soft surfaces and vivid light. What a universe that would be.

But when one discerns the tiny and the vast, the smooth and soft, rugged and awesome, it must occur that these qualities of the things of life here in our corner of the blackness of space are seen because He granted us the capacity to see. If life were reduced to experiencing only the necessities of survival, there would be no art. The very concept of things possessing aesthetic characteristics would never be known. If procreation were only a function of survival there would be no need for love. And so in the wisdom of the Creator there emerged a capacity to view life, sometimes only fleetingly, with an eye for non-essential beauty. To see beyond the necessity of things to

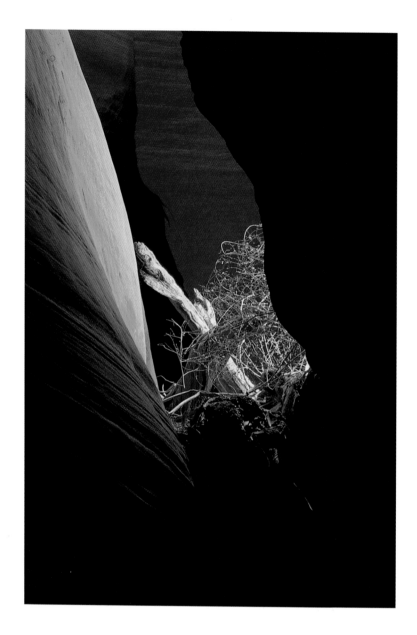

Antelope Canyon, Arizona

their other essence, that of wonder, light, color and beauty, to be granted this unique gift among all the creatures of life, the gift of perceiving beauty, is a precious thing.

And where is the essence of life displayed? All of us see it in common, and each of us sees it uniquely in something no other will ever know or experience. The clouds

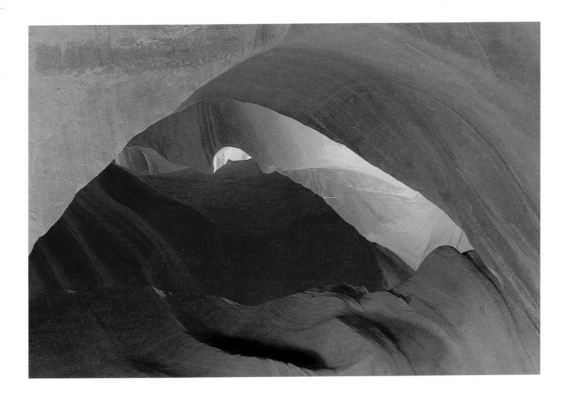

Slot Canyon Detail, Arizona

strike a pose for a moment in time in the summer sky when they rise and billow, building a massive tower of grays and blues and vivid colors, and a million eyes could witness the spectacle if they were turned to the heavens. A flower blooms in the deep woods but only the eyes of a wandering soul passing that way will ever notice the shot of color, and the final blush of a bloom.

What one may see in the brown decay of leaves and long dead flowers will be passed by when others are confronted by the same scene. Art is not universal in the sight of all people. It has been and will always remain free to be seen by everyone and no one in equal shares. What we have been granted is the gift of variety in the elements of our lives, and the capacity to see this infinite kaleidoscope if we only pause long enough to capture its inspiration and tranquility and the impact it can have on our lives beyond the sadly limiting utility of survival.

The Rain

Every soul on this blue planet will experience the miracle of rain in their lives. It is one of the most prolific constants that all people in every hut and home and Bedouin tent experience. It is the bringer of life to all mankind, to all living things, and beyond this element of life-giving sustenance is the force that shapes the ground we tread, the canyons we traverse, the forest mat that sends forth the renewable life of the woods. Rain is the essence of the art of the landscape. Imagine the life we would know if rain didn't fall, the absence of the beauty of living things that abound in varieties of life that are still being named that would never be.

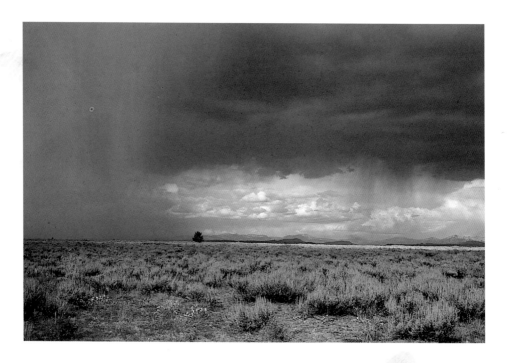

Teton Range, Wyoming

If all our lives were lived without the dynamic of rain, imagine the flat, the unchanging, the featureless landscape we would inhabit. The immense mountains that would reach ten miles into the sky, never to be worn away or covered by the beauty of snow; the loss of majestic glaciers and the panorama of clouds racing over head.

No rain. The sullen brassy sky with only a constant passing sun overhead, and the sameness of this featureless sky dome. Even desert dwellers are drenched in beauty with the fierceness of Harmatens and Monsoons, and then the roaring wadis and arroyos thunder to life with flashing floodwaters. This blessing of the constant change that rain brings, carving and altering the very ground we are anchored to, nurtures the beauty of living things that abound in varieties and forms of life that are still unnamed.

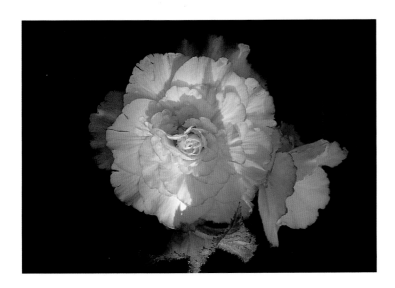

Tuberous Begonia, British Columbia, Canada

Rain brings the universal rose and the sculpted Andes as sure as it brings forth the arboreal lands of frost and miniature trees. The heads of blossoms some orange and red, others puce and fuchsia and colors without names are sons and daughters of heaven's bounty. These blooms are soft or fiercely spiked, some with green leaves and others held to the end of a stem with no reasonable means of support. The whorls and symmetry fill books of taxonomy and confuse and brew arguments among those who label these bits of creativity. But an insidious question underlies all of this variety - why?

Wouldn't a dandelion do? The rose is a complex and attractive thing; why not populate the world with roses; what is the purpose of all this complexity? If we had no rain, we would still have oceans, and all the poppies could grow on the shores of these immense bodies of water and life would continue unabated with never a territorial dispute, and never the need to change. At the end of the day, why indeed do we need this

element in our world anyway? Would the universal rose be prized or considered a weed? Without any color they could all be gray perhaps, or black or white, and all would be perceived as just functional elements to sustain the equally boring gray butterflies and bees that would pollinate them.

And what of these insects? Butterflies could easily be eliminated in favor of more industrious bees, and these too would only need to come in one flavor, vanilla perhaps. Variety. What real function does it serve after all?

The very eyes of the creatures that view the rain, and the flowers, the trees and the sculpted peaks and canyons could all be set in similar bodies, gray ones perhaps. The eyes would not vary, they too could be basic gray or black, or even white so they didn't clash with their supple gray skin. But against all reason, the eye of the beholder is the gateway to the soul of billions of subtle and dramatically different characters who feel the rain and can see the colors of the vast fields and meadows of numberless

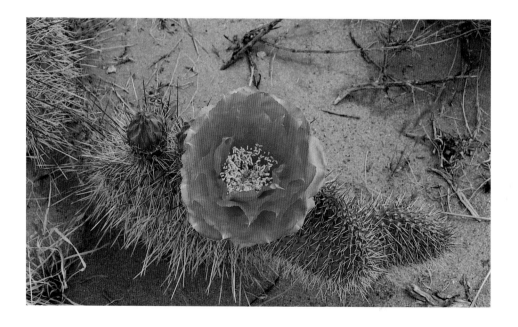

Prickley Pear Cactus, Page, Arizona

flowers, and they may in that rare moment, touch, even once, the delicate wings of the stunning butterfly. And this, all because of the rain.

The life of the universe is certainly complex. Rain comes on stormy clouds, or soft mists from a gray silent blanket of wet. It settles gently on the leaves and petals of flowers whose moment in time is part of their appeal; and there is perhaps a sort of angst about catching the show before it fades to shriveled decay and returns to nurture the next year's crop. But have you ever seen so much and so many!

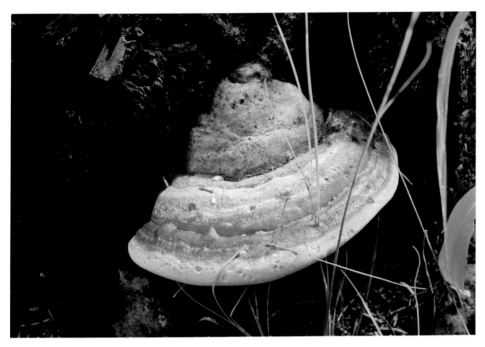

*Bracket Fungi
White
Mountains,
Arizona*

The cactus bloom is succulent and vivid; the violets of the deep woods are delicate and would collapse from a drubbing rain. Colonies of Banksia in a corner of Australia are contrasted with a trillion yellow-headed weeds in the Colonies that are hunted down mercilessly for planned execution. The primitive compete with the complex and at any given moment in time, the rain blesses them with life before they are removed from the palette, and their abrupt extinction permits the introduction of a new color to the forest floor, or the planted garden.

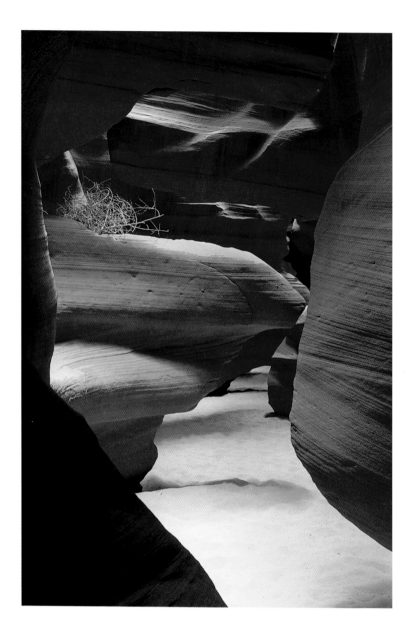

Antelope Canyon
Northern Arizona

The rain. Without it the colorful, the soft, the delicate, the spiny and the stalwart legions of forest and savannah would not be. Perhaps instead they would live underground.

The toadstool. One must admit, it is rare indeed to see a toad sitting on a sporophyte, and of all the life on this Earth that should have been relegated to uniformity, it is surely the humble mushroom. One variety, perhaps one that is good eating would be enough. Utility, the breaking down of dead and dying plants combined

with the bonus of being palatable and desirable to the human taste bud, what else is required?

But those insidious constants in the life of the universe, variety and change, are still not being explained. If fungus was designed to breakdown plant tissues, then why should it also function as a supplement to the sustenance of man? Form and function. The function may even be described as an element in a very rudimentary life cycle, but why don't all mushrooms look, and taste, alike? Squamous and sheepsheads, ear fungus and green ones, the colors and sizes, shapes and life cycles are amazing.

Rain brings life and the process of rebirth; never ending, always changing. The green ones and red ones and slimy purple ones were not here an epoch ago, and even this earth bound function of regeneration changes with the seasons, with the rising and setting, the rain drops on the earth and the trickling down of the rain on the bark. Fungi are a rain-nurtured thing.

Mushroom, Round Lake, New York

What of the parched earth, the vast undulating, sandy starkness of the mysterious desert? Rain is a staple of all abundant life that bursts from the ground, creating the artistry of trees, flowers and the moldering somethings that spontaneously emerge from the nether world of leaf litter and rotting things. But what of this desert. Here life is twisted, and swollen, spiky and colorful, all at the edge of survival.

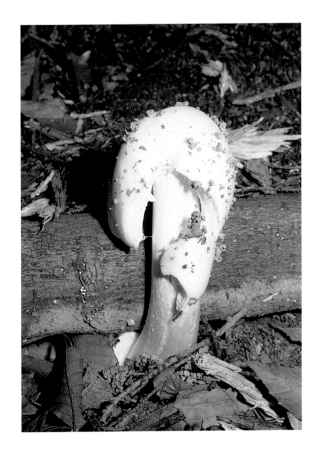

Perhaps it is to make us pause and wonder at the gift of green things and moist things. In truth it has a life and grandeur all its own, a beauty never surpassed even in the lushness of all that thrives in the basin of wetness.

When the wind and violence of the heavens raises clouds and dust, they inevitably bring forth the rain. Not the passive mists of the deep forests but the violence of the arroyo and the bold charging rush of the dry wash. Plants cling to the banks of these momentary raging veins of life, and the patterns and shades of green and brown and a thousand colorful blooms, are stark evidence of a thoughtful and creative genius that brings life and color, sand patterns and rolling stones that provide inspiration and pleasure to the dweller in the desert.

Whether it is the drenching rains of midnight or the cloud bursts of late afternoon, the rain pelts the sands and moss, the rock face and the deep grasses of the meadow yielding the life-colors and deep shades of afternoon that are reflected and shine forth in every blade and sand spit, flower petal and tree-form in God's studio. The rain, always the giver of life, but also the nursemaid of growing things that provides pleasure and restful contemplation, shock and discovery for everyone that is even a little alive.

The Wind

And what of Maria? The wind is overlooked and misunderstood as a creative instrument in His hands. While the rain falls, it is the wind that mixes the alchemy of heat and dampness, rising and falling, and gives birth to the rain. It is the parched blast of the air in the desiccation of the desert lands that blows the sand and detritus into dunes and leaf piles and the many creations attributed to this unseen force of whimsy and delight. Wind in the willows, zephyrs through the grass, and caustic dry hard gusts sculpt the land and the stones, and build the dunes that tomorrow will be mountains and the realm of yet unimagined color and patterned delight.

The wind. It never stops, it shifts in seemingly endless and fickle ways that provide us with consternation and determination to control its affect. But the bent trees of the tundra and the spiral shapes of the mountain pines are testament that the wind is ever present and must at times be resisted if life is to be sustained. The shapes and

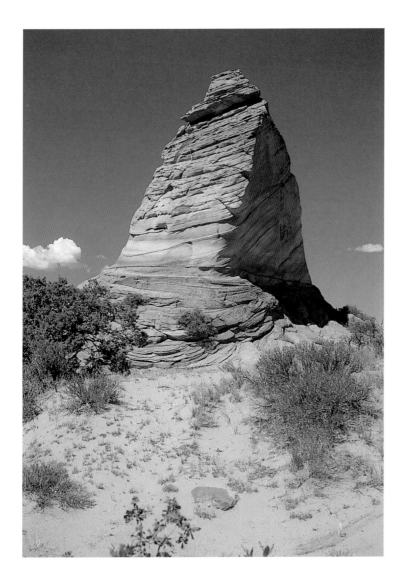

Coyote Buttes
Wilderness
Arizona

distortions are a marvel of visual fantasy. In straining against blasts of cold and frozen air, trees continue to branch and leaf and, occasionally, are simply blown away. Yet sometimes, as with the Bristlecones, these needled and leafy sages outlive entire civilizations; they stand against the wind and fire and ice for five thousand years, as dense as stone, with a living will and a muted color that speaks of constancy and a life beyond our contemplation.

The desert itself rises in the hot blasts of the Monsoon and builds walls of sand as fierce and eerie as anything we are blessed to behold. The moment of their passing

with tons of dust rolling toward the horizon turns sun light to dusk, and even drops a blood-red rain that makes our hearts take flight. But the sight of this giant canvas with wind and sand and tinted light is something to witness, not as a constraint as we so often view it, but as part of a living show, a transformed landscape provided to us if we would only see it, as inspirational, as divine art.

In the deep pine forests this same monster's small offspring gives us both a song and a sight of gentleness. The wisps of air, often barely moving the greenness, surround us in the forest. In autumn it is the rustle of leaves still hanging on the trees, and their movement along the ground as if they really had somewhere to go.

The wind; it speaks to us as it rustles and roars, shifts and settles the living atmosphere of the near and far. There is little that does not yield to this inexorable spinning facet of our living world as art. Look up and you will see it as it creates the gallery of today, look to the rock face and the fathered trees and see what it has done to mold and transfigure the gallery of yesterday. And somewhere, if you seek it, you will see the shape of tomorrow being born by the wind.

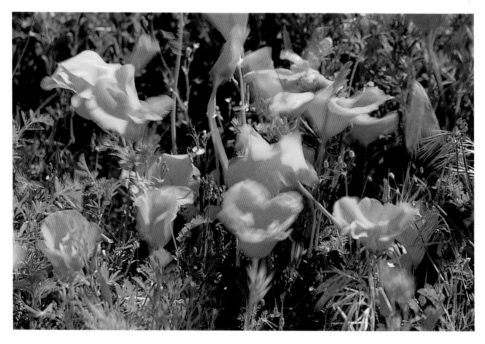

*Poppies in
the Wind
Southern
California*

Fire

The Universe is a caldron. It sparkles and flares, erupts and vanishes just as quickly, and the essence of God is in that fire. We see it as little things here in our midst, the cinders of the forest recently charred, the scalded rock that juts from the plane as a rounded cone, and the most fascinating act of the Earth, the shower and pulse of the volcano. Fire has been the cataclysm of change for all time. It has brought forth the birth of the hurtling stars of the great Center, and remains through every phase and form, a kinetic thing. Fire is never dormant, always restless. It dazzles and mesmerizes us as it has for a thousand thousand years.

It has brought us warmth and comfort, and even a symbolic passing to a life after this one. But one of its greatest gifts is its momentary beauty. To gaze into a flame and see the constant change of form and light, or brightness and color, the flaring up and fading away is an eternal attraction that has been with us since that first moment when we were granted the gift of its creation. Perhaps the beauty of fire is in its tantalizing nature - it can never be captured or even sustained. It demands constant attention, nurturing and vigilance or it vanishes. To look into a flame is to see a light show that mesmerizes and tantalizes but will not remain constant. The blues and greens, the reds and yellows, the orange and purple, the dancing up and down, the play on the eye of flaring and fading, they are all part of the most

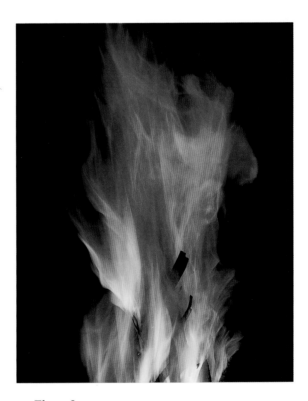

Flame I

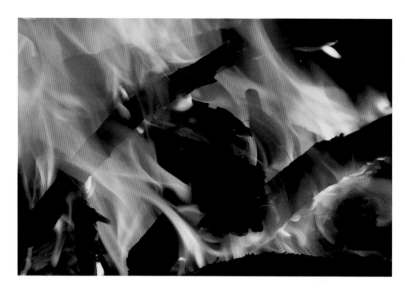

Flame II

captivating and beautiful kinetic motion in the realm of divine art.

The malpais is a constant reminder to all who live with its frozen ancient fiery surface. It is the flowing stone, the harsh, sharp-edged land of the now cold fire of the Earth. The ropes and folds, the bombs and ashes of the now extinct disgorging of the heated underworld, the products of the fire that have been bestowed on us from the hand of our maker. Liquid rock, the concept is as awesome as the sight of the eruption of the fluid earth itself. The fissures and dykes, the cones and badlands of ash and clay all tossed into the air with fire and gas and seemingly random motion. Can anything in this Universe be truly random?

Is it possible that every action, force and outcome in this inky blackness is without guidance. The fires of space and time have created a universal landscape of variety and beauty that is so immense and complex that it defies comprehension, and still the fires burn, describing new landscapes and visions, and the momentary flare and dance of the flame that continues to mesmerize and fascinate us.

Ice

The sculpture of enormous sheets of ice has gouged and scraped, ravaged and torn the landscape, changing and shaping the surface of this Earth for eons. The hanging valleys, the drumlin mounds and fertile grasslands are all testament to the force of ice,

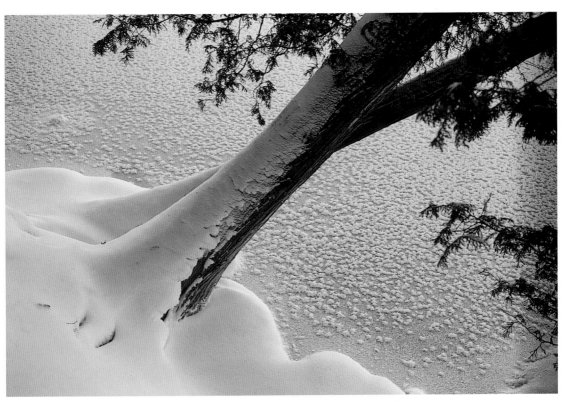

Winter Detail, Round Lake, New York

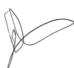

its ravages and its blessings. The forestlands of the northern latitudes of Earth have been changed repeatedly through cycle after cycle of this frigid scraping of the ground. What satisfies our eye today is new and different than it was in the grand forests of the boreal climes and dense seascapes of much of our temperate zones in the past. Much of this creative force is laid at the feet of cycles of heat and tremendous cold in this most inhabited realm of the planet.

The tree boles that shade and shed and die in the ever constant seasons have been selected and withdrawn and modified more times than we have discerned during the ages of frost and thaw. The hand of the Master has created and erased to recreate again the bark and fruit and leaves of the forests and wind tortured barrens of the high

latitudes and beyond. And still we have the ice, the mile thick grinding pressure of this most immense and mercurial force of aesthetic power.

Look to the mountain peaks and see the presence of this inexorable force. The freeze-thaw that provides jagged horizons and rock and snow reliefs that project majesty and power in ways that we don't really understand. It is art that tempts us to pretend to conquer its forbidden frozen fields, and still provides visions of power and temptation even when witnessed from afar.

Ice. It has a faintly repelling attraction that beckons us into its fold of snowflakes and wind, and then reminds us that to stay in the constantly changing delight of its presence is death itself.

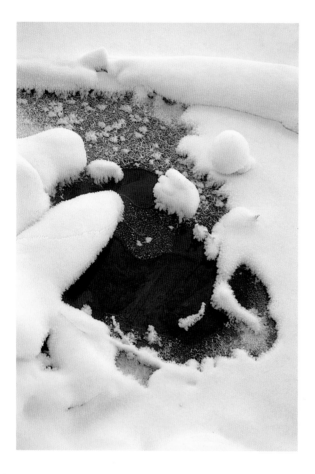

Winter Detail II, Round Lake, New York

Snow. The vision is at once inviting and transient. We see the layering, the cake-like coating of snow on trees and ponds, meadows and landscape, but as certain as spring arrives with the turning of the world, this coat of white will fade and wither and nourish the life of all things.

Yet can we imagine the experience and the delight, the intuitive realization that this act of cold artistry is as essential as life itself to those who live in the cycle of ice and sunshine that has been provided for us? The frozen lakes and the hoar frost on wind blown heights. The crystals on our glass

and the trails and marks of the passing of furry critters, man's passing too, recording his layer of history as well. As fast as it falls and forms rows and ridges on branches and withered flower stalks, it is blown away to build drifts and fill the bottoms with white warmth for those burrowed below. But we never seem to tire, at certain moments at least, of the spectacle and the artistry of this frozen feature of our landscape that leaves us moving slower, breathing harder, and yet marveling at one of Heaven's gifts, the fascination of frozen rain.

Madrone Tree
Southern Oregon

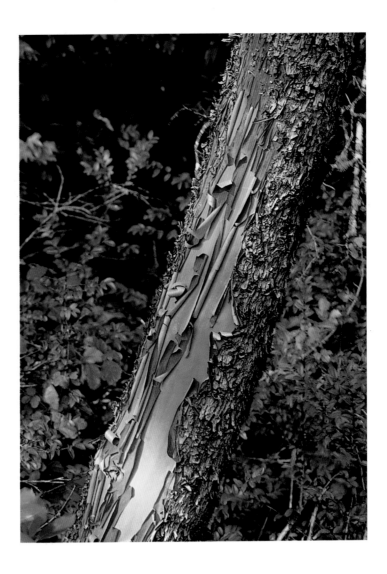

Sunlight

What splendor from the sky, the light that shines on all that God has made. All living things depend on the light of day, even those that seek the shade. The interplay of light and darkness forms an alternating clime of day and night that means life itself to us, and the creations of sunlight are some of the most exalted moments in the visage of the landscape.

Who has not looked at least once upon a sunrise that stops the moment, checks the rush to another place; pausing long enough to consider the beauty of the clouds and sun and sky. Sunsets, mauves and reds, heavy haze screening the sun to a golden hue, a perfect sphere that even cuts through the pall of summer city skies. To see the desert in the wild days of summer with thunder clouds and the rays of the sun streaking from west to east in an unbelievable arc of crepuscular rays that unites the world.

The sun; its inspiration finds expression through the hot and sweltering, showing a thousand guises of backlit clouds and reflected light that dances on the water of neighborhood lakes and alpine ponds.

The winter brings yet a new set of sights that remind us in the coldest air, that the sun will never retreat. The blue shadows in the forest and the million points of light in the crusted snow blend with silhouettes and frail-seeming trees to dazzle us with this passing canvas of whiteness. The moody brooding of the clearing storm when the sun emerges yet again to claim the sky as it battles the clouds for dominance; then the grayness clears in waves away from the welcoming face of the sun.

The flowers, the grass and trees, the bent wild stalks that are silhouetted against the dawn; the very morning breath of the land that greets the return of this greatest of all elements in the landscape as it rises again to paint scenes that are fleeting with the rebirth of flowers; or the timeless kiss on the pinnacles and caps of the mountains and desert sands. The sun creates the bright of day and the mystery and contrast of shadows. This painter's light is different from the cold and austere cast of the full moon, a light of mystery and even foreboding. The starkness of the night light that guides us from the lonely depths of the mountains when we are lost, and rallies the feelings of restlessness and angst that lead us to be unsettled.

The return of morning and sunrise is all the more welcome for the retreating night and its absence of the bright colors of day. A rainbow forms and doubles with the fragments of sundogs in the brightness of the desert. These bits of colored sky are

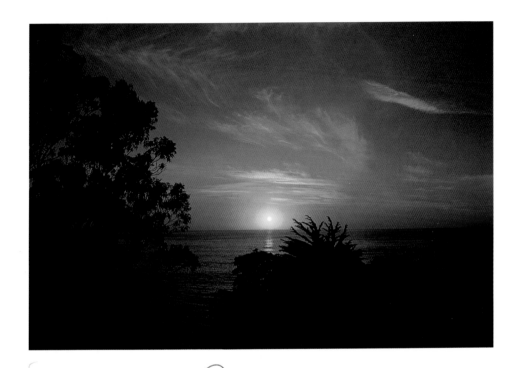

Sunset, Big Sur, California

blessings to a nearly cloudless day; they bring a touch of magic to the scene that is otherwise almost ordinary. And the flights of imagination that go with these beautiful strikes of color are as strange as we are able to conjure from the film of sky born clouds.

All of these ancient elements conspire in the hands of a master to stretch our imaginations and provide at once both solace and inspiration. These elements are life itself, the survival and necessity of all things that we must have in order to carry on our tenuous existence. It is the form they take, the aesthetic blessing of living beyond that tenuous edge that leads us to a higher order of life and living while we are here in this constant paradise of color and shape and motion.

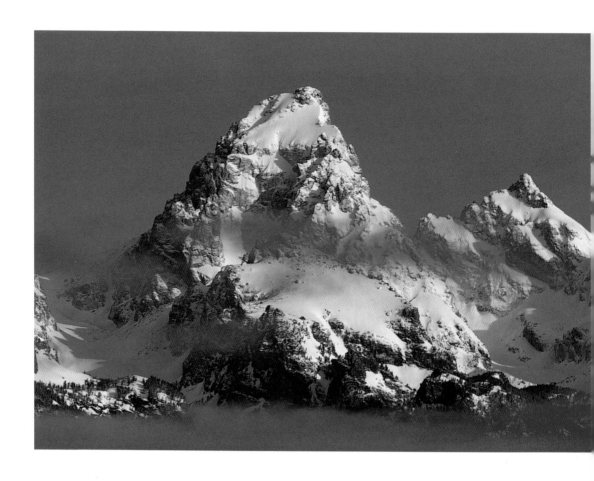

Grand Teton Range, Wyoming

Terrestrial Art

"To see a world in a grain of sand
And a heaven in a wild flower,
Hold infinity in the palm of your hand
And eternity in an hour."
-William Blake-

We are presented with so many instances of wonder and enchantment in life that often the stage for all the glory and variety is obscured by the features that meet the eye. We look to the mountains and are struck with consternation when we seek to understand them. We often worship their majesty and mystique simply because they are vast and dominant in our field of vision. The real reason may be because they seem to represent more than massifs of stone and ice. For all time we have been challenged by these barriers that block our way to tomorrow, and yet we still find something in them that is intangible, unconquerable.

The weather, the clouds and mist and snow that surround these peaks only add to the power they seem to project. Universal simplicity would dictate that these icons of dominance would be similar - afford little in variety of shape and texture. Plainness would be the consistent feature of all the thrusts and burning caps that raise themselves above the plane of earth, but instead we find deep greenness in the sheltered rain forests, the barren dryness of the frigid peaks, the snow caps of the quiet Vulcan-born cones and living things that are so often found nowhere else in the ranges of the world in these splendid shades and shapes and coated peaks.

The intrigue of the actions and reactions that build and destroy these ranges of power and mystery wash away and crack and freeze these pinnacles in one constant motion, and while we rarely see the powers at work, they manage to provide a variety of scenes and stages that keep us wondering at every turn. Rounded old hills that were

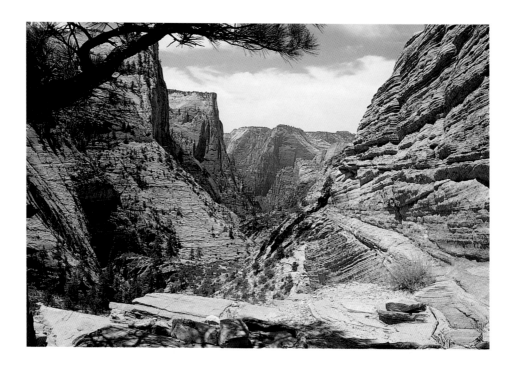

Zion Plateau, Utah

once craggy peaks are the homes of animals and plants that reveal themselves in countless ways. The mountains become hills and desert dunes in an ongoing continuum of relaxing forms that meld into the plain of the earth. Variety in all things. Dolomites and Alps, Appalachians and Malutis, Urals and Andes, the names and the histories are unique and similar at every turn.

Glades and glens and glaciers adorn them all, or have at some turn of the hands of time, and the result is green and gray and white with an array of blooming things that we insist on naming and cataloging and tallying even as they fade and die in extinction to be born again in a new array of wonderful colors and shapes and aromas. And as these majestic spires and turrets die in their own way, they fertilize the plains with nourishment and new beginnings by squeezing the clouds and begetting the rivers that drain their sustenance away to the flatlands and prairies. They generate wonderful

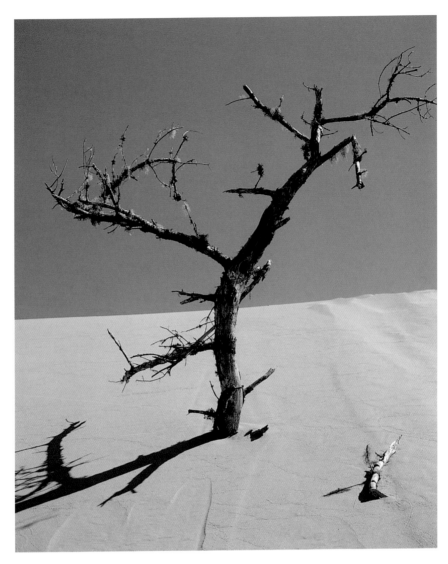

Sand Dunes
Oregon Coast

torrents that shoot down the hillsides and flatten out to meander and oxbow and bring life to barren sites that are green from the gift they are given.

The how of this beauty is not ever as enchanting as the why. In all these things there is a soul, a constantly changing panorama that provides a never ending palette of beauty and variety, wonder and intrigue, and the why lies somewhere deep in the spirit of everyone who seeks to discover the grand design. To seek only to find the gold at the end of the mythical rainbow is more of a misspent life and folly than the search for the meaning of life itself. This quest for why is certainly elusive, and perhaps no one ever

finds it for sure, but the quest itself must be the true purpose and value of the breath of life that we first fill our lungs with at birth. Its significance is never really enhanced by knowing the mechanics of how it occurs.

The land, the table upon which the feast of sight and life itself is placed, is also a canvas of constant fluid images that greet our every glimpse. The borderlands of the forest, the meadows of flowers and insect heaven, dunes and knee-high grasses, they all have a place and a time, and never is the future assured in that spot. The ground heaves and washes away, the dryness comes and forests are deserted of satiating clouds and evolve into the seeds and florets of grass and yarrow. This desiccation may grow cold and heave again with snow and ice and permanent frost, and the nights may seek to strain the fiber of life, but the one constant in the morning is change. It would seem that few would question this ever-moving process of evolution, of old things begetting new, the tall becoming the worn nubs of the earth as mountains to plains, and dead forests to deserts. Where we seem to diverge is in the design of this change in the earth's countenance; the face we see every day from a thousand vantage points but with the same two eyes.

As with a thousand other curiosities we are presented with the question of degrees of change and the chaos and patterns that seem to come with the sculpture, paint and canvas setting we call home. When we seek order in the world around us, we can readily find it. There are the ranges of hills in often predictable rows, and the verges of canyons that define great rivers and sluggish brooks, but the scale of these things varies with the land. To some the source of the stream is known; those who hug its banks and draw its life-blood as part of their own. To others, the Ganges and the Nile, the Amazon and the Mississippi, the source is as alien as the massive surge into the sea at its apex is for others. Rivers like mountains take on a certain aspect of life akin to the mystique and religious nature of the great mountains that foster so many of these great fluid works of art.

Water is seldom still. If it is flowing in a stream, it surges in a quiet pulsing rhythm that few even notice, or rages with white water and power in the thaw of springtime, showing yet another character and summoning up visions of energy and

rapid change. The mighty ones support the life of whole cultures and provide more than just sustenance to so many souls. They offer peace and comfort, visual relief and assurance that tomorrow will come with golden mirrors of sunlight and blue sky images that even the most commercial of minds will see as they make their way on its precious surface. It is there for all to behold, if we only look with seeing eyes.

So much is out there. The bark of the trees is itself a puzzle and a pleasure to inspect. The stringy wisps of hardwood cladding and the hundreds of piney cork-like

The Narrows
Zion Canyon
Utah

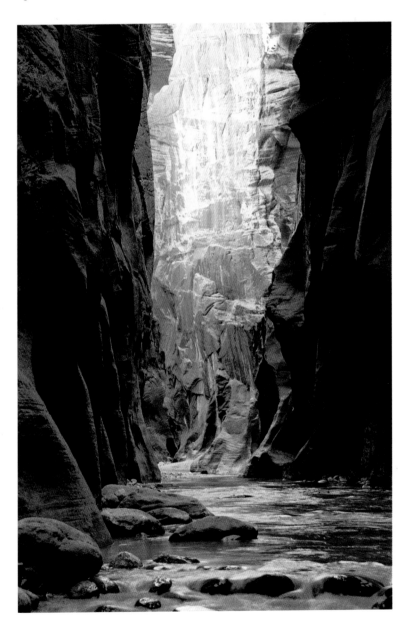

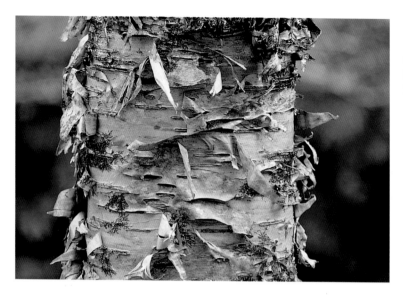

*Black Birch Bark
Smokey Mountains
Tennessee*

layers that fill the glens and slopes of the hills and valleys are part of this complexity. The boreal forests of delicate frozen white-barked dwarfs and the immensity of the redwoods witnessing the march of time as living things, add their own distinctions to the land. We inspect and probe and measure and are fascinated with our own quantifying of this life, yet this unique tree-sight is the compass of time and the thousand deer and furry pedestrians that we cannot even comprehend as a passing parade, witnessed these wooden monarchs through the ages before we ever laid eyes on even one of them.

Our sight is fleeting, measured in minutes and hours, and we are constantly bothered by necessity and desire. The forest sees the passage of natural beauty and never comments. It cannot feel what we feel nor can it consider as we can. It is both a participant in and a mute observer of this incredibly intricate cavalcade of colors and features and changing landscape. Yet it has a thousand years of life that we will never know. Its youth is nearly like its old age; where we are helpless at birth and vulnerable as we progress toward death. Our lives are lived intensely and with possibility where this great silent forest is patient and stalwart, defenseless against the fires of God and man, and the termination of life by our will and sharp implements.

Fire From the Land

How is it that we could ever fail to see the grace and beauty, the cauldron of order and chaos that boils and simmers at sunrise and sunset, just as the conflagration of

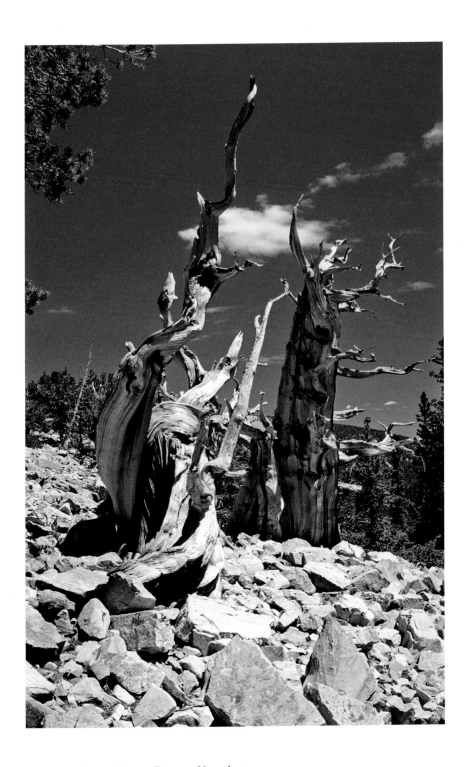

Bristlecone Pines, Eastern Nevada

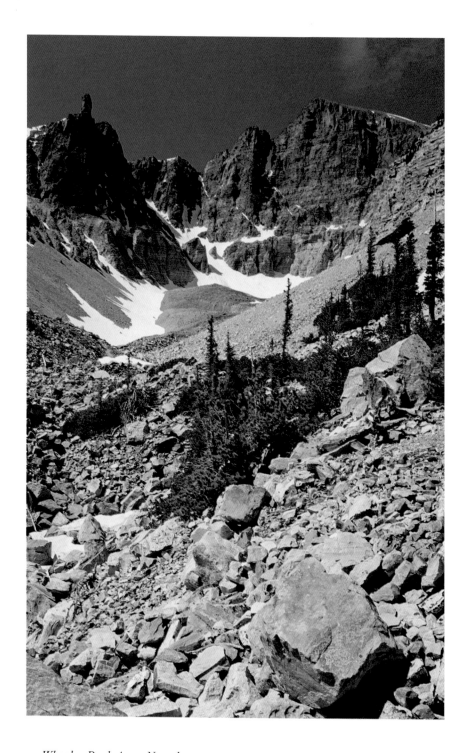

Wheeler Peak Area, Nevada

the liquid center of our world comes boiling and rushing out in color and ferocity. The showers and flows, the bombs and billows of countless ruptures in the landscape provide change and zest and fury. But they offer beauty and grandeur on a scale seldom witnessed in all of our existence. These progenitors of majestic peaks and islands are of living rock, a truly animated landscape that is surpassed only by the sun and stars in power and might. And when these fissures and peaks and cones are spent and at rest, dormant and extinct, they age gracefully with wreaths of smoke and snow and fireweed to bring new horizons; changing, always changing. To see the crest and flanks of Kilimanjaro and Egmont, of Hood and Rainier, and mighty Fujiyama is to see the evidence that speaks loudest and stands tallest of God's presence. Not as a product of randomness, of cinder cones rising out of cracks and fissures, but the force of beauty and change rising from a divine will and seen by us through our rare and precious ability to appreciate what is set before us.

Caves and Canyons

Our curiosity drives us forward as it has from the beginning of time. It has taken us into the doorway of the universe, to the bottom of the sea, to the tops of countless mountains and through spartan and immense deserts. But one of the most fascinating places we have poked our curious noses into lies underground.

Tunnels and caves and slots in the rock, canyons of every size and description, they have all afforded us fascination. From these elements of subterranean cracking and weathering and wearing out, we have found sights of incredible color and form. They do not lend themselves to function, they do not preserve or protect the mother rock and they do not contribute to life or the balance of creature colonies in their midst. They shine and glow and mesmerize us in ways that only the perception of a value beyond utility could.

To walk and crawl and stand in the presence of this rare beauty makes one yield to quiet contemplation. Loud noises seem out of place, a sense of holiness pervades. Ignore that, and just absorb the magic of the light show on the rocks; search for the why of it. Let go of the what or the how, consider the privilege of just being there, of seeing

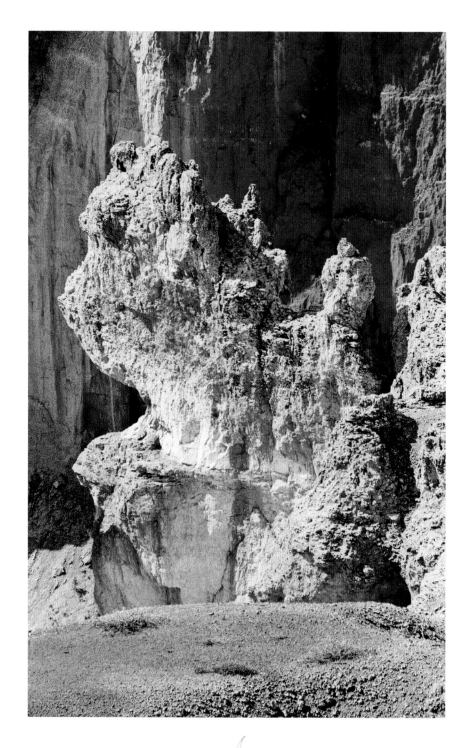

Hoo Doos, Bryce Canyon, Utah

*Bryce
Canyon
Utah*

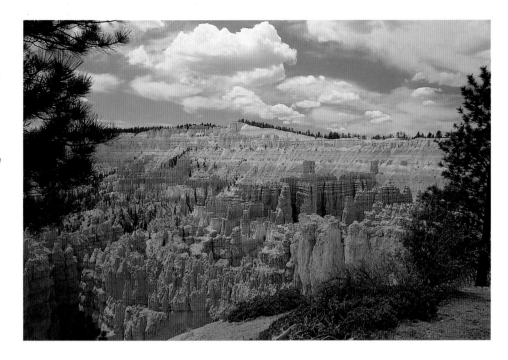

the illumination, the darkness, of breathing the air and observing something that only
you can see and only you can consider. Beauty.

Who would imagine the beauty in rock? The tempests that blew eons ago,
shifting with the seasons through all the compass points, and with constancy and a will

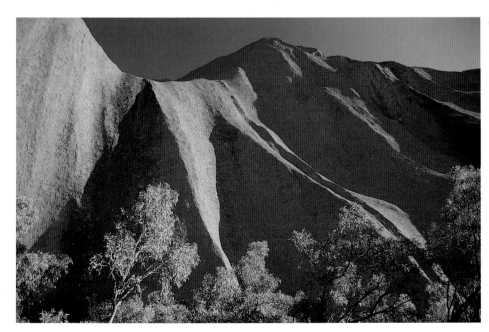

*Uluru/
Aires
Rock
Australia*

they built these battlements and crests and mesas that afforded the furred and hooved a place to ramble and live and recycle their lives. To us they provide a spectacle of bands of color and shapes only a child could imagine. They glow in the sun and quietly fade at sunset as they have for ages that we cannot comprehend.

The tiny particles of sand and dust that were driven into the air by will and design, have left a legacy of time and purpose that provides more than just a glimpse of the past. Tomorrow and next year these hills and caverns will go back to dust and will wash away to the sea. They will find the flat land and resume their quiet deliberations as soil and silt. But for this moment in time, while we are here, they provide backdrops and inspiration, awe and fascination about the spectacle of the land that speaks to us in color.

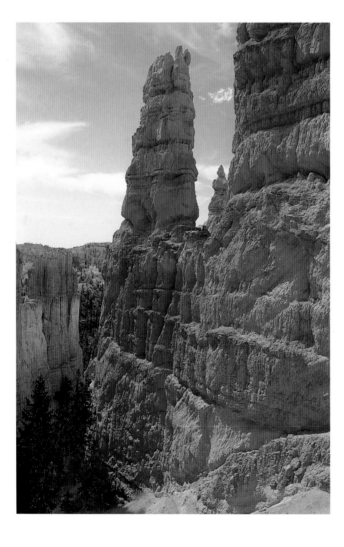

Inner Canyon,
Bryce Canyon
Utah

In the quiet remotenesses of these caverns and canyons is the temple of color and sand that hides from view. The knifelike silhouettes of rock slots are solemn and silent. The sun barely penetrates, and the snow only sifts down into these fastnesses in its most determined moments. At summer's hottest, the rays of our distant star find their way into these fractures and turn the rock sides to furnace hues that glow and speak in their own red-orange-yellow tones. A passing cloud and the glow is gone, snuffed out like a candle, and rekindled just as quickly when the starshine returns. Almost invisible in the vastness of the desertscape, these secretive deep riddles in the rock offer neither sustenance nor refuge to us or the furry pedestrians that often walk there. The flashing rush of water that streams through these conduits of hidden magic sweep all before them and leave nothing in their wake but the renewed and cleansed rock faces that will glow again with the reflection of golden sunlight. Who is this light show for? Not the scampering mice and passing coyote. The colors seem to be lost on them. And these deep cut canyons have no value to us to stay alive or foster more of our numbers. They are for looking at. They seem to be for the greater glory of art and beauty, and little more.

Valleys

There is a place tucked in between the majesty of mountains, which is quiet, green and peaceful. For the dreams and inspiration that come from the crags and peaks, eventually settles to the glens and meadows, the tarns and cienegas where we dwell. Valleys are nurtured by the mountains, protected and even defined by those upright ranges of rock and snow.

Seen from the slopes of hills surrounding them valleys beckon with their trees and grass and brooks. Scenes of tranquility and sanctuary are instantly apparent to our gaze; part survival, part aesthetic. These green treed swards are seen by experienced eyes as havens for life, ours and many other creatures. Yet they also seem to appeal to a deeper sense of instinctive attraction – a distant longing for home and rest perhaps, even beauty. The trees that add the texture and dimension to this space may mean shelter and fuel to some part of us, but they offer shade and summer respite from the sun, and music and serenity are derived from their leaves. Even in winter, they provide a sort of

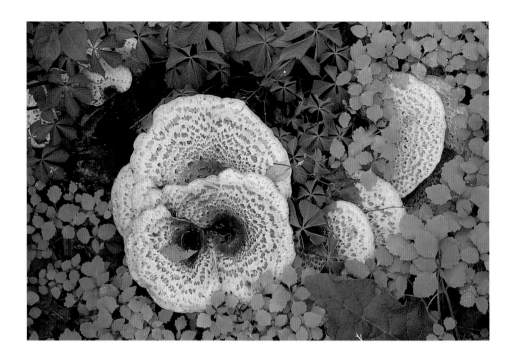

Bract Fungi, Bank of the Erie Canal, New York

warning to us to retire into a warm place, as they crack and creak in the cold wind, their stripped branches clattering and clicking a message of cold…

The grace of the willow and the full crown of the maple, the shaggy hickory and white bark of the aspen and birch – in all of these there is a subtle expression of difference. Why aren't they all just the same? What value is there in variety – beavers have favorites as dam trees, the deer are selective in stripping bark for food to survive the winter, but most trees will do for all God's creatures. Is the variety for us, or were we created to appreciate the variety? Did a master designer create the elements and the sanctuary of the glens and meadows, and then foster us to live in this paradise of variety, or were we engendered to populate and appreciate this world of creativity through unique gifts of self-awareness and sentience?

It would appear to be a monumental loss to us if the flowers and mushrooms, the trees and bushes and birds were all the same color, had the same leaves, and sang the

same song. Monotony would have no meaning, as there wouldn't be an antonym for anything in life. Variety would be as alien as the necessity to see and feel and taste anything in our world; we would be assured of safety and security and numbing sameness. Curiosity would be diminished to a survivalist definition, and we would all look alike, be the same height and grunt in the same monotones. Seeking and searching would be limited to the necessity of finding the next fur bearing rabbit-lion-mammoth-deer, a "ralinde," for dinner, and the menu would never change.

The glen would only provide shelter, and it would rain every day, briefly, and the sky would be gray, and trees would all be 30 feet tall with gray leaves, and the ground

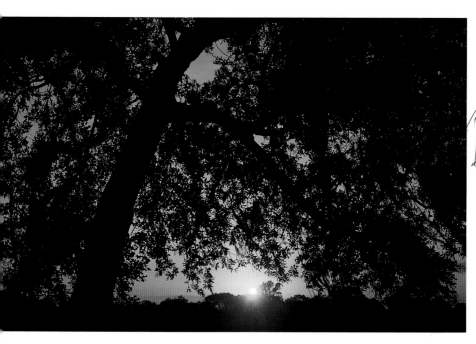

*Sunset
East Texas*

cover would all be gray and of one height and specie. The grass, yarrow, straw and brush would be "graystrob" and would provide sustenance and allow herbivores and omnivores to survive.

Soaring thoughts, and heart touching moments of exquisite emotion would be lost. Quiet interludes of contemplation and sensation would not exist. For the variety that we often take as a birthright, but seldom acknowledge as the very essence of what

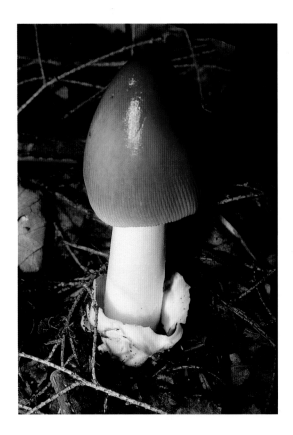

Fungi, Round Lake, New York

makes our lives interesting and enviable in the universe, is also the very heartwood of spirituality, and one of the greatest symbols of this variety is the tree.

Trees

Fortunate we are to stand at the base of the massive redwoods and sequoias, to be awed once again by the creation of these plant factories, and not have to see them as just lumber and remnants from the past. To consider the size and the immense history of rain and sunlight, fire and snow that has covered these quiet witnesses to cycles and change is extraordinary. Sometimes the quiet of sunlight, then the quiet of a fine rain. Rabbits and deer, grizzlies and raccoons, the impress of uncountable insects, and then the brilliance and delicacy of a wing of butterflies. From the seed of a miniature cone no bigger than the cub of a mighty bear, comes the pattern and direction, the size and scope and majesty of such great trees. There was selectivity here; one can surely see the variance with so many other green and sappy things, the question remains why this unique tall thing that resists mold and fire and can last two thousand trips around the sun is but one unique and fascinating element standing at the center of it all.

From there to the soughing of the lesser forests of pines that blanket the mountains and valleys of immense landscapes is the true bounty of much of the world. The bed mats that uncountable animals found so desirable at the end of the day before

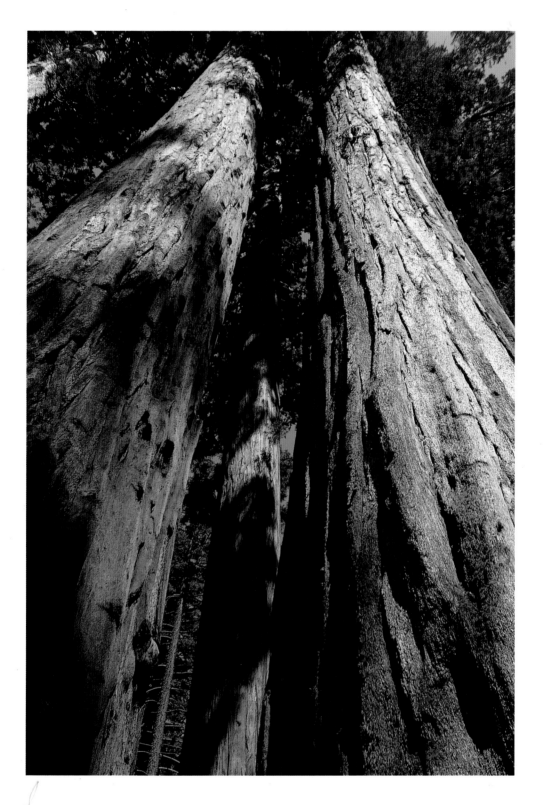

Sequoia Trees, Eastern California

Tree struck by lightening, sap resin from wound mixed with blowing red sand. Bryce Canyon Rim, Utah

we were ever granted the chance to share this space with them, lie throughout this wondrous world of tall green things. The soap, the sap, the tincture and the wood; a bounty and a thousand uses from this kingdom of the earth. To name these fellows we have chosen balsam, and long leaf and ponderosa. The slopes of mighty mountains are the forbidding residence of the loblolly and the spiral shanked pines that twist in the perpetual hurricanes on mountain faces. The high lonesome remains the home of the

ancient bristlecone pine, father of time and patience, that has outlasted most civilizations and is still gripping the shards of granite and slag that provide it an anchor and a spot in the sun to pierce the air.

Nearer to our valley homes we are treated to the big leaves of the maple and the oak, the chestnut and the fat boles of the beechnut. In these we find even more to be intrigued with. The eucalyptus with its peeling bark and perpetual green leaves, shedding to be sure, but never letting us suffer the loss of shade or comfort; this same anchored, ancient statue in the forest has found a comfort of its own in most every corner of this world. It is peculiar, but somehow in reflection it seems some how crude that we have developed in such a way as creatures ourselves, that we use these vast, complex and infinitely beautiful cohabiters of our world as we do: cutting them down and disintegrating them in fires as fuel and as expendable elements in our lives. Whatever their fate, they still offer themselves without flinching as subjects worthy of admiration for their unique appearance, smell and form.

Trees on the Cliffs of Zion Canyon, Utah

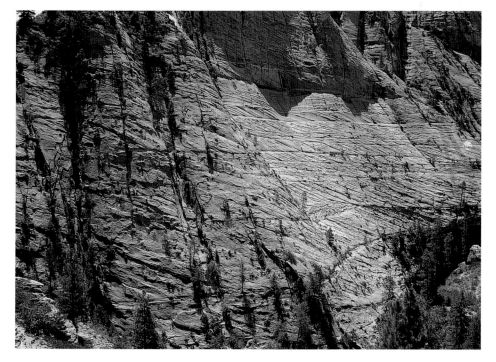

The view of trees is not limited to the vastness of forests or mountain slopes, to the Piedmont and flatlands of pine barrens. They travel to the edge of the desert and even to the tropics, as tingle trees in Australia and stinkwood in Africa. Names like baobab and quiver tree, and descriptions that call to mind their utility more than our view of beauty; where then are the honey and butterfly trees? It seems a bit unusual that we would need so many names for the yew the larch and the fir, if, as we so often postulate, the variations came from natural selection. After all, who was it that did the selecting?

Desert

When the land is washed in sunlight and the rain is scarce we give the country a name: it is the desert, the desierto, a place apart, where we go only on quests and to search for avenues to unknown places. Yet, in this cauldron of shifting earth and patterned winds, we find sources of wonder and changing landforms that intrigue us both in their demanding qualities and the subtle varieties of color, form, transport and even the sound of these forbidden spaces.

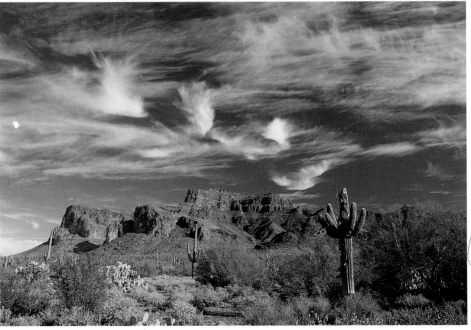

Superstition Mountains, Arizona

Deep in these dunes is the constant sound of shifting sands, the saltation, the spilling over of unnumbered grains of sand from one momentary ridge to the face that forms in its shadow. It is a quiet incessant sound, heard even over the whispering of the wind, until as a force the wind comes in a frenzy and the sand is no longer heard, but is felt. The grains are blasted on the rock faces of ridged forms from the past, and the movement is hurried. These same quiet dunes that boom in the light of day, and sigh as night comes on are the most mercurial and certainly the fastest landforms to sweep the

Nambung, Western Australia

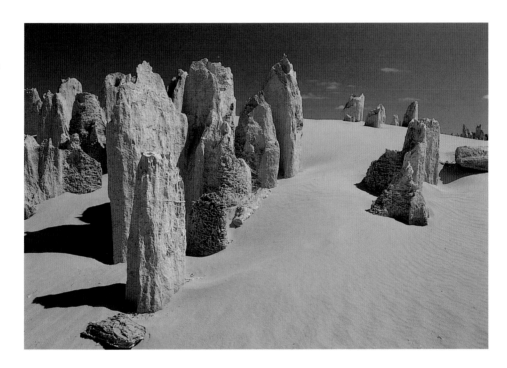

hard pan of the world's landscape. Mountains are eternal relative to our short and fragile lives, but deserts can change form and shape and size in just a few seasons, and then continue to morph into new and constantly changing shapes and presences before we see them again. Wastelands? Desiccation and barrenness? In our eyes, certainly. But the most energetic palette of God; yes that too.

It seems that no matter what extreme we go to in order to satisfy our wanton curiosity, there is always something else waiting for us to discover. We have foraged over much of our world for reasons that are sometimes clear, and more often just

Namib Desert, Southwestern Africa

because we cannot restrain what is most central to our very natures, curiosity. We have surveyed the heights and depths of the lands we have been granted, and the seas that surround us on all sides. We have flown in the air and gone deeper into the cosmos, but even in the deep recesses of the Earth we have found more than the ample and necessary for our needs, for even in the most tantalizing recesses there is a curious form of pleasure to be found.

In the desert the wind blows, and mountains crater and go to dust, and the wind still blows… The dust of seas and blowing hills finds order in the flat lands of deserts. Travelers find refuge and immense heat and cold in these incredible quiet places, and while patterns and order seem to be alien in this refuge of silence and open space, it is indeed ordered. Wind rows and fantastic stars and scimitars, crests and waves and slip

zones form patterns in these mobile seas of loose crystals. Where do the patterns come from, and why? What gain is there to elaborate shapes in this vast sandy waste? A crest or star or barkan seems a bit over dressed when a jumble of fine particles could just as well fill the voids between here and there.

The ancient dunes of times long past show these patterns of order and form, and it all falls back to the wind, that featureless invisible something that seems to be as fickle and unorganized a presence as any in our world. It requires a bit of sorcery to explain how Maria could hold a template for sand particles there in its invisibleness, and yet the Sahara and Gobi, the Namib and the Mohave are built according to this unseen blueprint. Evolution; somehow it just seems beyond the spectrum of optimal choice to fashion

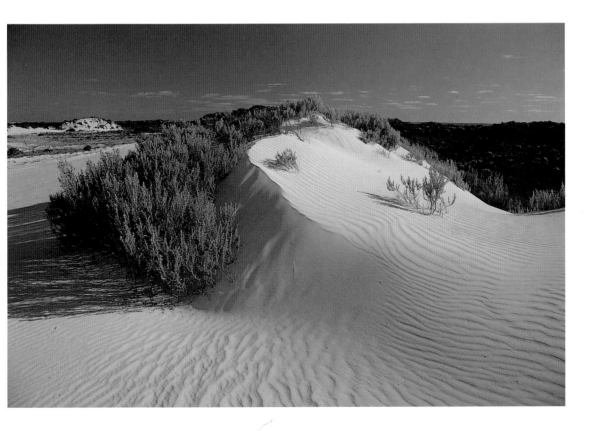

Coastal Dunes, Western Australia

shapes and angles that serve no discernable purpose other than to provide elements of divine art.

Dripstone

Liquid rock, not the fiery kind that bleeds from the molten insides of Earth, but the dripping, dissolved rock that requires ages to seep and drip and splash in the recesses of explored and unexplored subterranean caves and caverns throughout our world is its own kind of passive wonder. The still plinking statues stuck to the tops of ceilings and the ancient curved and smooth statues on the floors of caves that are still alive, still changing, inexorably, one mineral rich drop at a time, are of special interest. And the quiet, dry, dormant caves that time has muted and left for us to seek out, and for

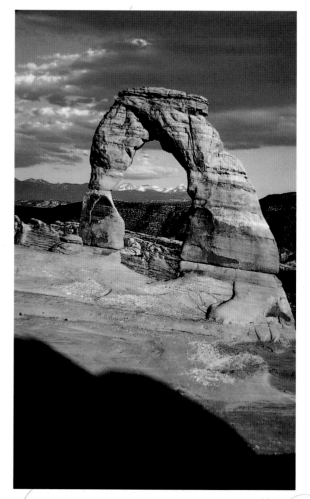

Delicate Arch, Arches National Park, Utah

the shifting of the earth to eventually decide to bring back to life, or to grind into the dust of the living crust of our world, are quiet and stationary. When they are lighted and spring from utter darkness, a darkness blacker than the star lit universe, they reveal towers and stacks, straws and curtains growing from the ceiling that are unique to this alien darkness hidden from our sight.

When the light flashes on them they reveal a delicacy and variation that is found rarely in any part of our surface realm where ferocious tempests churn and wear down and build up the surface of our world. These infinitely precious and delicate forms are

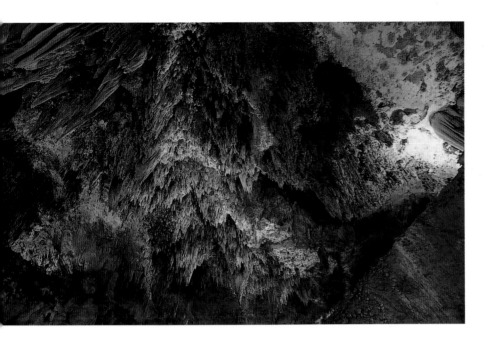

Stalagtites, Carlsbad Caverns, New Mexico

Stalagtities and Stalagmites, Carlsbad Caverns, New Mexico

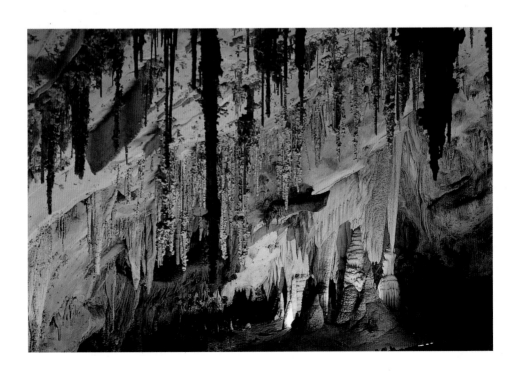

of no value in the procession of the ever changing universe, perhaps they are simply quiet experiments, notions of trial and error that have been accomplished in secret, and are out of the mainstream of the evolution of the universe as some would maintain. But to see them in their beautiful and colorful finery, to witness the patience and the variety they express even for the moments they are revealed to us, makes one pause to consider the why of these secret works of art. The reason may be that they are there to be discovered, for us to be able to revel in this near silent treasure just awaiting discovery in a hidden part of our universe; a silent, secluded reminder that wherever we look in our ever-expanding universe, there is the hand of thoughtful prescience.

Flowers

As the collection of cosmic dust spiraled into the glob that is earth, and the moltenness and congealing eventually spawned the waters of the seas, the emergence of cooled landmasses began to vie for dominance on the skin of the globe. The sliding masses pushed and dove into one other, and the majesties and drama of the earth were at hand; color was spread about to the glory of…well no one was here to glorify God, but

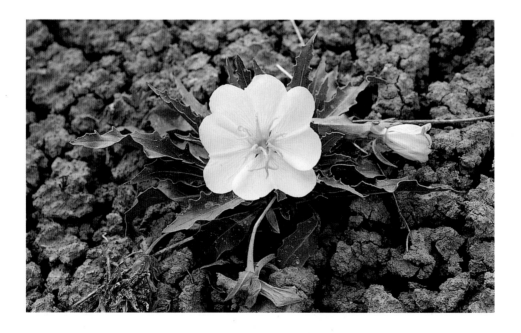

Prarie Evening Primrose, Badlands, South Dakota

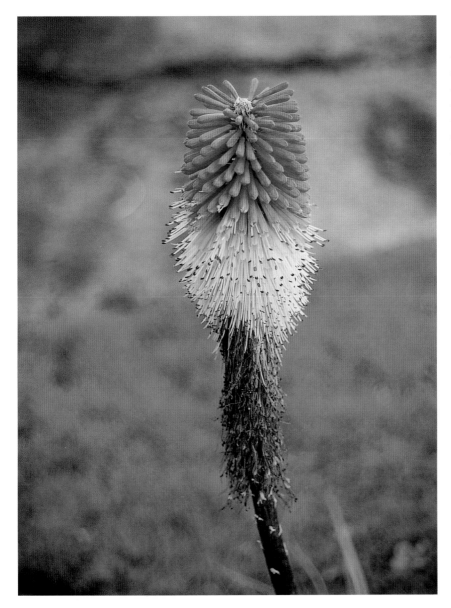

*Devil's Poker,
Maluti
Mountains,
Kingdom of
Lesotho,
Southern
Africa*

the colors came out nonetheless. The escarpments of these masses of rock gave birth to cloud bursts and streams and plunging falls, to ice and snow and glacial rivers of grinding and churning rock and ice. In all this, the landscape became varied and wondrous, forces of change became more recognizable and the surface of the earth took on a sort of life of its own. Amidst all this churning and molting and evolving, flowers bloomed.

Flowers, those special gifts of fleeting distinction that adorn the glade and desert, the mountain heights and the watery courses that bisect the face of all we survey. Tall ones and minute ones, blossoms of the entire range of colors perhaps in the universe, on spikes, and frail stalks, and vines and attached to the boles of trees. Perhaps the most conspicuous sign of life and design in our existence is the intricate spread of kinds and sizes and colors of these spots of life and regeneration. From the snowbound near-frozen trumpets of the just spring varieties to the bold ones in summer and the frost tinted and dying sprigs in the autumn, they provide us with a sort of tranquility and love for small and fragile and fleeting things in other parts of our lives. Yes, they have seeds, and those from the dandelion and milkweed and tulip offer one more chapter in the entertainment and comfort cycle all flowers provide.

Stuck on the sides of volcanoes, wedged into the rocks on mountainsides, bursting from fields and meadows, they are everywhere. There by our forbearance, that we will not eliminate or wipe out their frail but persistent presence. White ones, blue ones, pinks, and purples, and oranges of hues imitated but never really captured, for as they blossom, so do they fade and change even as they grow old and fall to the rich

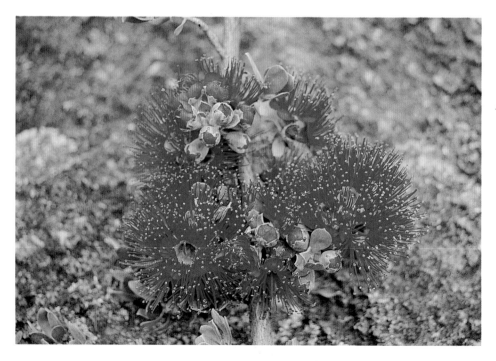

Christmas Flower, Western Australia

harvest of compost to nurture their children and distant relations. The nodding violets with days to thrive and the snowcaps and crocuses, amazing in their ability to spring from nearly frozen soil and to put forth such colors, the source of which is still a wonder, and a question, why?

The place is often ordinary, by the lane, in the woods, beneath the needled shank of a cactus; it is not in the placement, but rather the appeal and even emotion that they stir in us by their very presence. Deep in us there seems to be a kin to the color and smell and the presence of these denizens of what – rebirth, sorrow, love and subtle feelings of the way we once felt; the loss, the arrival of life, the panoply of emotions that are ever present in our entire lives. All this just from the spots of color that greet us from the ground. Imagine the difference if they were all just gray.

Cactus

In dry and open places, where the sky is immense and the stars are bright enough to see by at night, there is a unique array of growing things that are truly rare and set apart from all that we know. Spines and needles and insidious fuzz that pierces and sticks and travels unbidden on the unfortunate and unwary, for all these things we have a name – cactus. For all the variety that occurs in our world, there is a special breed of critter that can find water where there seems to be none, that latches on to the desert pavement in the most unlikely places, and even seeks out other cactus to serve as a nursemaid until it can grow and eventually dominate and succeed the host.

The cactus. It is thought of as home to a thousand creatures that fly and crawl and hop, it provides shelter and water and sustenance to those small and large who know how to use these bristling stark shanks of green and brown. Wrens and owls and cottontails are at home in the precious shade and protecting needles as robins and blue jays are in the fir and maple. The cholla, the ocotillo and the saguaro are all gathered in this spartan expanse of big skies and intense sunshine. The orange flags on the ocotillo and the butter-white blossoms of the saguaro stand out in the spring when the cactus comes into flower. The tiniest seeds are scattered to the four winds and somehow in this sparse and revealed landscape they find purchase and start anew.

Saguaro Cactus Skeleton, Superstition Mountains, Arizona

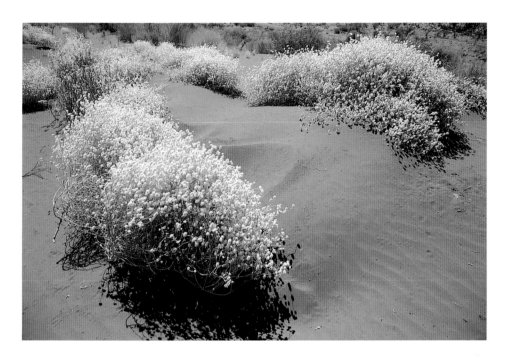

The Red Heart, Central Australia

The human side of these desert plants is the blossoming season. Many of the spiny types drop parts of their branches and seem to jump on passersby creating havoc and grave discomfort. But most bear flowers of the deepest and most enticing colors imaginable. Colors to decorate and attract, colors that seem so much a counterpoint to the irascible and forbidding host. The rose's thorns are no equal to the danger of cactus needles, and the luscious petals and colors are as deep and varied as any found on that temperate bloom. The desert takes no prisoners and yet it remains a place of color and variety and wonder for all who venture there. For all of us who wander the earth, this bit of landscape provides as much sustenance and beauty as any other, though the sight to see its gifts and live in its bosom requires a willingness to conform to its requirements and adapt to its life flow.

All of life has found purchase on land, in the sea or, temporarily, in the air. The rock and sand and soil that we have established as our home in this spatial wilderness

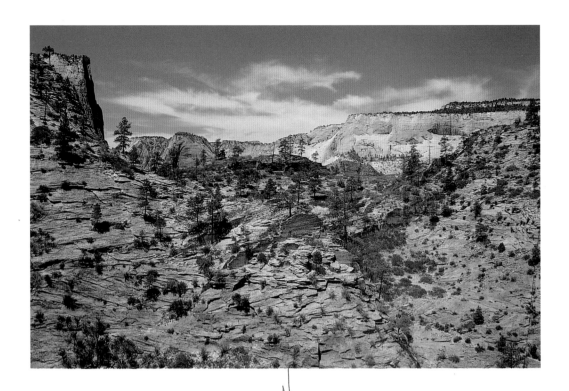

Slickrock Country, Southern Utah

has also been deemed the resting place of a complex web of life. While we are at home here, we have been driven to seek and explore and define this complex of solid forces that seem to have given rise to our life zone. At some point as we wandered, or searched, or sought salvation, we determined that this land had more value, more meaning and significance than just our survival. Forces were at work that seemed to make the cycles and periods of all that we encountered seem at last linear – a continuum of actions and consumption and mutation.

What we have come to now in this evolution of self awareness and self discovery is a cross roads; perhaps both an individual and social fork in the road that makes us decide whether butterflies are evolutionary creatures, and dinosaurs are represented today by crocodiles, or if in fact that life and landforms have truly evolved through eons of time, that the only time frame we are really concerned with is the

emergence of our own self-aware knowledge of the creative force of everything that we survey in the universe. The perspective is relative only to us.

Islands

Islands are curious. They have no clear purpose in the scheme of things. They do not improve the design of the earth, nor do they add to the march of evolution. Quite literally they create relics of the past, models of plants and animals from bygone eras, outdated, obsolete. True, the varieties are healthy enough, and the balance of living things remains constant unless or until a singular event or cataclysm occurs, but they are still on a sidetrack, a path that slows or ceases to develop or evolve all together. Are islands anomalies of bits of flora and fauna that have been cast adrift from the surging activity of the land and sea, or are they more than that?

As a creature, we have found refuge on islands throughout time. Cast adrift on the sea, isolated and in an inhospitable realm of liquid, the sight of an island has meant

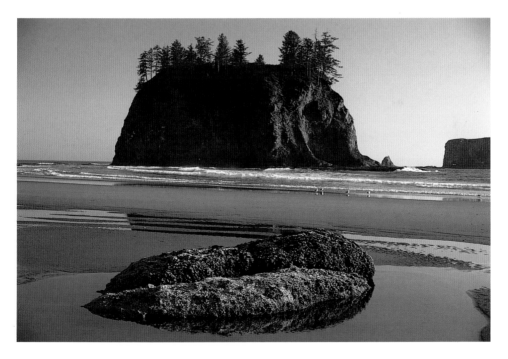

Seastacks, Olympic Coast, Washington State

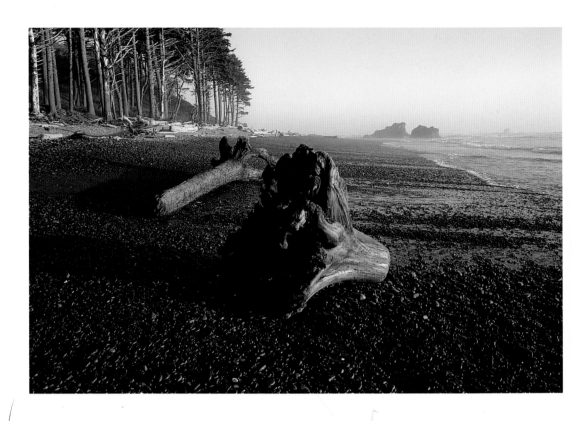

Redwood Trees on the Beach, Pacific Coast, Washington

salvation, sustenance and relief. There seems to be almost a special purpose for these bits of dryness in the oceans of the world as they have given rise to religion and beliefs, art and folklore by the people who settle on them. There is a fascination about the birds and flowers and trees that has given rise to worship and ceremony and an interpretation of divinity in the earth and water and sky by those who embrace these sea born rocks. Yet, for all that is offered and laid bear to us, we seem driven on to the next toehold, to the next sanctuary, and eventually back to the evolutionary engine of the continents.

Along the way, we have come to see these dots in the sea as works of art. The palms, the sand, the exotic and the unknown become attractions in their own right. The relics of the past in places like the Galapagos and Hawaiian Islands are set aside for their rarity and beauty and yet we go there because we are attracted not to the utility of these places, but because they afford relief from the known. We have not learned to harvest

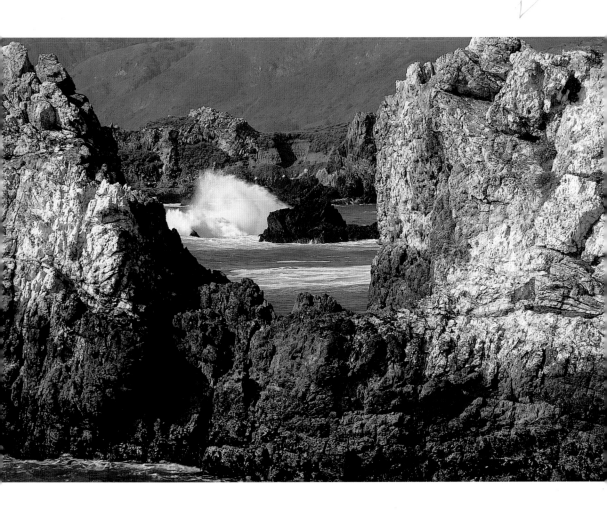

Big Sur Coast, California

the rare and nearly extinct versions of living things to create new and different strains for the evolutionary bullet train that rules the continents, though one day we might. Instead we have come to view these unnecessary bits of flotsam as aesthetic retreats, intriguing curiosities and escape from the known limits of our every day world. For us these unique places of unnecessary dry land have been elevated to the status of precious refuges to see, feel and experience as pinnacles of sentient release. To us they are more than dry land in the midst of a sea.

With all the grace and beauty and panoramic changes that enhance the earth, the question of how land and animals are related is a curious one. The subtle and majestic landscapes of the earth have been forming, dissolving and reforming for much of the lifetime of the Earth's existence in space. The solids and liquids have been splashing and sloshing for eons with first one dominating in a certain spot, and then the other. And so this ever-changing, non-living stage has offered a multitude of sets, long before the living thespians that are us, the plants and animals, were introduced.

In this way, the beauty of color and variety that we see in the rocky and watery landscape is actually removed from the beasts and the plants that now inhabit it. The land is enduring, life is not. This spinning brown and blue top will go on hurtling through the blackness of space for what to us is eternity – the true definition of that word. But life will change colors and forms and appearance in a smooth line of transitions in response to the form and action of the land and sea.

It is a true quandary to try to decide whether the living rock and sloshing sea were the creative elements that begat all other life, or if a higher order influence used this stage set to place the elements of mortal life, the genetic strands and the inertia and cosmically pervasive impulse for ever more complex chemical and biological systems to evolve in the universe. Chemicals can split and bond in numerous ways. But the compulsion to create higher order systems is not explained in any way by even this simple characteristic of chemical elements; there is far more to the organization and interaction of all things known and unknown, than we can ever assign to chains of logic and happenstance.

Hairy Faces

Small fuzzy things, the beaver and the cat, dog and wombat are all here at the pleasure of the land and water and weather. In this planetary crucible of change, there seems to be a need for a modicum of moderation so that life will not expire from heat or cold or astral blast. At this point along the line of life's progression, these warm and hairy creatures have come to be admired not just as raiment for the dominant species of the moment, but as objects of adoration and beauty.

What is it about a kitten or cat or dog that appeals to us not as a beast of utility, but as a cute and handsome and innocent companion; at least some of these feelings are not about dinner, or the makings of a comfortable pair of slippers. We see an aesthetic side or dimension to these life forms that is hard to pinpoint or attribute to our past or need for survival. Would the cry of a kitten mean anything to us the first time we heard it if we didn't know it was a defenseless small creature in need?

Cute is not a survival word. To us it is superfluous, something unnecessary but recognized as being of value. Cute is aesthetic, it brings up instinctive feelings and perspectives that are at least partly due to our view of the world as a place of beauty, of something other than utility and survival. Companionship and loyalty and even subservience are part of this relationship between man and small furry things, but there is always some degree of appreciation for the color and texture of fur, for the expression on a small animal's face.

Some might say we see ourselves reflected in these faces of fur, a deep-rooted primeval past when we were bush babies and lemurs ourselves. Others will have none of that; man is man and has never been anything else, and by their definition they are absolutely correct. We have only been human from that point in time when we became self aware and were granted the ability, the faculty to see the dimension of all existence that transcends necessity and survival – beauty and variety for the sake of wonder and pleasure and not simply a gradual string of successively advancing life forms. At that moment in time when we could discern our uniqueness, our reflected selves, we became capable of conceiving of the cosmic force that we call God.

It is in the face of a kitten that we see something transcendent-wonderful, familiar and artistic; something in us and of us, both emotional and aesthetic. The significance and meaning of this is at least in part indefinable, and at once instinctive.

The Frozen Edge

One area of this vast artistic landscape that is seen by only a few of us is the edge of permanent frost and permanent warmth – the tundra. It is big sky country with areas so vast and mountains so naked it seems to strip away the sanctuary and the comfort of those who are from gentle realms. The snow and the granite and even the smoking tops of the vents of volcanoes are both seemingly barren and clean at the same time. Life struggles here, not just in a sort of frantic animal against animal and plant-to-plant dominance, but against the fine line of survival at the hands of the elements.

The trees that sprout and mature in this area are old by the time they reach the knees of a caribou. Everything is in miniature; the blossoms on plants must be sought

Green Lakes, Central New York

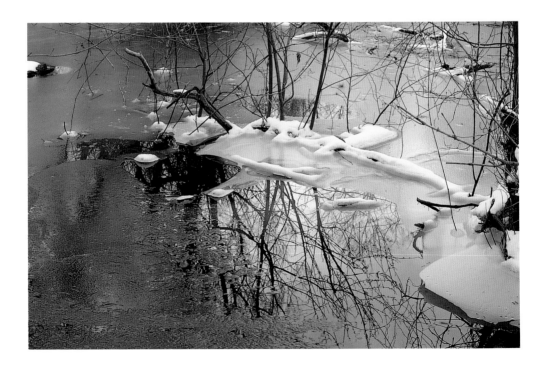

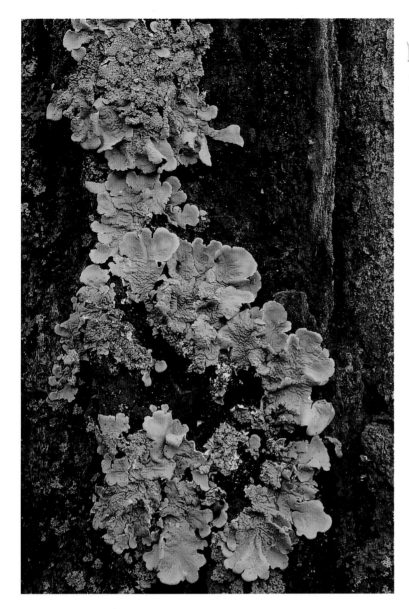

Mid-Winter Thaw
Central New York

out in order for us to find the buttons of color and miniature leaves. It is cold. The melt

water of the very long, cold dark season sits on the surface and holds the green stuff in

its soggy grip. Briefly, the small things slowly unfold and breathe short breaths, show

blossoms and variety, and curiously, vanish with the advent of polar ice.

The transition from forest to muskeg to tundra plains is one of the fastest

changing zones on the earth. As slow as it grows its dwarf leaves and flowers and bark,

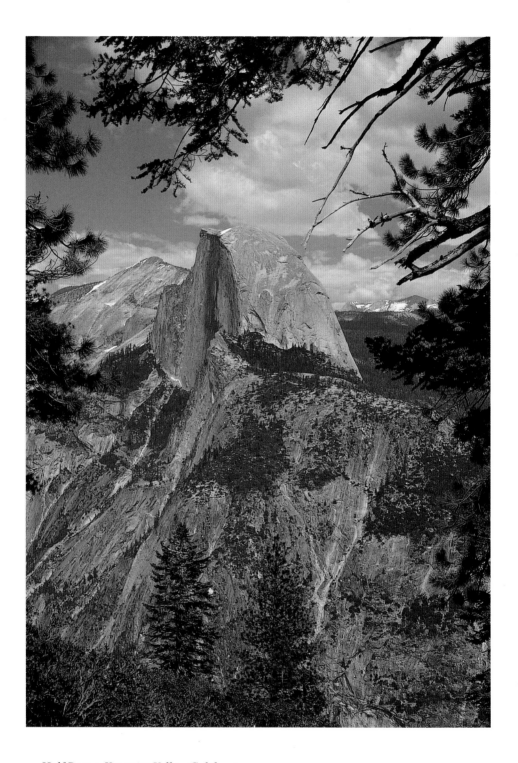

Half Dome, Yosemite Valley, California

Lichens in Winter, Upstate New York

the ominous crush from the north has repeatedly plowed and ground this thin skin of soil pushing the life zone far to the south. Yet, through this brittle life, the beauty and vastness of this area creeps back as the ice cap retreats, and builds its cold soil, and alters its form and color and shape, and is restored.

In this darkness and cold, the real sense of what life can be, the very creation of life forms, goes on. Bits of motion are everywhere, on the surface of the land and even over many watery surfaces. Insects, bugs, flying and crawling and hopping forms, display more varieties, shapes, colors and behaviors than any other type of life here.

Insects are colorful. We seem to have found such a fondness for these small nuisances that many collections of moths and butterflies are treasured by our own species. It is both strange and unique that one species of creature would collect another simply as trophies, for colors and shapes and patterns, having nothing to do with utility or function or survival.

Orange fuzzy ants and iridescent winged moths, scales on wings as thin as air, and almost furry varieties that plunk down in grasslands and woodlands; what a creative notion to make creatures so small yet so unique and attractive to us. Mosquitoes and fruit flies are amazing and pervasive, and certainly have a functional quality in irritating larger and more complex creatures. And they are so incredibly the same – they might be the ideal insect – functional, prolific and mundane. Eliminate a thousand and a million take their place. Where is it written that the lowly mosquito shouldn't be the template for the magnificent butterfly or moth?

The relationship among creatures is well established, but the original blueprints for their design have never been discovered. Ants – big ants, little ants, leafcutters, army ants – only a person deeply involved in exterminating them would find them interesting. They are rarely curious or attractive, they are certainly prolific and hard to reroute, so why can't they be varied in color and shape and pattern? They are functional to be sure, one of the Earth's small refuse recyclers, and apart from their often faulty judgment about what constitutes refuse – according to the dominate species – they are very efficient; but boring. And what about their large cousins – the ancient and indomitable cockroach?

These rapid, clicking bottom feeders have been living dustbins for more epochs than one can conceive of. Through plagues, and frozen ages, through times when the

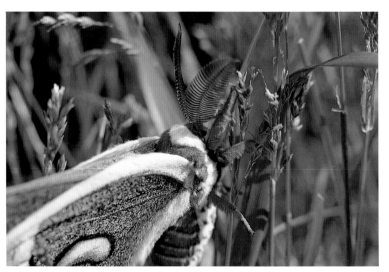

Cecropia Moth
Manlius, New York

Earth has gone still and volcanoes and seas have washed over the land, these constant-motion, six-legged critters have been cleaning up the litter of the ages. Through all this time and environmental variation, they have remained nearly unchanged. A little bigger, a bit smaller, a bit blacker or browner, but the essential cockroach is a basic model; no chrome, no power windows, no shimmering colors or beautiful shapes and lines. Just raw efficiency. For a creature without peer that has survived virtually intact for longer than any other living thing, why the lack of beauty, of variation, of aesthetic?

If all insects are necessary in this unexplained complex of life forms, why are some mounted on the wall while others are stuck on the bottom of a determined shoe. All are important in the contribution they make, but the enormity of variation seems too challenging to explain. Some make and roll balls of dung; some sting mighty arachnids and create a long-term larder for their young. Others break down and digest the matter of the world, while worker bees make honey and ant cousins aerate the soil. For all this, the question of who gets to look in the mirror and find an admiring image is still a bit of a mystery. That old saw about the survival of the fittest does not seem to apply to the most handsome, and so, after untold ages and even more uncountable generations, why haven't the cockroaches and ants become the world's most advanced pollinators as well as recycling units?

Grasslands

The long grass, the prairie, the steppe and pampas, the sea-green and gold – is found all over the earth. Nestled between the mountains and the seas, the tundra and the tropics, this vast area of wind and grass-song is extraordinary in its dimension. It does not have the vertical reach of the mountains or the depths of the canyons to entice us; instead it is the ever-changing sky that dominates the mood, the color and the variety. The green is lush and compatible with the blues and grays of the heavens.

As climates change and the sky is squeezed of its burden, and the sun begins to prevail, the grasses thin, and the tufts and cactus gradually appear. To the vision of all-seeing and curious creatures, the intangible appeal is not just color, it is the vast, almost overwhelming sky – closer to God sky – home of the visionary who sees forever, who is

Winter Grass, Upstate New York

hemmed in by the mountains. The color of the land is short and stretches to the horizon, but it is not varied; it is enormous.

The motion of the grasslands is one of the most beautiful aspects of this vast plain of nourishment. The wind in its incessant almost moody way, weaves itself through the stalks and stems of the grasses and sedges, twirling and twisting and then pushing them over for an instant in its passing. The high winds of winter and the summer storms with their burdens of snow and heavy rain force the grasses into mats, and seem to end the playful and ever changing sheen of the open fields.

But the grasses are more resilient than that, and always find the spring in their stems to reach for the sun in summer, and defy the blanket of white dormancy in winter by pushing up new green shoots to tease the wind.

The sudden crush of hail seems to end the spiritual life of these numberless stalks of graze and browse, but those that are broken and battered fall back to the nourishing earth with the now melted elixir of water and begin again. The bruised and slightly battered bounce back once they are unburdened from this frozen beating, and

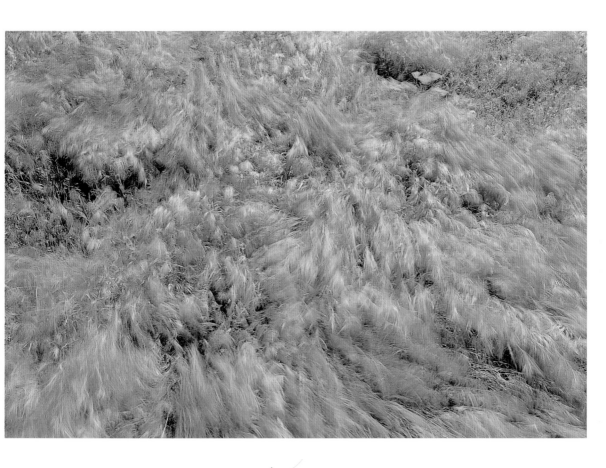

Grass in the Wind, Southern California

rise to the rays of the sun. The wind persists and dries the sea of stalks, restoring it to its former self

This waving dance of subtle color has a musical accompaniment to it, delighting the ear as well as the eye. It is like a true windsong ever so subtle, a concert of sight and sound that is, to us, calming and reassuring in its constancy and familiarity. The interplay with the sky makes it a foreground for the beauty of the clouds in blues and grays that sweep over the plains. The sunlight and the cold, the full moon are all magnified by the grasses constantly waving at their feet. The motion rarely stops, just takes a momentary pause – almost as if it needs to move just to stay alive.

And in the broad beat of a sunny day, or under the fingernail light of a new moon, the critters and crawling things just add to the complexity of this wondrous, subtle work of art. The hairy and the furry that feed the fast and the cat –like, the soaring and the diving who spy out the movement in the middle of the swaying fields of grasses and flowers and nettles – the banquet is set for all, and the subtle interplay is laid out for us to observe and appreciate as well. We do not visit this ocean of life just to eat the grain and consume the game; even the most jaundiced and unobservant are pulled in by the cloud towers and the sea like antics of the grasses. Here perhaps is the most isolated form of beauty, for the scenes are subtle and vast in almost unseen details, not in soaring and emotional terms. The beauty of the plains and all they hold is there for the sensitive and aware and even the detached observer who is not mesmerized and dulled by daily tasks that numb the senses.

The sunsets and sun rays, the terrible clouds out of the west, these other elements of this artistic set can inspire awe, or fear or focused awareness, but the sea plains provide the base line of color and motion and life that this all plays out against.

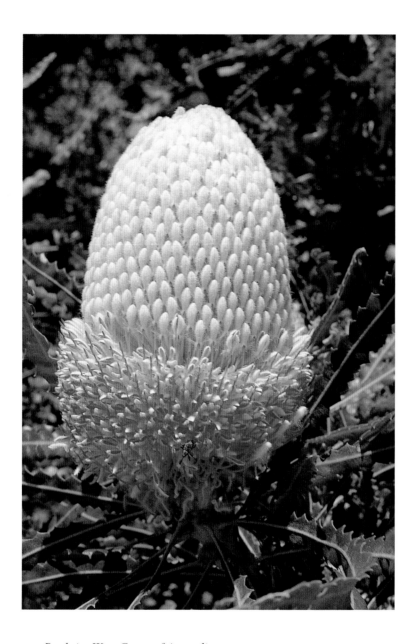

Banksia, West Coast of Australia

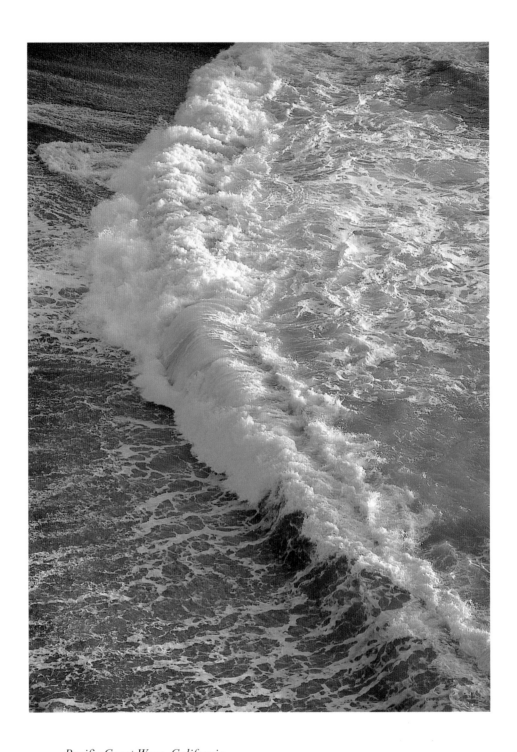

Pacific Coast Wave, California

Patterns

"The highest happiness of man…
is to have probed what is knowable
and quietly to revere what is unknowable."
-Johann Wolfgang von Goethe-

When we peer back at ourselves from space and see this blue ball of clouds and water and patches of brown earth it never seems to enter our minds that the earth itself is an example of a pattern. All of the spheres that we see in our family of planets, even the colossus of the sun are spherical. We are all twirling and flying around in circles about each other, about the sun, and even in larger paths, hurtling through the inky blackness. Who said, "Let there be orbs!" Is this marvel of universal organization, gravity, truly a random occurrence? Why did the emerging matter of the universe from the celestial bang suddenly develop the urge to glom together and compact itself into zillions of spheres ever compressing and exploding and absorbing each other's neighbors? Why do we have to be forced into this roundness; where is it written that longness or wideness, or perhaps most preferentially, randomness is not as acceptable as sphereness?

We are informed that there are almost too many of these space balls to be counted, yet doesn't it make us wonder at the very persistence of this urge to roll up into a basic shape no matter what material we are made of, or the size, shape or constellation we are a part of? Randomness; it certainly has many interesting implications in such a busy place.

But the wonder of roundness is rarely seen on this side of the atmosphere. Where do we see truly spherical shapes in our colorful landscape? Our close-up, patterned world is shaped by many forces, yet seldom do we ever see this titanic urge to roundness. In our often brilliantly colorful and sometimes muted world, we see other shapes and patterns everywhere; the ripples of waves, the blending of colors into bands and stripes and the shapes of trees. The lines and veins in delicate flowers and new

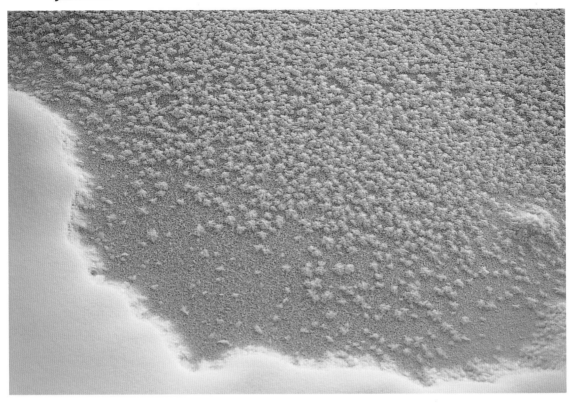

Frozen Pond, Central New York

Algae on Rock, Pacific Coast

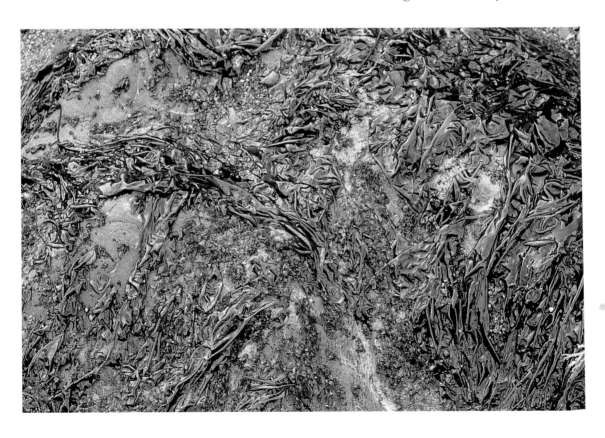

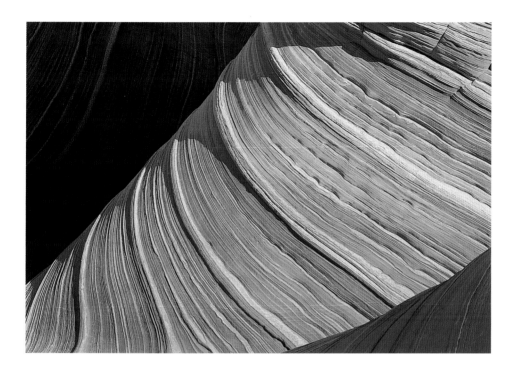

Coyote Buttes Wilderness, Arizona

green leaves and the undulations sand forms in the desert treat us to ever varying patterns caused by the wind and primal direction. Patterns are in the ranks of hills and layers of rock in mysterious canyons. We look up to see clouds sometimes jumbled in chaos and then in quick succession they form close matched rows of bulges and bellies that belie the big winds of storms, and the symmetry of iron anvils and impending frog-strangling deluges.

There are the patterns of flower petals and blossoms that are crimson and deep blue, yellows and oranges and a hundred shades of white and green and Christmas red. The surf swept beach and the wind swept desert are testament to these patterns of creation. Not the genesis of the universe, but the subtle, soft, persistent patterns of small things in our lives and in the landscape that so often eludes us. We cannot comprehend random patterns; the concept is alien to us if we look beyond its surface. How do we declare something to be a result of the force of evolution, of randomness, and then find

Autumn Leaves, New York

an unmistakable pattern in its path? Too many accidents, too many flukes, too many mutations, and far too much organization even in this understated order of patterns found in every corner of our world.

Why the cosmic interest in patterns and variety anyway? The wind is not often thought of as being a patterned force in our world. Like fire, it is an elusive something that cannot be touched or felt, seen or captured in a bottle. It seems to have a spirit of its own, an existence that mimics fire – it can move the air, but serves no purpose other than what we assign to it. It wears down the earth, builds sand castles and churns up the blue waters of the oceans, but is it simply an afterthought? Did it just come with the package of matter that was delivered in the form of the earth and a galaxy of neighbors that are buffeted by their own forms of atmospheric motion?

The wind; it is not simply the sandpaper against the rocky furniture of the earth's skin, it is poetic, it transfigures us in subtle and bold ways, it changes our thoughts, it frightens us and inspires us. It provides exhilaration and turns us away from the measure that it takes of the winterscape and the storm lashed land. We see something in this wonder of creation that transcends the mundane and the waryness we often feel for its potential to destroy and change. Why? It is after all just air being propelled by the sun and temperature; it functions as a creative force in altering the surface of any sphere. If

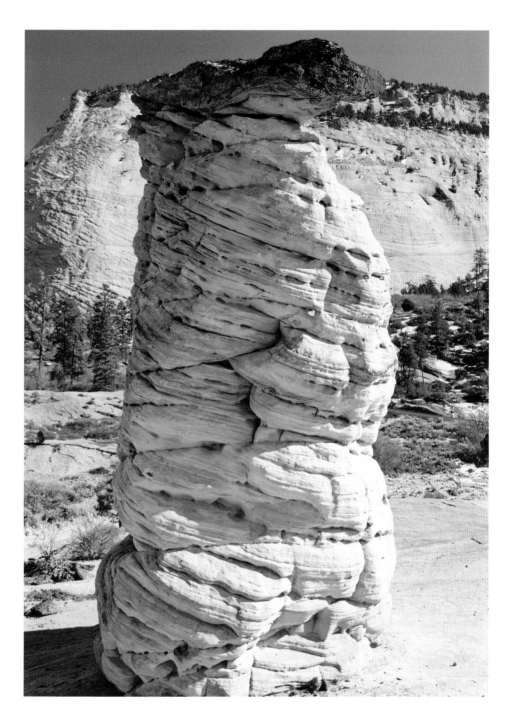

Sandstone Pillar, Zion Canyon, Utah

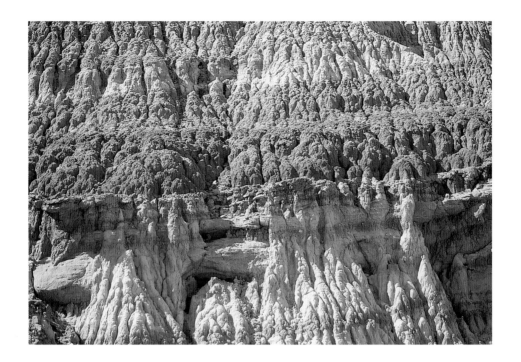

Badlands, Vermillion Cliffs, Utah

we thought only that much of this wonderful, intangible spirit, we wouldn't write poems about it and sing songs in praise of its strength and wonder.

It moves the sands of far off places to ever-higher banks and dunes and rippled faces of barkans and crescents and star shaped ranks of ever shifting deserts. The ripples in the sand; why are there ripples in the sand? If there is to be a wind at all, why not just move things around and reduce the mountains to rubble. Instead there are these fascinating patterns and shapes and textures that give us the impression of something far more complex, something far from random. We are treated to the sight of whole mountains that have seen untold ages of winds that have blown and layered the orange and red and white sands of the desert, and then shifted, and stacked the loose detritus of these dry lands in crossed patterns, eventually forming the mountains themselves, and the result is beautiful. Crossed patterns of granules layered into shapes and forms that

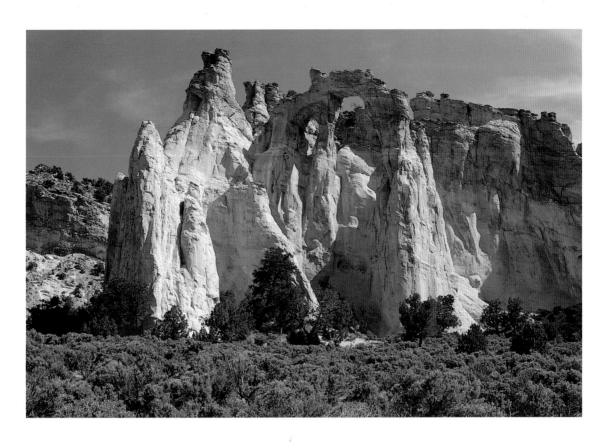

Grosvenor Arch, Southern Utah

reveal an order, a sense of design, patterns that transcend the notion of whimsy and epoch scale mutations.

Waves in the ocean pulse and throb and create ripples and patterns on the sandy bottom of these vast seas. Patterns of motion turn the liquid beauty of water into a caressing sculptor who imposes a divine order unto the soft bottoms of the sea, and again we are left to ponder the why of it. The persistence of waves in water and light and sound, the elixir of the wind and the surf at land's end; whose edict is being heeded here? Could the motion of throbbing, massive suns and delicate sub-sea currents have arrived without reason and design? Was there no plan to provide order from the tractless

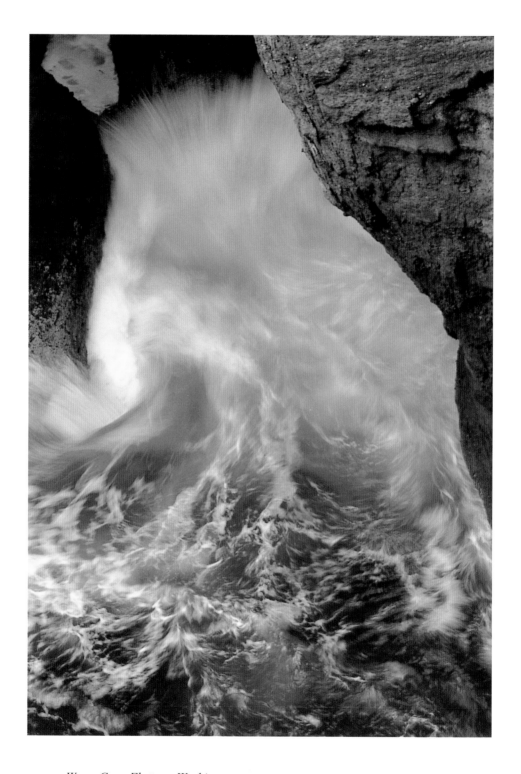

Wave, Cape Flattery, Washington

vastness of time and space? It is hard to imagine that all of this came from random, thoughtless chance. Yet there is much to be discovered about patterns and chance, even in the clefts and recesses of the landscape itself.

Deep inside a cave there is blackness, and often the trickle of pure, mineral-laden water. These mazes of chaos in the subterranean earth follow cracks and splits, and often tubes where lava once flowed. But in some of these patternless recesses the light of the sun penetrates, and into this gloom and darkness a glowing unreality of living rock is revealed – beauty in a place that we would never consider looking. Fleeting, often without the pattern of the daylight and moon-drenched surface where

Beach Composition, Lost Coast, California

we live, but captivating and awe-inspiring for its color and animation.

Clouds. After eons of time looking at the sky we now fill books with the patterns of the wind born moisture that decorate the heavens; we have labeled and classified these ethereal forms and assigned values to them as harbingers of fair weather, and storms and unsettled conditions looming over the horizon. All this to establish categories for the rising, clumping, racing moisture that is formed by the wind into waves and hillocks, and anvil shaped mountains of mist. Clouds move back and forth in a rhythm, swelling and shrinking and falling on our heads, yet out of this constant

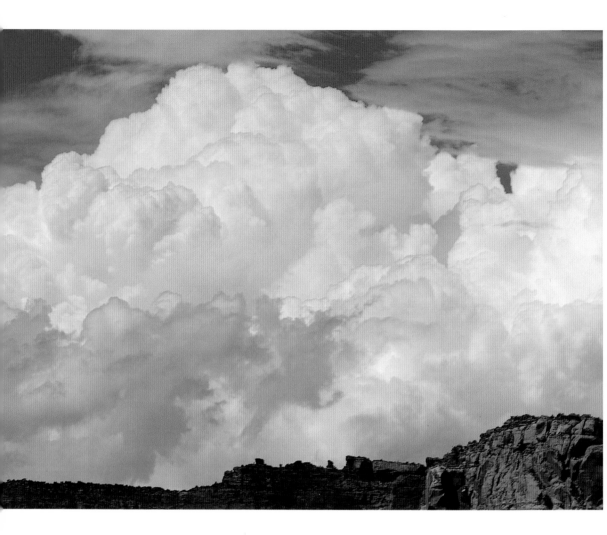

Clouds, Southern Utah

motion and seeming serendipity, we witness patterns in the ranks and piles and forms in the white and gray and sunset colors of clouds.

Clouds seem to mark a boundary, a transition between order and chaos. They form a sort of free zone where elements combine according to whimsy, often as blobs and blankets shaped by the landscape as fog, and then without a plan, they emerge as ordered billows and the tails of horses. They warn us of wind and weather, pacify us with contrast to the blue heavens and grant us renewed life through rain and snow.

These puffy escapees from universal planning inspire us to dream and create and even to impress categories and classifications upon their ever-changing presence in a ritual act that is as silly as trying to cage a ghost. But like ghosts these amorphous presences evaporate without a trace at the command of the wind or the sharp slope of a mountain. We always seem determined to box up everything that we discover in our world in a separate taxonomy, even those things that lie far away. What of the acid clouds of distant worlds, or liquid winds on planets just beyond ours. Are these close neighbors different from us? Do they have the same warp and weave of change that our sky born harbingers bring? Do they exist just as a constant force in the ecosystem of their patterned worlds, or do their clouds present the patterns of change and creativity that we witness in the glowing reds of a dawn sky, or the bruised blue-blacks that portend the sanctuary of rain and rejuvenation? Can we see the future in these shapes and colors and patterns in the heavens or are they there as part of an elaborate model of creation and beauty that we are blessed with the capacity to see?

Is there some art in this chaos? Do we look for the elements of pattern and shades of color in order to find what we deem to be art? How do we designate these shapeless masses as a form of expression? It seems to be one of the elements of a divine gift that we are given the opportunity to see His creative talent at work, forming and reforming the sky, faster and more completely than any other canvas in our lives. This part of our universe, the one that is so vital to us, is always being recreated. The rain and snow, the drops of life-giving moisture could just as

Clouds, Everglades, Florida

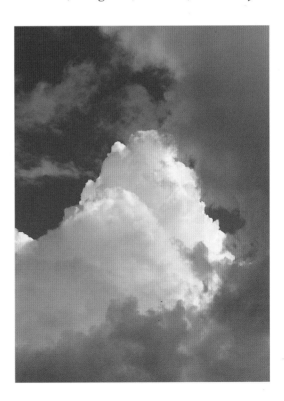

well fall from an even shroud of clouds with no variety, no color, no drama or grandeur. Yet our sky is home to brilliance and subtle change and chaos, and yet we don't seem to care to consider that the gift of the beauty of clouds and not their function is the true manna for our souls.

Chaos. There seems to be little in this life that is truly chaotic and bereft of a pattern. The universe seems shot through with order and organization with shapes and

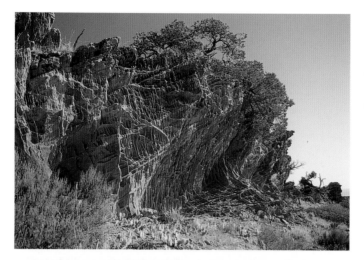

Box Lattice Formation
Vermillion Cliffs Wilderness
Arizona

Beach Composition II, Lost Coast, California

sizes that appear to fit so well. Can we consider all this to be random also? The fields of flowers, the stripes and whorls of seashells, the sand riffled into dunes and windrows and the fairy rings of mushrooms; our lives as far as we can see and dream are dominated by these patterns and shapes.

It is the nature of matter to assume these shapes, we are told. The sum total of all the matter in space is a vast complex of actions and reactions, and what we see and perceive are simply the momentary states of these various actions and reactions. All matter assumes patterns just because of its nature and the forces that are manifest in it. Hard to believe that that is the driving force behind the very nature of the universe and everything in it.

Through all this, are we even capable of random thoughts? Is it not more likely that virtually every thought that enters our heads is derived from some other experience, action or combination of bits of information? Is there anything in the universe other than the very beginning of this incredible creation that is truly original? Probably. Do

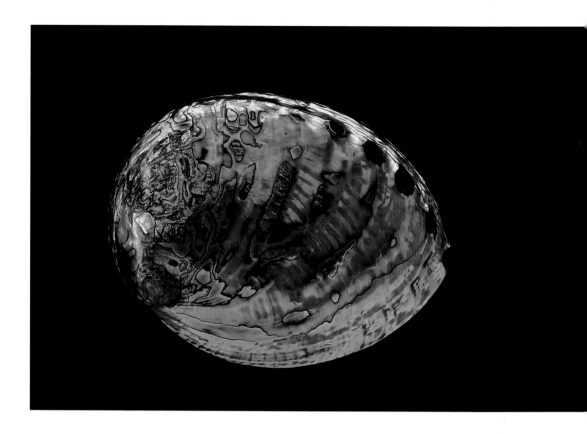

Polished Abalone Shell

we think thoughts that are inspired by new concepts and information; certainly. But when did originality begin in the universe, and at the same time, was the die cast for all new concepts and matter to be created in the first annual cycle of the universe itself? Has anything new been introduced into the celestial family in the form of matter, life or forces since the instant of original creation?

To listen to some, all forms of life have been and still are continuously changing. Here on our world, the swimmers begat the crawlers and they derived the flyers. Now we are everywhere. Was this part of the big bang, or was it part of the great evolution of God's plan to populate the void with matter of all shapes and colors, to seed space with colonies of life forms that could go where their fins-feet-wings could propel them…and no further? There is such a vast degree of complication to all patterns that have emerged over time, and yet as we find subsequent layers in our perpetual digging into the past

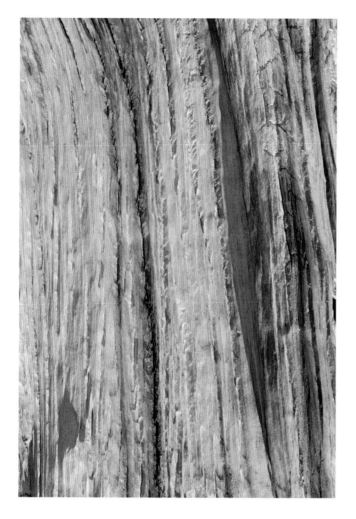

Bristlecone Pine Detail, Eastern Nevada

lives of the universe, we seem compelled to declare in our flawed wisdom, that we have discovered the final elements of whatever we are currently exploring.

The trees that surround and nurture us appear from afar to be a green mass with patterns that somehow conform to the landscape that they cover, even forming rivers and canyons of green and yellow in the autumn as the leaves turn on the aspens. Bold white birches ring the mountains high up above the less hardy maples and oaks. Patterns of yellow-greens and brown-greens, vermilions and ochers and just sad brown oaks, when left to their own designs, form patterns.

On closer inspection we find individual tree shapes of spreading crowns; vase shaped elms, the wispy branches of perennial green willows, and stiff blue-green pines that sigh in the wind. The patterns of the branches are constant, at least in the span of a life time, but the minute twigs and buds are ever changing in their design over the far reaches of creation, providing new patterns and colors and textures to bless us with that pinnacle of delight, aesthetic beauty; the art of the tree.

Some of the bark of these trees is deep red and luminescent, while the skin of others just peels away leaving new growth and vivid greens and shriveled brown paper. Some is tightly wrapped and gray, others shaggy with all the colors of the rainbow; and then there is the bark that bends and forms paper and canoes. Why aren't all trees simply gray, with one form, and one shape? Why aren't all trees part of one great uniform family of hermaphrodites so that they could stand alone or together in a forest and thrive? What purpose drives patterns and variety?

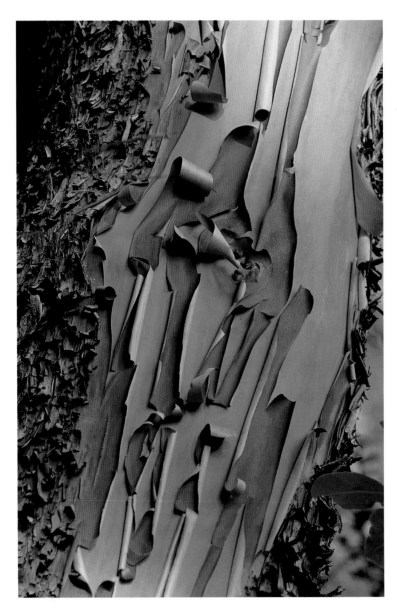

Madrone Bark Detail, Oregon Coast

Crystal Formation, Death Valley, California

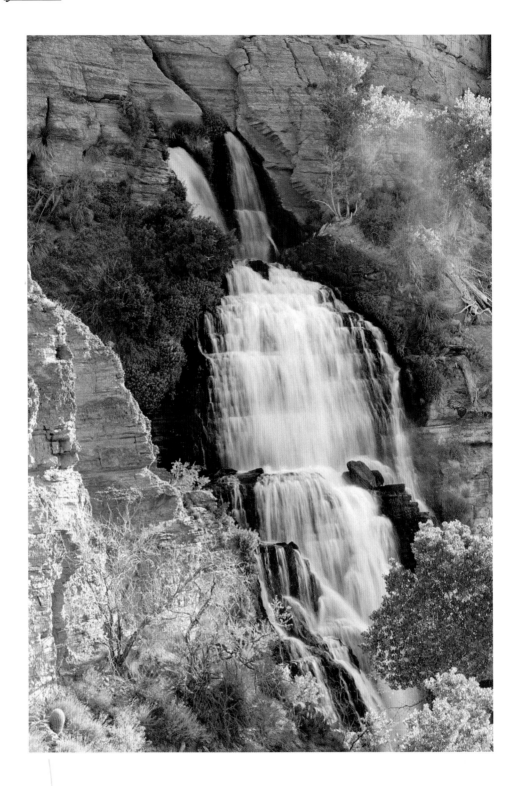

Thunder River Falls, Grand Canyon

Liquid Art

"Oh, I have slipped the surly bonds of earth
And danced the skies on laughter-silvered wings;
Sunward I've climbed, and joined the tumbling mirth
Of sun-split clouds, and done a hundred things
You have not dreamed of, wheeled and soared and swung
High in the sunlit silence. Hov'ring there,
I've chased the shouting wind along, and flung
My eager craft through footless halls of air.
Up, up the long, delirious, burning blue
I've topped the windswept heights with easy grace
Where never lark, or even eagle flew
And, while with silent, lifting mind I've trod
The high untrespassed sanctity of space,
Put out my hand, and touched the face of God."
-John Gillespie Magee, Jr.-

In all of God's miraculous universe there is little that can compare with the flexibility, immediacy and variety of heaven's blessing - water. In our world, it changes form from solid to liquid to gas, and falls and flows and grinds in an infinite number of places. The beauty of this ever-present and vital substance takes form according to the landscape it finds itself in.

The sun beats on it and makes it rise in steamy forests and fog bound shorelines and over vast seas and oceans. There is a magic here; part of the unceasing cycle of matter moving through space, but also a constant transformation of form and state that serves no purpose but to alter the surface of the landscape and add drama, dimension and anticipation for much of the animal life of the planet. Do the wildebeests and grizzlies feel anxiety about a drought or harsh dry season, or are they spared the anguish we feel when the rains don't come and the winter never breaks? Are we the only ones to see the fuzzy arch of a rainbow and drifts of beautiful snow as something other than an insignificant detail delivered with the saving rain and silent winter?

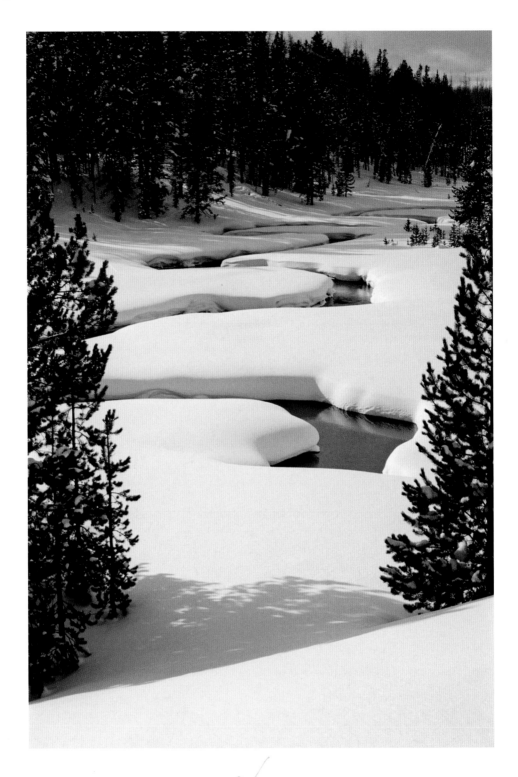

Yellowstone Plateau, Wyoming

Do animals ever lift their eyes to the sky, or do they instead live out their lives never seeing anything above their shoulders? Are we alone in our capacity to raise our sights to see the transformation of the world through the rain and snow and brilliant sunlight, or do we share the world as a wondrous and fascinating homeland shot through with watery images and the promise of bounty, and fear of drought and loss? How much of this are the animals we cohabit with spared, or do they cringe and feel the coming loss as we do when the rains don't come and the grass is in peril? We may never know, but for us, the sway of the clouds and the saving grace of rain are our very life in the balance.

For all our watching and probing and emoting over the actions of the waterways of our lives, there is actually very little we can do to alter them. To harness this liquid

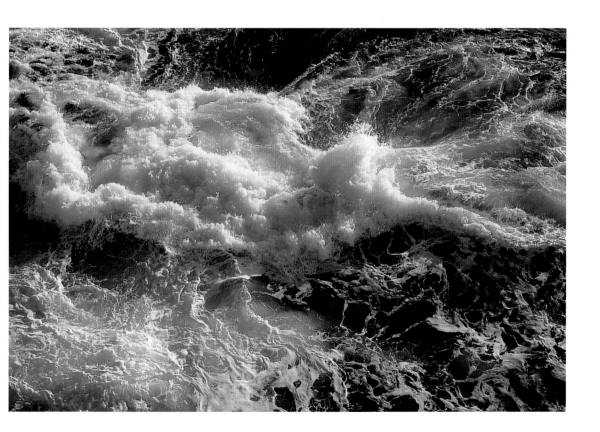

Surf, Olympic Peninsula, Washington

world is one of our greatest temporary follies, for like the dike of sand that we build to hold back the ocean, when we work on one end, the other is washed away. We dam the mighty rivers, and the silt piles up constantly and relentlessly, and the water prevails once again. Managing this slippery substance has proven to be one of our greatest challenges, and yet we never really alter its true course. It is pushed in here, and it pops out there. It is pumped out here, and the ground subsides and caves in leaving only a crusty hole. It can't be destroyed or created, but when seen as part of the vast untempered landscape, it appears in a never-ending cycle of beautiful forms.

Water covered the earth we are told in one of its former lives, with much crashing and flashing and constant hot rain. It was perhaps a time of universal dullness, with black-gray clouds and sheets of silver rain, and the actual time it took to cool this hot rock, for us at least, means nothing. Time on that scale is without significance for our rational minds and sensitivities. A thousand of something is hard to really comprehend, especially in terms of cycles about the sun. In years, the notion of a million is pointless; we haven't been looking at the stars and contemplating our image in

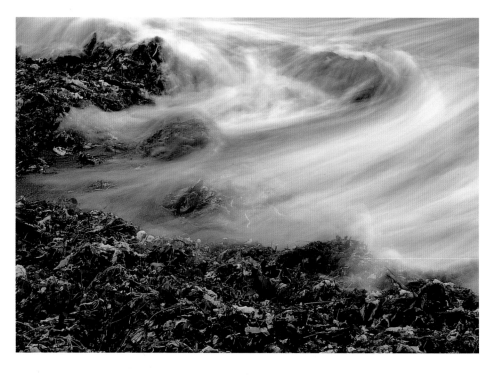

Misty Surf
Pacific
Coast

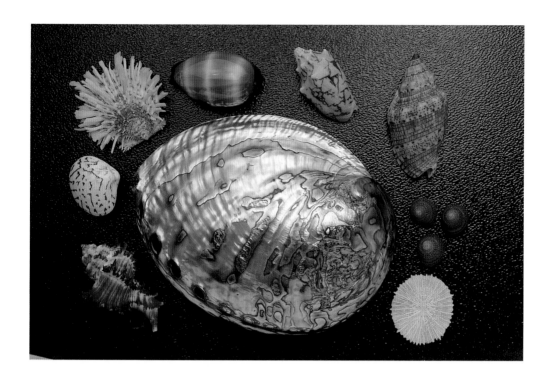

Shell Arrangement

Murex

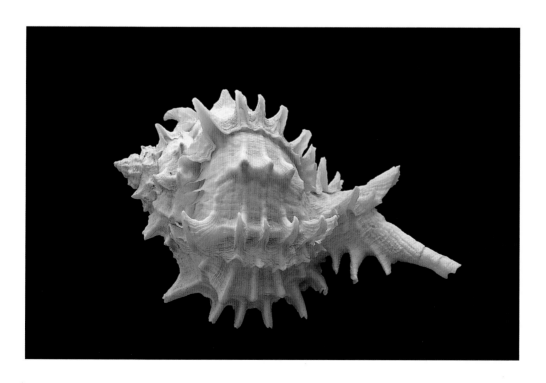

a quiet pond for even a fraction of that time, so what is the significance of eons and epochs when they only describe the various molts that Earth has undergone?

Out of all this murky guesswork, of patchy logic and surmise, driven by one of our most ennobling and compelling compulsions, curiosity, is the momentary revelation of synthetic truth. Even with this force behind it, the true facts about the earth's ancient past will always remain conjecture, and we will be better for it. The idea of a precise past will always become the prognosticator of a precise future, but we will never capture beauty in such a precise way, and that is perhaps one of the greatest features of our very existence. For every revelation of certainty that we proclaim concerning the reality of the universe, there is an embarrassed chuckle that emanates from our children as they

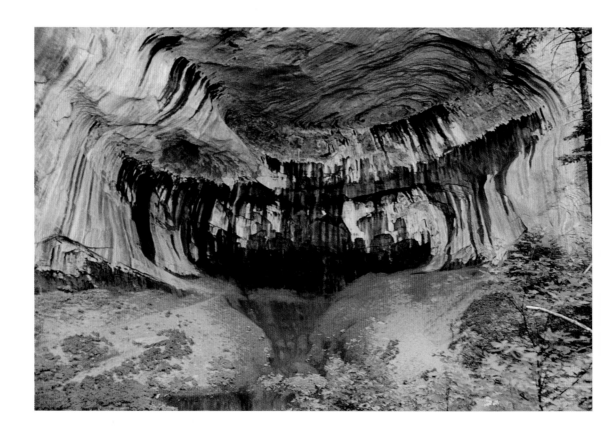

Kolob Canyon Region, Zion National Park, Utah

discover new universal truths, and cast those of our generation in the hopper of silly hypotheses once again.

Through these passing ages of rain and moving continents, all the wonders of this beautiful world were born. The blue of the sky emerged from this curious blend of elements, came together, spread and intensified over time. Colored creatures in the seas, assembled by a divine hand, have added complexity and variety to the oceans of the earth. The land has been molded and shaped by all that has fallen upon it, and sprung from the liquid stuff of the earth's hot crust. At some point in the epochs and eons of surging landmasses and ever-increasing rains, the most dynamic and fruitful feature of the earth's history emerged, the shoreline.

From the murky past of sloshing seas and rising and falling landforms, this thin line of birth and gestation became the seam of creation. The life of the sea lunged onto the land and begot the life of the land. The finned creatures crawled out to seek, what, dry land? Perhaps, or possibly it was their destiny as described in a book of prophetic design, a species for all seasons and a seed for every realm. The whales that were once of this land, retreated to the sea, or were drawn to their true destiny. Questions of magnitude and simple notions lie here, but this incredibly bountiful and creative shoreline is and has been the scene of more mystery and creativity than any place on Earth since the clock began ticking for us.

The very life and origin of the watery side of this dynamic crease where wet meets dry, was a virtual miracle – right elements, right temperature, right atmosphere, a thin film of breathing space, and color. It would be worth an idle moment in fact to think about the future of all color in this realm of change and upheaval, as well as its past.

If the birth of this world was monochrome and simplistic, and today it is a complex of shades and tones and brilliances, why would we suppose that we have reached the plateau of universal color pots and natural shades? We may be at the universal peak of this warp and weave of chromatic expression, and the future may be

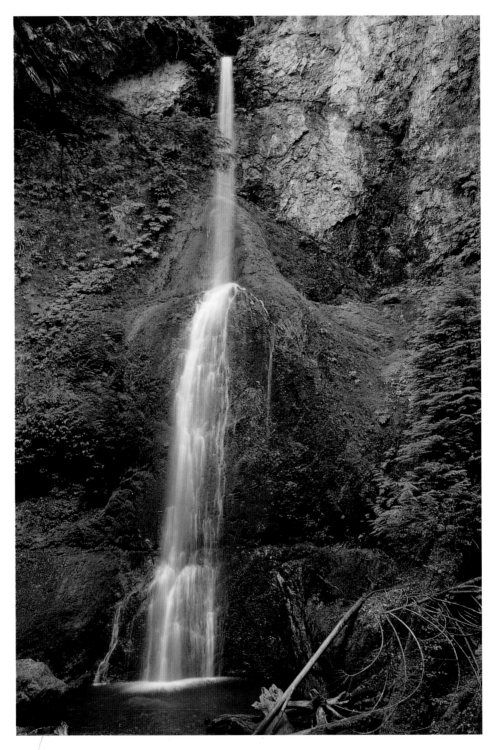

Marymere Falls, Olympic Mountains, Washington

toward an ever more subdued and bland landscape. Could there be in reality a history of color that has emerged with the ever-increasing dimension of life and homelands in the universe?

Was the rainbow of all creation established at that stupendous moment when all matter was supposedly released so long ago, or has it too emerged and evolved with the miracle of creation and destiny that all life and all worlds find themselves a part of? Were puce and burnt umber in the land of the dinosaurs or were the subtleties of earth and sky slowly derived from the ever-expanding life forms and landscapes that have thrived and died and thrust their rocky heads toward the sky of the universe? A neat notion that what we see as color today never was before, and what will be in the landscape of tomorrow, will never be seen by us until then.

Then there is the texture of the rain, a dozen kinds of drops in drizzles and torrents and gentleness that find their way from the ever elusive clouds that transport what we have come to recognize as the very essence of all life. Was it because the water was here first that we were born of it, or was its presence foreordained; thoughtful preparation for the complexity yet to come, a set stage that was necessary for all the beauty and life that would eventually depend on it. Was it a plan, or just another methodical mutation and chance happening that some would describe as the true logic of the universe?

The sky. It is intriguing to contemplate the sky, looking up, it is blue with decorative elements scattered about, moving as all things seem to be. The sun and moon and stars plotting courses across the dome, defining day and night and even the march of the seasons. The stars making streaks and arches and circles depending on time and distance and relative position to us; all this forming a vibrant and kinetic ceiling for everything that happens closer to home. For water is the real magician in this realm. The clouds and motion of water on the rise or rushing to earth become the most intriguing and changing elements in the drama of the sky.

The magic is the suspension of this liquid in the realm of the sky. Nothing known to us defies the pull of the earth and stays suspended in the thin blue skin of the sky for more than a fleeting moment except this beautiful material that is forever

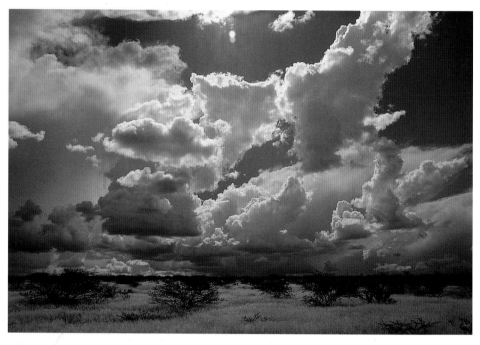

Sky Over the Namibian Highlands, Namibia, Africa

changing and morphing into so many incredible shades and shapes. The clouds are always visible but when we approach them they are as nothing, just damp memories, fuzzy somethings that will not hold us or stop us, yet they seem to have a presence and life of their own because of their inner spirit, the wind.

This ever-capable resident of the sky is even more secretive in its ways and can appear from nowhere and disappear as quickly. It is a creative force behind these ghost-like cloud vapors that has the power to create the rain and hail and snow, and drop it to earth to take its place in the inhaling and exhaling of the land and sea and sky. The wind is perhaps the most elusive and creative element in all of life as it drives and coaxes and carries the elements of creation in its midst. The cold of the north, the heat of the day, the sand blasts of the deserts and the moisture for all things travels in the maw of this

great moving ghost of the landscape. The wind is powerful and magnificent, and yet can bend a flower with the gentlest touch and move mist and soft rain through a deep forest almost without showing itself. The wind is a companion and seems most significant when it is not at our backs.

The drama of the sky is touched and caressed by the antics of the wind, and is enhanced in a different way by the presence of the sun and moon. When the sun crawls toward the horizon, especially in the cold winter of the desert it illuminates the dust and cloud matter and creates an incredible firestorm of brilliant orange and red. It often shoots rays

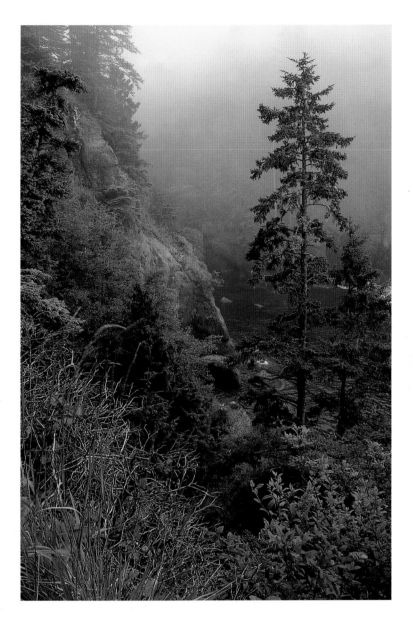

Olympic Coast

from one horizon to another that provide us with a fleeting pageant of the excesses of the sky and its ever-changing elements. The sight is by design momentary to invigorate us and to tantalize us with just a glimpse of the sky's high art before it quietly and swiftly

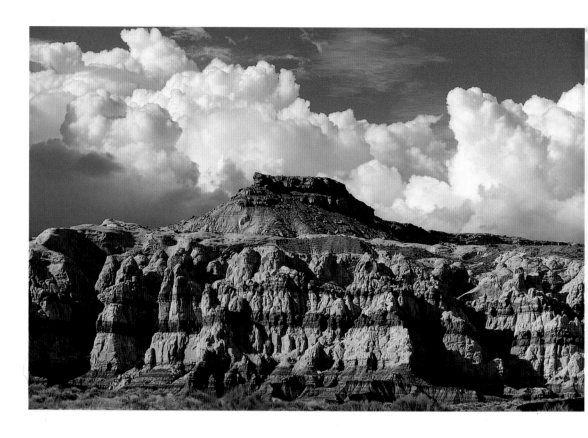

Vermillion Cliffs, Utah

passes into the dusk of pale gray and then night. Those moments of sunset and sunrise though, are some of the most significant we are ever treated to in our lives.

The moon too creates its scenes with bunching summer clouds and the starry sky. In high mountains on those rare summer thunderous nights, the air is so clear that we can reach to the heavens, and when the billowing clouds flash their magnificent night lightning from head to thunder head, the full moon can add an element of etherealness to the scene by turning the earth into a silvery ghostlike planet leaving an indelible imprint on our memory of this rare event.

The clearness of the air in the desert at night adds to the presence of the moon. In the cold night of winter, the full moon can light up the high points of the landscape and put the desert in relief. This stark either/or light is at once valuable and

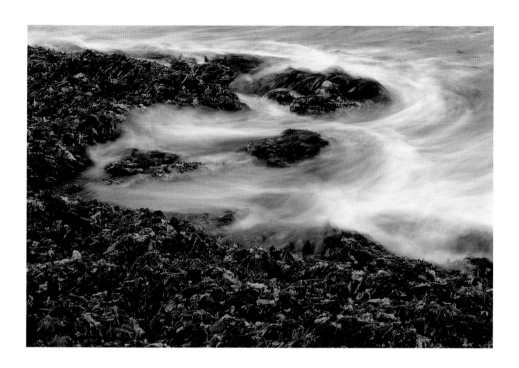

Misty Surf II, Pacific Caost

disconcerting. There is something about a bald night full of moonlight and relief that touches us to the quick. It is a sense of the mystic and unnatural, and yet is guiding and coldly useful at the same time. One may need it to survive, but it is unsettling. In places of damp and clammy vapors, the moon is another thing all together.

In the sky the clouds are an ever-shifting presence in the world's lungs, and are as essential as the need we and every other living thing has for the element of water. What other delivery system could have been devised to spread the life giving moisture we require around the earth? Rivers would soon dry up if not for the fall of rain and snow and hail. The great rush to the sea would very quickly cease and the oceans and stagnant ponds would lie dormant and inert. Life would change profoundly, and for most everything on land there would be quick extinction. Only those organisms that could make it to the last fringe of existence, the shore, would survive, and the reality of the day would be, live on seawater or perish. For the very essence of this beautiful

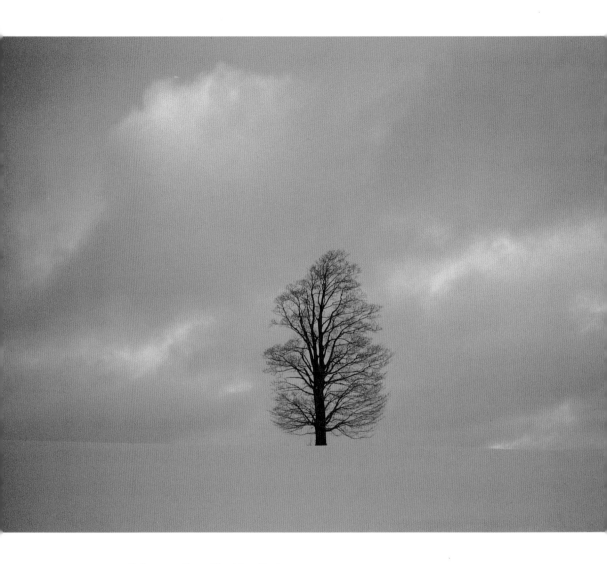

February, Erieville, New York

blanket of air and the system of air ways and ever rising mists and moisture, make life possible for those creatures that live on the land.

We always seem to strive to identify patterns, to describe all that we see in our universe as a system, to collate and categorize living things and the inert and infinitely far off in this same taxonomic way. Yet the counterpoint to all that, at least the most common and familiar would be the clouds and the weather that is always with us. It is not the goodness of the weather, interpreted as the variety of moisture or lack of it that we desire at any given moment that should be the subject of our mood or scorn.

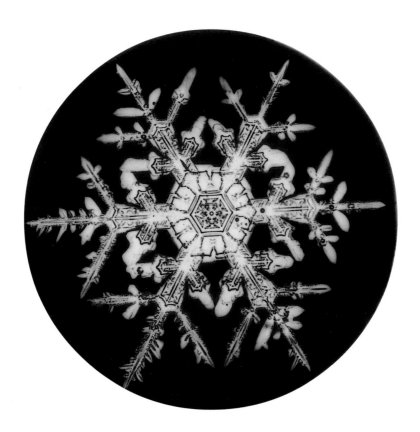

Bentley Snowflake I

Rather, it should be the beauty found in the variety of the weather that should intrigue us. Beauty in the clouds and the rain and snow is constant, but it must be seen as wholly outside our control and appreciated for its independence and ability to be ever on the move, and changing by the hour. Living with and appreciating this greatest of all creative and dynamic forces in our lives should certainly be preferable to expending emotions and anxiety over its untamable character. The ebb and flow of the elements in the sky should provide wonder and visions in all weather and at every point on our compass, and should remain an integral part of our lives, a source of fascination and

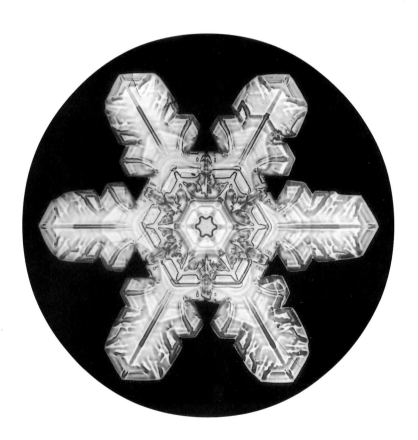

Bentley Snowflake II

intrigue. Where have we gone astray in thinking that the very essence of such masterful and wondrous forces in the life of the planet is counter to our somewhat awkward and artificial homelands? To see and to build in recognition of the forces of destiny and creation from a higher order would surely result in a more compatible and fulfilling life for all.

Back in the ether of the sky, what comes of these wondrous clouds and their master the wind? To see the snows of early winter and the driving blizzards and bluster of deep nights in cold climes is not just the drama of survival. It requires curiosity and adventure to go out into the storm and realize that it is not bad or good, but instead is indeed an adventure, a time to look into the driving snow and feel its tingle and sting, to have it suck at your breath, and then embrace its spirit. It will subside, it will blow away, it will turn to spring in another round of light and darkness, but the moment of its passing is a small drama of elements conspiring to stir the winds and blow the snow flakes and crack the trees, at least for awhile. And that moment is the thing, the fleeting chance to be in it, to partake of its revel, and it cannot be lived any other way.

Then there is the night in the forest, the full moon strong behind the clouds and the great heavy fall of snow that piles up as you walk in it. There is such a quiet that you catch yourself stopping just to hear the silence. The bird, the deer, the squirrel are all abed during this silent padding of the earth, and something tells you to be there too, but the sensation of quiet drifting and piling-on is mesmerizing, almost achingly beautiful. The implications to all the big and little creatures that live in this forestland are forgotten. Your life back there is of no consequence, it is better than any entertainment as it envelops you and gives you a sense of peace rarely ever experienced, and yet it is just part of this vast cycle of necessity that some would posit is the way of the universe. You cannot go to the woods on a snowy night and not be moved, and the reason is that you are blessed with a unique capacity to experience beauty and the soul touching vision of divine art.

The realm of the sky can be loud and even frightening too. A rush of noisy frozen moisture can startle even the most lethargic character when a barrage of hail crashes into your reality. What good is there in this? In our utilitarian vision of life,

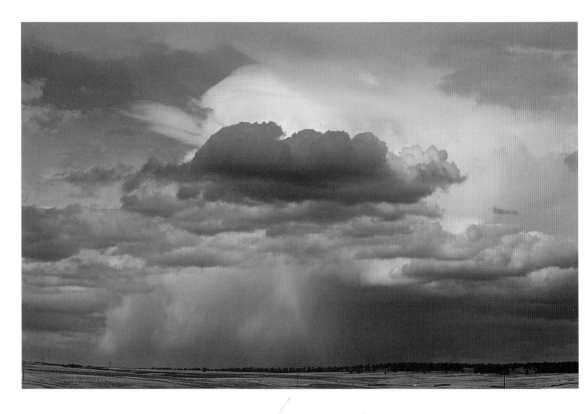

Sky Over Western Nebraska

nothing. This outburst crushes green things and shreds leaves and perforates any small creature unfortunate enough to be out in it. For us it is a rush of emotional anxiety as we duck for cover in the trees or any other shelter at hand. In the torrent that follows, in its suddenness, there is a loud outburst of crashing and clattering on any surface that tries to stop its seeming rush to the center of the earth. What we gain from it is a sudden change in our tranquility, a reminder that all things are fleeting, that the capacity of the sky to stun us is very real, and then the onslaught stops as quickly as it started.

With seldom an exception, there follows that constant companion of this frozen pummeling of the earth – a rainbow. Almost without exception this heightened moment of wonder is followed by a brilliant flash of fractured light that makes us pause for however short or long a time, to admire the sky-rain-hail-mist of this moment. A sight

Snowy Woods
Upstate New York

created only for us to gaze on for a quick tick of time, and then it too is gone. The magic of a hailstorm is a precious thing.

Our sky is a busy place. The snow, the clouds, the hail and sleet, the harbingers of seasons and moon cycles, all these are displayed for us, and most probably no others, to see and imagine. These elements of sky lore are there for us to use to prognosticate the future of events and to seek to decipher some unknown code. But there doesn't seem to be a code, and whether the logic of the weather even exists, there is one constant that

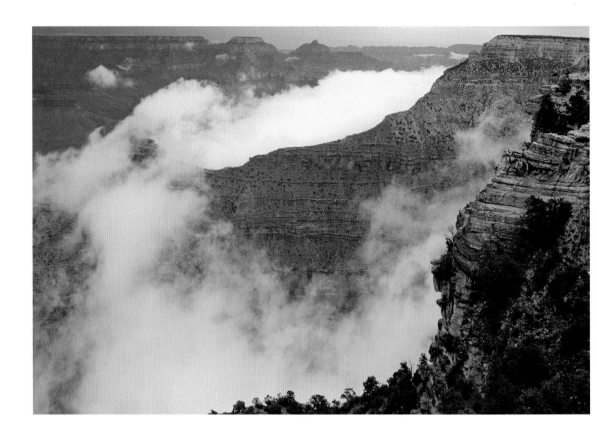

Fog Rising, Grand Canyon of the Colorado

requires no logic to understand: it is a beautiful place, this sky. When birds fly through it, when haze fills it, when the dark banks of ominous rain-filled clouds approach, when the moon shows only its silver cuticle and the sun is like a presence and not just a jolly smiling face, the sky is offering us an art show that has been on the road since we were old enough to admire it. We cannot live without it, the sky and all its elements, but we are blessed with the chance to see it as more than our salvation too, as the greatest stage in our entire existence for sights and sounds and beauty, for theology and salvation, for wonder and inspiration. This incredible infinite layer of time and features is far more than what we credit it with, even as we rely on it for sustenance and believe in its cycles and patterns. The true value of the sky is in its intangible gifts.

What settles out of the sky and lands on us without a sound – the fog, the ground bound clouds that fill our space and trap the light and make mysterious and ethereal the very places that were familiar so recently - all this comes from these wayward puffs of moisture that fell from the grace of the sky. It cannot last, and it will not, it will burn and shrivel and disappear without a trace as ghostlike elements of the sky often do, but not before it touches us in a somewhat unsettling way. Perhaps it is our compulsion to search and see and look anxiously to the horizon that is thwarted by this powdery dampness. Fog is after all rarely invited and is generally confusing, but there is an element to it that peeks our curiosity and adds an element of uncertainty and vagueness that appeals to our artistic sense. We are actually attracted to the slightly misty

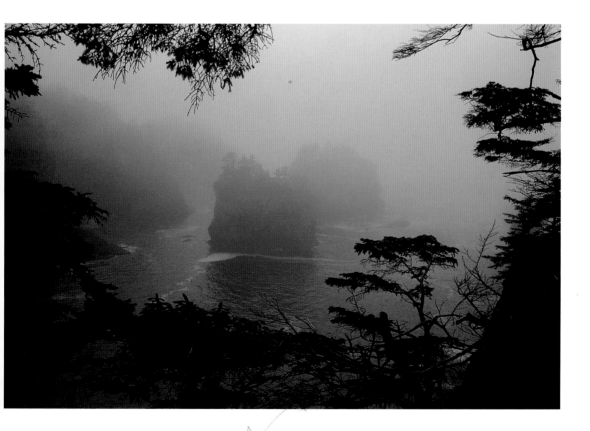

Olympic Coast, Washington

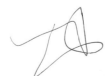

Bay of Fundy, New Brunswick, Canada

Malpais Lava Beds
Idaho

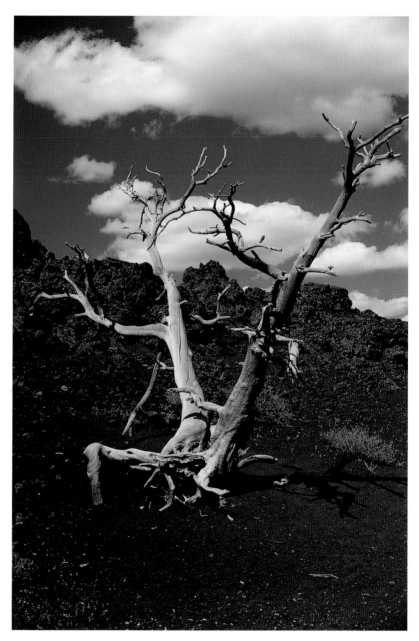

appearance of things in our world that are familiar, as they now appear cloaked and uncertain. There is something in our nature that seeks this apparition and tries to puzzle it out.

Then there is the misty dampness that accompanies this marvel that also leads us back to shelter. It is an uncomfortable place to be, this foggy bottomed feeling place,

whether it be moor or snowscape, the deep forest or the shore of a great sea, we would prefer to admire its sullenness or at least try to pierce its veil from a place of security, of sanctuary. Fog seems to play a part in our lives as much to lead us to realize that colors and shapes and far vistas are more desirable than we realize when only exposed to the sad monotony of continuous clear days. The anticipation of anything desired has a strong response in us, and yet those who live so close to this foggy landscape seem to find solace in the earth, in flowers and squirrels and the things that thrive in a place of abstinence and sunshine denied. Some things in our domain seem to act as blank pages and masks of the real bursts of inspiration and quiet beauty that are found so common elsewhere.

We seem to be resident in this misty earthbound landscape at a fascinating time between epochs of hot and cold, burning cinder and cold wasteland. Some time in the past, the surface of our world was molten and pocked with craters and flowing liquid stone. As our world cooled, the variety of the surface began to differentiate into vast seas and very warm land falls, and more variety was created. Now, coincident with the advent of an inquisitive species, we seem to be divinely blessed with perhaps the greatest contrasts the world's landscape has ever experienced – the molten stacks of volcanoes, and the vast frozen realms of the poles and high mountains.

In our great and varied landscape, at this point of contrasts in landforms and all the other measures of variety, we have found ourselves fascinated by the curiosity of liquid stone in our midst. To the unschooled, the very notion of rock flowing and dripping and showering down on the earth would be incomprehensible. What power, what force, what source could generate this phenomenon; the earth feels solid after all. If not for the cracking and shifting and sliding that goes on under our feet, we wouldn't experience these ruptures from the subterranean depths of the earth. The blasts and spewing of the guts of the world would not come to build vents and breathe the air of the surface.

What we have been given is a chance to see and experience the splendor and awesome landscape regeneration of this incredible force – vulcanism. The esthetic of this force is almost frightening when it bursts forth from the molten innards of our

Mammoth Hot Springs, Yellowstone Plateau, Wyoming

world. Often it makes itself known by slowly oozing and bubbling its molten contents out of vents and holes in the surface of the land. Over generations these flows build mounds and immense mountains of great proportion that startle the eye. With names like Kilimanjaro and Mauna Kea they grace the horizon and even become god-like to residents living in their shadows. We find ourselves in an age of fire and ice, and these hot mountains often become capped with glaciers and frosted with snow. These sentinals of a distant powerful past are now yielding to the etching and chiseling of the

elements as they are slowly reduced to sand and ashes once again. But the dragons still live in other nooks of the planet's surface, and they generate inspiration and fright of their own.

Blasting and bulging and collapsing with incomprehensible power, these ragged tears and hot spots in the land's relatively sedate surface shout from the underworld in words that cannot be ignored. Explosions from these magnificent towers create spectacles often seen round the world. The awesome catharsis of liquid inner matter thrusting into the atmosphere can shoot steam and cinders and liquid rock high into the sky and boil and build to a height and girth unparalleled by any other event in God's creation on this solitary planet.

The nature of vulcanism itself is a great feat of creativity. Melted rock under the crust of the earth lies in pools of nondescript red-hot magma. These minerals, molecules and elements, roil and churn and are contained in a liquid mass of no distinction. But when it finds its way to the surface, it emerges in showers and gasps and explosions that create a thousand mountainous shapes comprised of a hundred forms of beautiful and dangerous lava.

Bombs of hot congealed rock fire out of vents and craters rolling down slopes forming bulwarks of rocky nests in ravines and washes. Ash piles up as the wind carries the dust to leeward, and over ages the deposits become painted piles and melting badlands that are marvels, and provide a tremendous array of colors and forms. Capstones and euthanized trees are buried for more ages, and emerge as crystallized forms in dozens of muted and deep colors. Whole regions of the landscape are first smothered and then later revealed as rock and mineral works of art.

Other forms of this liquid mass are pumped out of these fire holes and fascinate us with the heat and searing capacity of their lava flows, burning and encasing all that is in their path. The tubes and ropes and sinews of these flows provide glimpses of that brief moment between the glow of liquid stone and the blackness of solid rock – cooled

by the air and contact with the earth. For the rarest look, we watch under the sea as the molten mass pours into the salty brine, and pillows of liquid rock freeze into solid stone as they hit the cold ocean. The moment of contact is fascinating and mesmerizing – nothing quite like it exists, and all of this comes from the seeming blandness of this red surging underground paint pot.

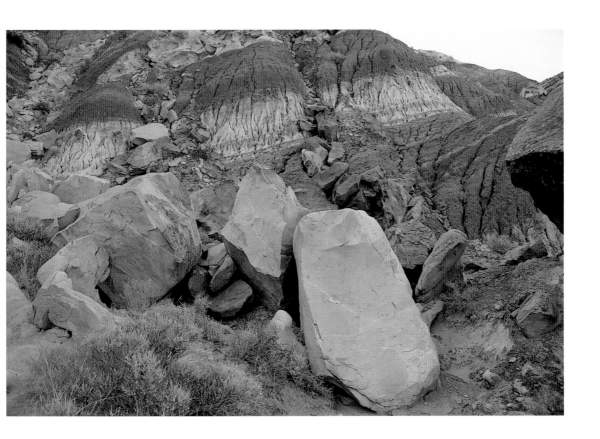

Grand Staircase Escalante National Monument, Utah

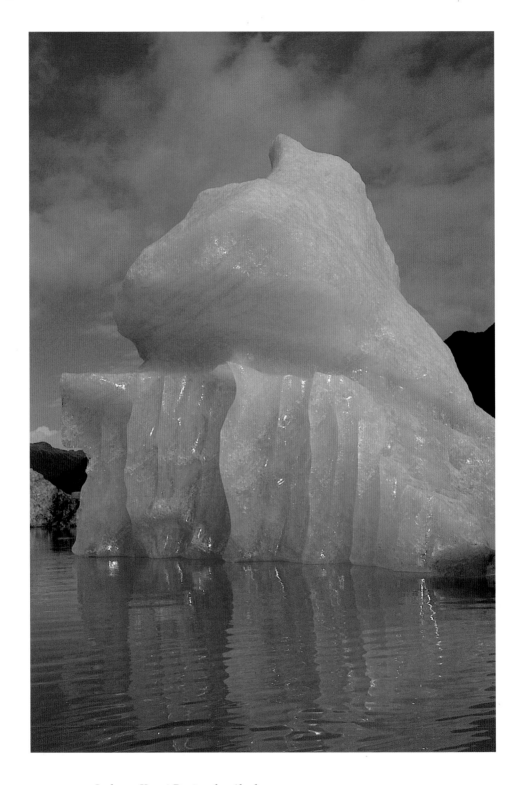

Iceberg, Kenai Peninsula, Alaska

Liquid Art II

"Under the microscope I found that snowflakes were miracles of beauty…
Every crystal was a masterpiece of design and no one design was ever repeated.
When a snowflake melted, that design was forever lost.
Just that much beauty was gone…"
-Wilson A. Snowflake Bentley-

The process of creation on earth takes many forms. Animal life and plants combine and recombine creating an untold number of new and continuing life forms. But the boldest, most violent and most aesthetically creative form is the red cauldron of the center of the earth as it overflows. The wonder of liquid rock as it builds a bit of new land in such a grand range of colors and forms and shapes on the surface provides one of the most unique and elemental forms of creation that we can ever witness. The transformation is on such a grand and even cosmic scale that it reminds us of the hand of the Master at work.

The liquid that is the source of all life is not the magma of the earth, but the simple compound of elements that emerged as the stuff that would engender everything that has come after. Water was here, and then there was life. The hot primeval rains that eventually evolved to produce the wonder of snow, begot a new aerial art form, the snowflake.

Crystalline shapes whose beauty is lost on us almost entirely as they fall and crush each other on impact or melt on contact, are, as they freefall from the heavens, a seeming infinite number of tiny works of art – not utilitarian functionaries, but fleeting bits of beauty. Perhaps one day we will find a way to observe these heavenly wonders for their extraordinary variety and six sided shapes, but not yet. The constant question of why comes back to raise our brows, for obviously the need for variety in snowflakes is unanswered. The functional quality of each flake could, perhaps should be satisfied by one common crystal – solid, durable, flight-worthy – like sleet. But once again, the

Winter Sunrise, Manlius, New York

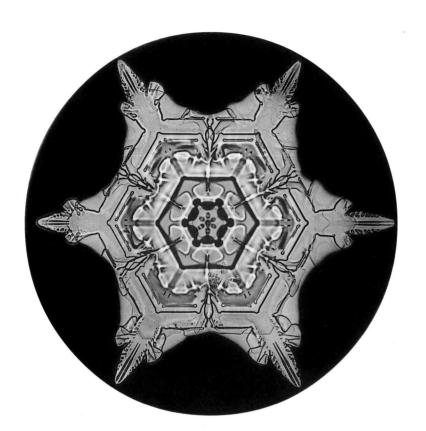

*Bentley Snowflake
III*

*Bentley Snowflake
IV*

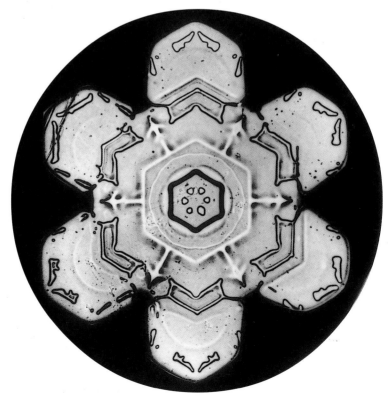

air plays its Kokopelian tricks and blows the frozen concoctions into countless forms and spiked shapes and we are the ones to find delight in it all.

Poets have found inspiration from the falling flakes that unite to form a sort of unified whole that drapes and droops and sags every tree and bush where they land. Yet though it begins as a million flakes tossing and twisting in the air, is then transformed into a seemingly unified whole as it measures up on the ground, it then reverts again, melting and returning to drips and droplets and vapor, returning to its aerial beginnings.

Winter Lake Scene,
Upstate
New York

The mutations and transformations are as interesting as the outward appearance of this white miracle.

Frost is another wonder of the liquid world that touches us in so many ways. It is the genius of crystal fantasies that appear on trees and plants, in the grass and even on glass; one of our own creations. It forms almost as we watch, but like the "watched pot that never boils," we cannot see it being created with our eyes. It will emerge almost from thin air, a combination of the moist air and the cold of the surface – it just appears; like magic – from nothing, a pattern, a form, beauty.

In regions of pine forests and jungles of green trees, on broad expanses of tundra confined to small spots of rare landscape, the wonders of Vulcan are revealed to us in pulsating and spectacular forms of liquids dancing and roaring and bubbling in the air.

Mammoth Hot Springs in Winter, Yellowstone Basin, Wyoming

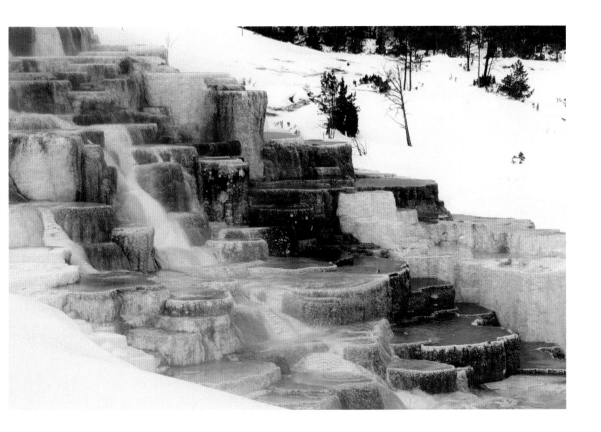

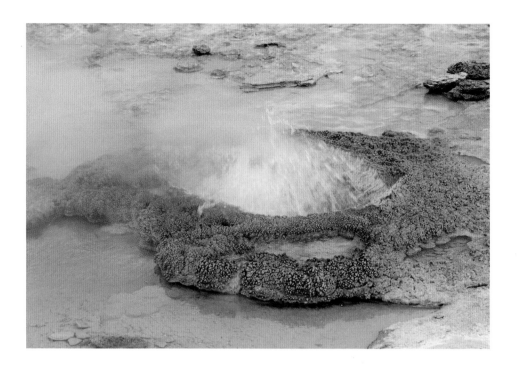

Fumerole, Yellowstone Basin, Wyoming

Geysers become an intriguing and unique spectacle that combine the furnace of the earth with the delicacy of water in webs of surface veins that surge and suck with both regularity and inconstancy in these far reaches of the world.

The steaming fountains are rare and spew their super hot blasts for mere minutes before collapsing back into their dark underground holes to be reheated before shooting into the sky again. Many stay hidden for hours and days, eventually becoming extinct and drying up. Some pulse and roar with fits of steam, never certain of their fate or commitment to blasting up at full force. Others are as faithful as clockwork, at least for now, and will create a spectacle that will inspire awe and admiration in us. And then there are the quieter works of hot water art that fume and bubble and terrace their mineral burdens, creating complex dikes and pools and mud pots that inspire often strange and even silly names. But the attraction to these phenomena is enduring.

Hot water and holes in the ground – the combination seems quite unimaginative, yet in the hands of a Creator, it becomes a park of colors and variety. Bubbling gray-brown-orange mud that never goes beyond the pot it stirs in. Add to these deep throated pools of mineral rich broth special blends of colorful algae and the result is an iridescent blue-green flower shape of almost clear water fringed with orange.

The terraces are also there, no reason really, but the hot mineral laden water that rolls down these hills begins to puddle and pool. Small dikes and ruffled fringes begin to form, and the logic or reason of it is lost in the appreciation of the result. Time, the element that always adds to the creative process – contributes to the building of fleeting battlements that appear and mount the landscape in pastel colors and the occasional blood red streak. They add something very active, alive, and replace everything within the radius of their spreading turrets. The mounds reach as high as the heated flows will push them, and the plumes of cooling steam will wreath them as the percolating water washes over the terrace walls. Then it is gone, back into the earth to discover a new path or be drained into the cauldron of recycled beauty and forced once again to perform this spontaneous display of building prowess and creative talent that emerges from the dark realms of the earth.

Whether these displays of liquid art are blasted and shot into the air, or bubbled and trickled out of the earth, whether they have traces of minerals to deposit and form terraces that inspire wonder and enchantment, their appearance and our pleasure are testament to the extraordinary creativity in one small corner of our lives, by this simple substance called water.

When rain lashes at hillsides and in deep forests, when snow piles up on the slopes of high mountains, we seldom think of the eventual journey all this wonderful liquid will make down to the sea. The changing landscapes that mold and funnel water as it makes its way to the staging point of the sea are all part of this great adventure. Lower and slower it travels until it blends with like-minded molecules in ponds and lakes, fed by streams and rivers. Moving rock and silt and sand, roiling in fast moving channels or slowly sifting through mazes of the landscape, it is inexorable.

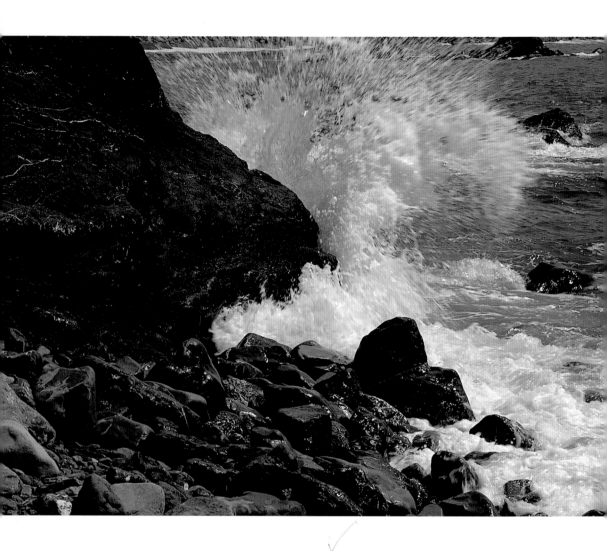

Surf , Cape Flattery, Washington

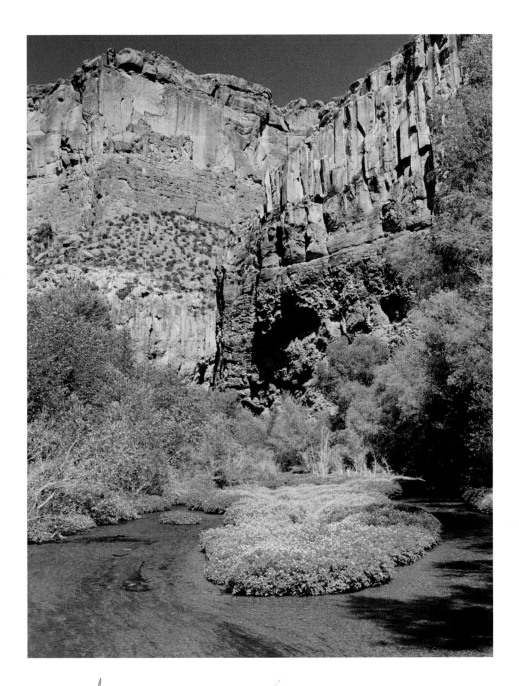

Aravaipa Canyon, Arizona

From just visible fine mists as clouds in the sky, it forms ideal raindrops that fall to earth, discrete, not too large, not too small, not with killing force, but as nurturing droplets. When these earthbound bits of fluid strike the earth they become one of the most flexible substances in our universe. Like magic they can combine instantly and become puddles or join in a group presence on the surface of a lake. They can split on the edge of a rock as they fall and become a dozen droplets scattered on the ground. They can join a trickle, and then become a rivulet, a brook and a stream, and begin the journey to a momentary resting spot at the bottom of the landscape.

These incredible drops can fall to the earth and separate into tiny bits of life sustaining moisture, split and split again as they are pulled down to the roots of a mighty oak or the hungry tendrils of a saguaro. They are divided into earth-bound mist too

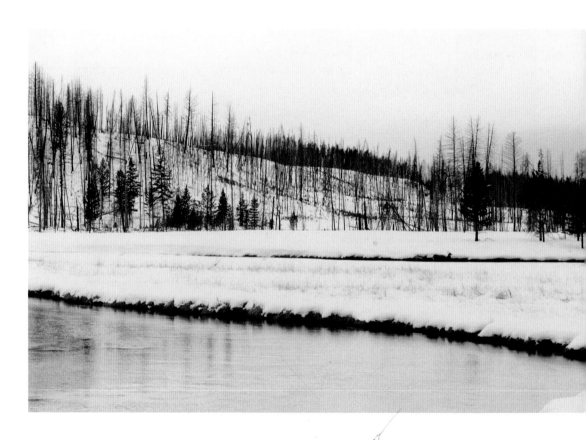

River in Winter, Yellowstone Basin, Wyoming

small to see, by the subtle force of gravity and the mechanics of the particles in the soil. These tiny specs of life-giving refreshment enter the roots and nodes, and then they begin their gravity-defying journey back to the sky. The stalks and the trunks of uncountable trees and plants convey these bits of now just humidity up into these trunks and branches, pulling against gravity and pushing each other ever upward toward the heavens, being used for countless tasks, and then finally emerging out on the surfaces of leaves and stems to find the wind.

Once again the sun draws these specs of liquid up into the sky to find residence as fog among the treetops or as blustery cloud heads pushing over the tops of hills. For some, the trip is higher, to afternoon thunderheads building into tissue paper mountains that have gained almost a solid character by condensing so much of this fine mist into raindrops, and hail and snowflakes. Some will shoot to the high heavens and become cirrus – almost heavenly films of moisture that will race through the high atmosphere finally returning to earth far away, carried by high winds until they find equilibrium, and fall back as mother rain.

Oak Leaves in Snow Shower, Prescott, Arizona

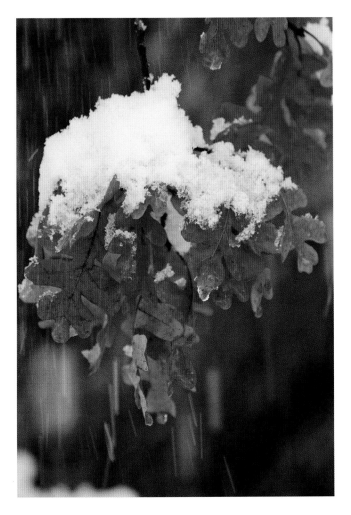

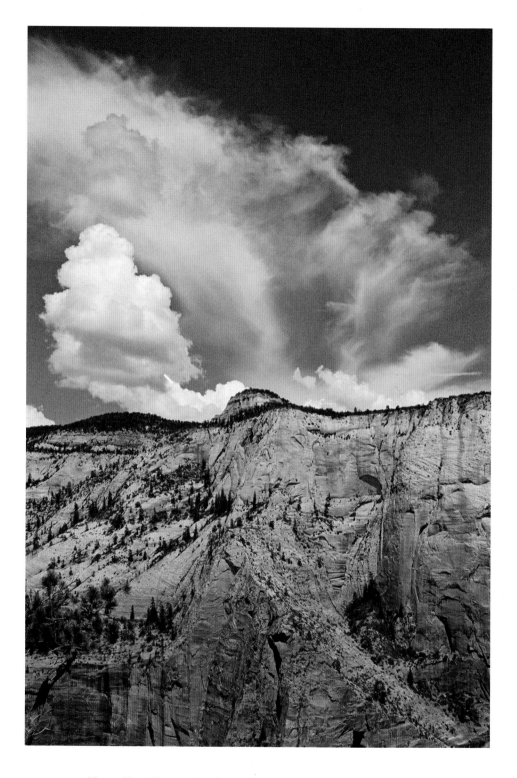

Upper Zion Canyon, Utah

The system is beautiful. The very intricate nature of water in this world is admirable and fascinating – complex and, beautiful. Along the path of this incredible journey, the liquid of our lives forms and separates, splits and splits again, is dashed on the ground and spills on green surfaces. It falls as rain in the desert and often evaporates back into the clouds before it even touches the earth, a mirage, a spirit-like sight to see. It separates into smaller and smaller bits as it moves to the roots of plants, and naturally divides again to be drawn into their tiny porous shoots. Its journey back to the sky is as complex as the convection process of an ancient tree, or as simple as sunshine on the surface of a quiet pond. But ascend it does to reform the clouds, color the rainbows and add brilliance to the sunrise.

The skies are an incredibly complex stage for this ballet to be played out in. The variety of the show is what draws in even the most preoccupied and unaware, and provides the curious and yearning a place to begin to look for the meaning of life itself. No matter how much we probe and analyze and describe the ritual of rain and its journey in the landscape, its beauty and mystery will never be diminished.

The rain and snow that falls to earth takes one of an almost infinite number of paths in its perpetual cycle of nurturing and renewal. One of those paths is as a river of ice that starts on a lofty mountain peak, and rides the canyons and valleys in snow bound regions as a glacier. High in the aeries of the peaks in the polar regions of the earth, the snow falls interminably. Only in relatively recent history on this earth has there been snow, but these masses of ice have accumulated fairly quickly, and have found haven in cold and far off places.

As with all things that are thrust up in the landscape, there is the inevitable reach of gravity to pull them back down again, and so it is with these troughs filled with snow and ever bluer and more transparent ice. Gradually, inexorably, the weight of their accumulations begins to move down-slope, inch-by-inch, foot-by-foot, grinding and plowing the bottom of the trough, and then the canyon, and then the valley, until they reach the sea or the warmth of lower climes. Along the way they churn up the soil and plants, and even push the moveable menagerie of small furry beasts before them, moving, always moving ahead.

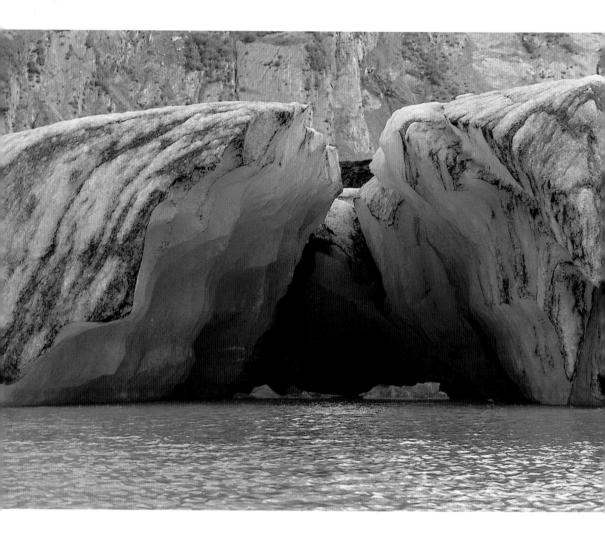

Glacier Face, Kenai Peninsula, Alaska

The beauty of all this is seen up close, and far away. This ancient ice melts on the ploughing front edge and reveals a color rarely seen anywhere in the landscape. The blues and greens are rich and deep, and the color seems to be even more intense in the glacier's heart. These massive, ponderous leviathans contain tubes and caves that disgorge their melted contents and provide a view of the depth of these frozen freight trains with their delicate and rare scalloped and sculptured sides and ceilings.

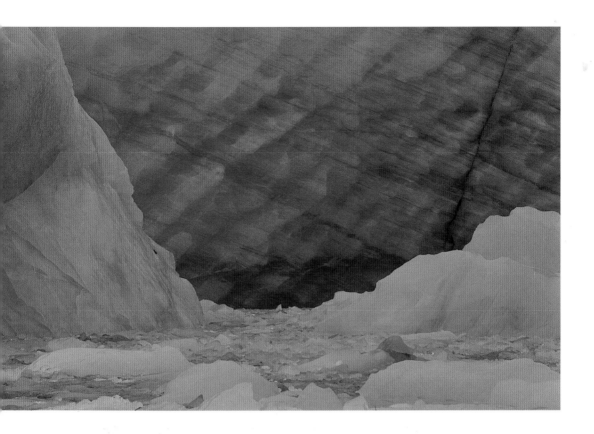

Iceberg Detail of Blue Ice, Alaska

When seen from afar, they have their own magnificence. The chance to see the enormous flow of these new-age masses as they slide down one valley, and collide with another coming down an adjacent valley is a very overpowering experience. Seen from a mountain side, we are treated to the symmetry of churned earth that forms stripes in these glacial masses formed as each ice train grinds and sideswipes the other, perpetuating its own exterior decoration while it combines with another. The graphic artistry is truly on an immense scale. And so they flow together as two rivers of texture and color, scouring the valley floor, and creating rare sculptures on an enormous scale.

At this juncture in the history of the landscape, we are also treated to an almost religious experience when we view the results of these masses of flowing ice as they retreat leaving immense canyons and valleys. The canyons have been given names like

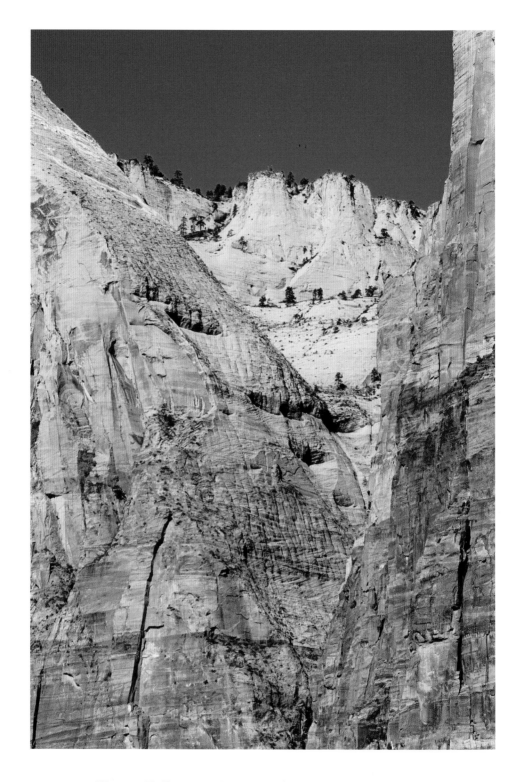

Hanging Valley, Zion Canyon, Utah

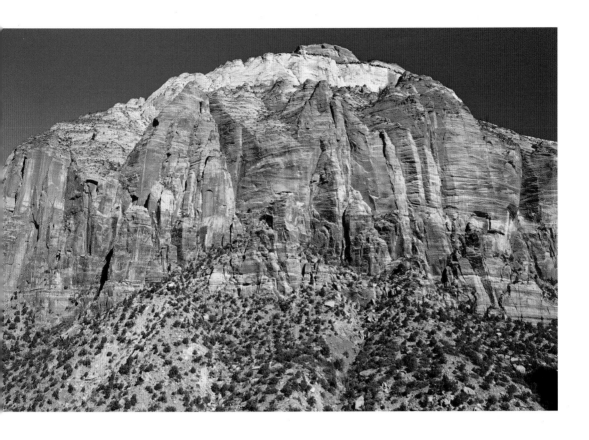

Canyon Wall, Zion Canyon, Utah

Yosemite and Zion and their cliffs soar high into the sky with hanging valleys and sculpted and spalling cliff tops, the result of enormous pressure and force, all of which began with an infinite number of snowflakes falling gently and humbly to the north so long ago. Just from the modesty of water frozen in the sky settling to earth to join and compact and build towering masses thousands of feet thick that flowed as all water flows, inevitably to the sea.

We are granted the chance to see the sculpture of the ages on a scale and in a form that once again has no purpose, is indeed just a random occurrence, but that stirs within us a feeling of spiritual awe and splendor. It is difficult to stand in the shadow of these colorful monoliths and not feel moved, not to feel something akin to a force

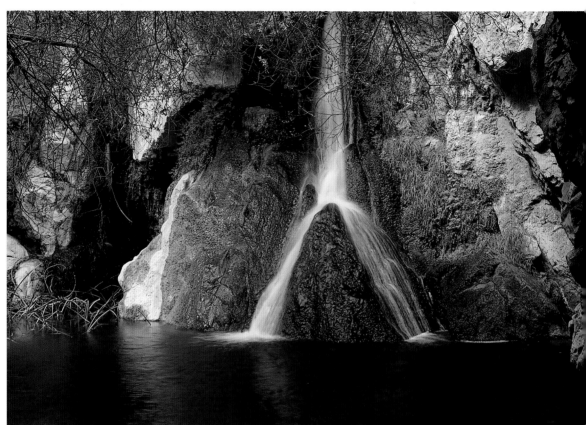

Waterfall, Death Valley, California

beyond our comprehension. The valleys and canyons are hidden away, they are not the center of civilizations, but they offer a connection to the mystery of life and the forces within the universe that speak to us when we enter here. Yet so much of this spectacle is non-productive. The cliffs and peaks and the balds of the slickrock are a memorial of sorts to the passing of ice and the hand of the Creator in a way that makes our blood run faster and almost requires us to stop and pay homage to the magnificent result of all this power and grace. Flowing ice, another creative urge from afar at work here in our presence.

For all the wonderful variety of life that lives in and around the flow of water as it trickles and babbles between the banks of brooks and streams and rivers, there is the reality that as time has passed, those same routes that are defined by these waterways and raging rivers will always be changing. As the mountains and valleys rise and waste away, the course of water from the highlands to the valleys and the sea changes also. The crag that gives rise to snowmelt is worn down and the melting water becomes a general soaking that seeps into the land and finds underground caverns and

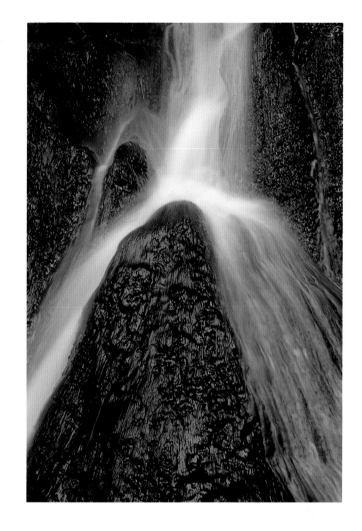

Waterfall Detail, Death Valley, California

pockets and plant rhizomes to nourish, and the streams lose their speed and definition. As these landscapes change new ones appear to create new channels and crags to funnel the moisture and elixir of all life that the earth is blessed with.

In our time, here in this wonderland of originality the changes that are manifest offer a constant enumeration of all the forms that water and the landscape have ever offered. To be sure, they are not all in one place, but they are all on display in some location. Of the watercourses leading to the sea, few phenomena fascinate us at much as the falling of water through the air. Waterfalls are like magnets to us, we are drawn to

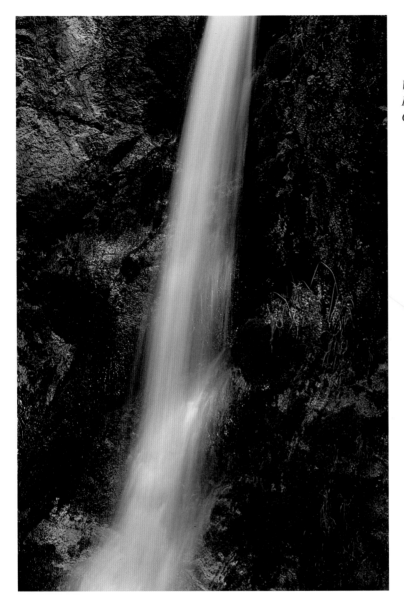

*Waterfall Detail,
Big Sur State Park,
California*

see them in their modesty, the neighboring stream with its small rapid, and the regional tipper that plunges over a cliff as high as a house, nestled in a glen.

In the desert, these rare and beautiful falls create even more magnetism because of their incongruity in a land of little water and the often surrounding beauty of the rock. They shoot out into space, to be suspended for only a moment, yet to seemingly defy the ever-present pull of the earth's reality, gravity. It is perhaps the attraction of the savory water, the thirst quenching, refreshing, vitality of water itself that is so evident and

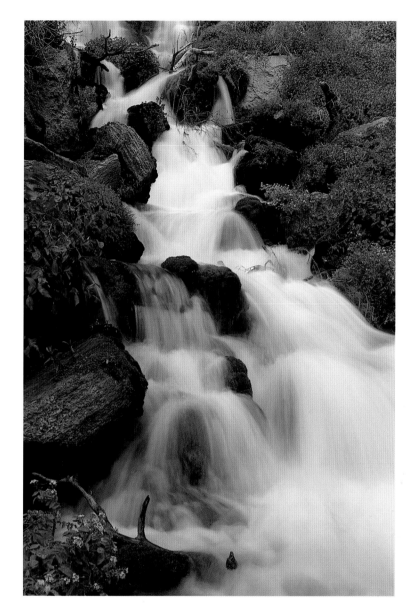

*Below Thunder
River Falls,
Grand Canyon,
Arizona*

immediate in this display. Something draws us to it; it is an ancient attraction that is

constant and ever present. We see in it something of grandeur and yet also the unknown,

the unrequited. Few of us are immune to its magnetism, and yet these wonders serve

little practical purpose. The value to us is far more one of vague and indefinable

fulfillment and almost need than practical use. The old mill, perhaps, was one use, but

aside from the nostalgia of a bygone age, the falling water remains one of our most

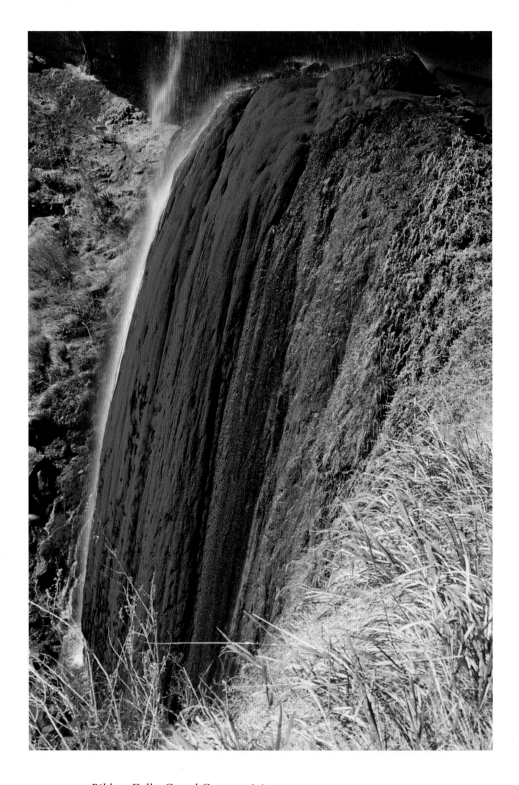

Ribbon Falls, Grand Canyon, Arizona

treasured natural connections to God and another dimension in life that is not so obvious, so patently beneficial, something that is indeed just fulfilling and magnetic in its appearance and beauty.

Perhaps we will always look to falling water in the landscape to inspire and draw us to it. There is no superficial or even complex explanation for its origin, it is part of the cycle of water from high to low with a piece of the path missing, a step in the otherwise continuous channel that all water seeks as it finds itself rushing ever downward. The magic will be with us because we can't exactly explain the wonder of it, and yet we see it universally as part of our dreamscape, the aesthetic of the world.

There is little in our experience of this water filled landscape that affects us so much as water at rest. Ponds and lakes and tarns are created and quietly fade from the

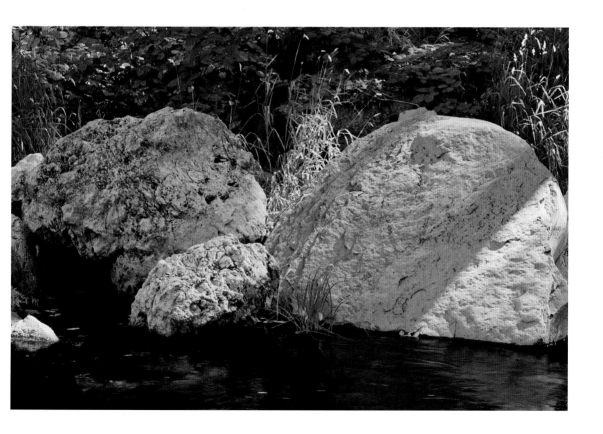

Oak Creek Canyon, Arizona

landscape of the earth in the same inevitable way that streams and rivers are born and are flush and fade to flatlands in the constant motion of all things. We dream at the side of a quiet lake; trees and grasses and flowers, and a constant supply of animals big and small in attendance. The inspiration that comes from this emotional tincture seems to flow from the possibilities, the life and the quiet that is the very nature of these waystations for water. The streams that flow into them create a place where every living thing seems to find a haven and replenishment. The narrow banks of the stream give way to sand spits and beaches, grassy shoulders and rocky outcrops.

In the north woods, these lakes and hidden ponds are almost undiscovered by us and have remained a haven of wildlife and green things that seek their shores. When we happen on them we see the play of light on their surface, the sunrises and the sunsets, the disturbed motion driven by the wind and the distortion of birds breaking the surface. The mixture of all these wild signs and our own often disturbed longing for something that seems to exist out there on the other shore, the other bank of the far side of the lake does more than just entertain us. We see a beauty that is tranquil and inspiring and often even disquieting in the interplay of wild things and this magical pool of liquid. Seldom do we ponder what the scene would look like without this magical treasure, the plane of grass or rock that would take its place, the absence of life and motion and small disquiet.

Water when captive in such places is for longing; it is the setting point for the sun's eternal habits and the start of all days. These basins and recesses will fill with soil and leaves and the landscape's detritus; all in good time. But when they hold the precious elixir that allows all things to live, they bring to us that wonderful illusion of beauty in light and dark forms, all the colors of the sun rising and summer storms. The sparkle of prisms created by the wind that transforms the surface and excites the eye. All things gather here to drink and seek food and even shelter, but we see so much more in this margin of transition from the firmness of rock and soil to the fluid light of shimmering water.

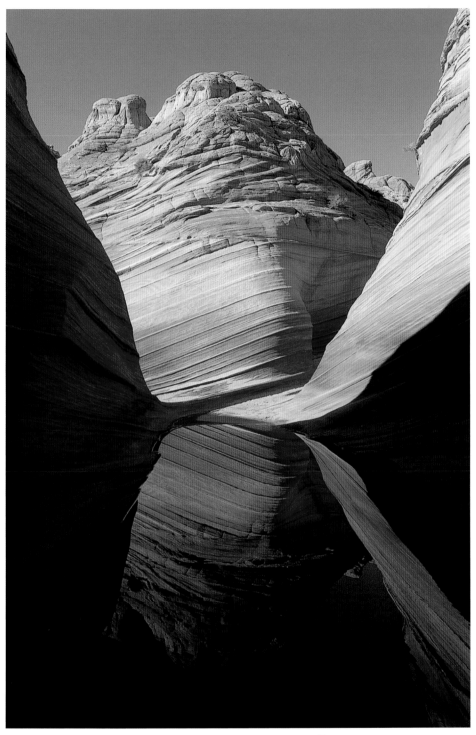

Coyote Buttes Wilderness, Arizona

When night comes and the moon light spills across the pond, it adds even more mystery, more questions more magnetism in our souls. We see the cool moonlight on water as something that touches our deepest emotions. It draws and repels and quietly disturbs us. The feelings are difficult to describe, but they are ever a part of the view of this wonderful supine neighbor that affects us in so many ways. Perhaps that is part of the mystique of its presence in the quiet forests and mountain realms. The light creates dark places in the trees and makes its presence even more appealing and important. And when day comes again we are transported to new feelings of relief and expectation, feelings that would not be felt in the same way far from water. Feelings that are engendered by these quiet places where water rests and charms and nurtures all things waiting to be born to the sea.

Winter, Prescott, Arizona

The wonder of lakes and ponds, the light and disquieting affect they have on us is transformed once again by the passing of summer and the warmth and the life of all things that seek comfort and shelter there. The leaves fall and the grasses tarnish, the animals scurry and head to stronger sunlight, and the bareness and cold of winter comes to the lake. As mornings come later and sunsets are premature, the miracle of the freeze advances over the lake, and like so many other miracles in this landscape, the liquid becomes crusted with an ever-thickening labyrinth of crystals. Ice is formed from nothing. The reality of this is taken for granted, but the wonder is there for all to contemplate.

What use do we have for the frozen surface of our most vital substance? The transition from liquid to solid serves no perceivable purpose in our existence. If water froze into these curious and marvelous forms and shapes at a temperature beyond the range of what we enjoy here in our world, we would not be able to experience its dazzle in snow and hail and hoar frost. The lakes and ponds and streams in so many lands where we live would only be cold, but never frozen. What use is this crystalline marvel we call ice? If it did not exist in our world an element that provides us with a vast variety of beautiful images that we take for granted every day of our lives would be gone. Imagine the loss of all things frozen, from the land, the white tops of mountains, the untold beauty of every snowflake, the glassy edges of the first freeze on the lake, the animals that would not be among us because they would not have the frozen regions of the world to live in.

Even the poles would be gone, and we would lose an element that we are able to appreciate as no other; a land of eternal variety that provides us a backdrop to imagine and create and wonder, and to see those sunrises and sunsets and blowing blizzards of snow. With the gift of curiosity and the privilege of seeing all things through eyes that can perceive wonder and color and emotions, the miracle of the transformation of water to ice in the very landscape we inhabit is one of life's greatest wonders. In a cosmos of such incredible extremes of heat and cold, we live in this tiny band of cool and tepid with an element of liquid beauty that seems to defy the very logic of the randomness that is suggested as the condition of our existence.

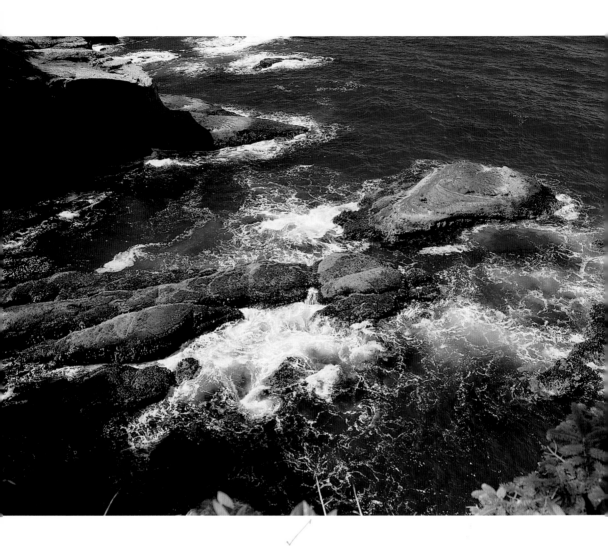

Olympic Coast, Washington

The primal force behind all water in our lives is to seek the ocean. It may fall as rain on the prairie and be caught in gravity's grip and be drawn far beyond the voracious roots of the grasses and flowers of the plains. When it does, it settles into lakes far beyond our sight and the light of creation. The snow and rain of the forest is often taken to the stems and trunks and leaves of the short and tall in these woodlands and grassy meadows and becomes the conveyance of life for these plants and the woolies that inhabit the land. And yet much of all that falls and melts and rushes down country, that

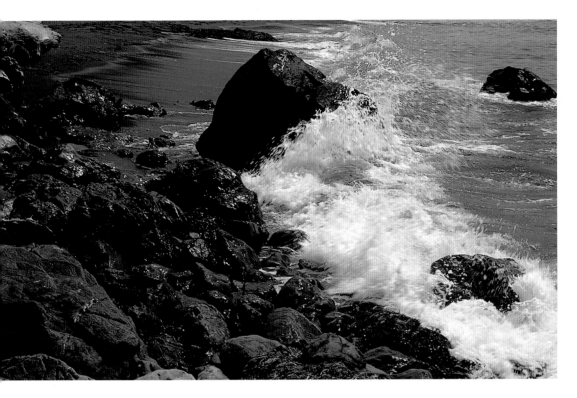

Lost Coast, California

forms the brooks and creeks and rivers, finds its way to the bottom where all water ventures at some point in its cycle, the sea.

The life of the sea is independent of ours. The light and darkness, the life that it holds and carries on its shoulders would be there without us. We are creatures of the land. We venture into this watery realm ever more frequently in our own spiritual and physical evolution, but it seems no matter how far we go over the top and into its depths, we will always be strangers there, not able to survive in it or on it, just visit and marvel at it and take from it.

Water seeks rest it would seem, and when all the rushing and meandering and ox bowing down lazy rivers is over it finds its ultimate low point. It rises and falls in these vast oceans, and it travels in great currents and rivers in the seas by the moon's force and

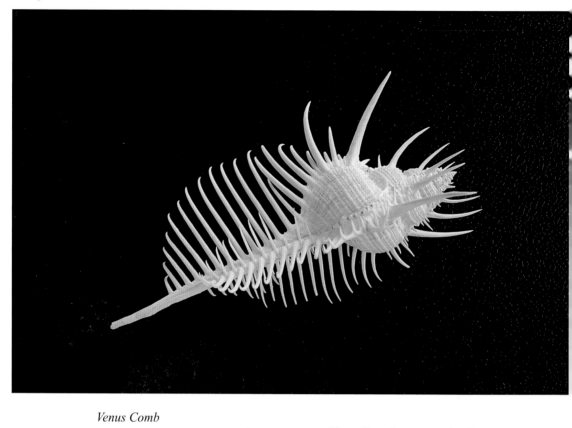

Venus Comb

Three Strawberries and a Cowrie

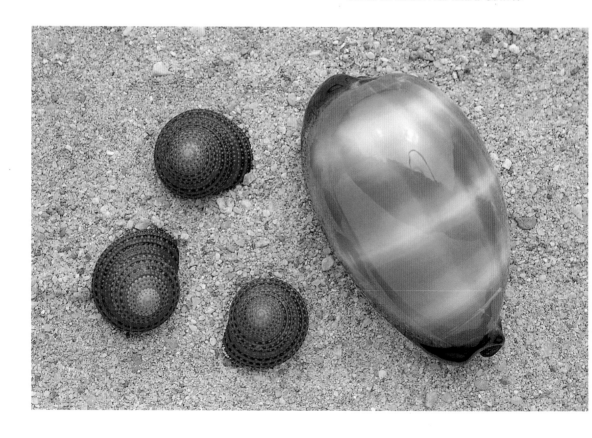

the winds and even the turning earth. But it cannot sink any lower. It reaches a point of equilibrium when it returns to its true home, mother ocean.

In our eternal need to triumph and proclaim the next final point of knowledge, we see the oceans as essentially understood, as complex, but manageable. It seems something of a conceit to arrive at this notion simply because we have probed deep spots and measured big currents. We have trapped and labeled and categorized life forms and water samples and drawn a relief map of the bottom of this great sea chest, and yet we seem to have missed the real point the real essence of the sea itself. It is the wonder of all these things together that is its greatest value to us. The synergy of all the parts of the sea keep it far beyond our grasp, our understanding and even perhaps our appreciation. Pictures, glimpses that are taken at moments in its life are the best we can do to represent it in all its complexity and presence on this earth. We have traveled and sent machines into space to look back at our world and the pictures that we have taken show these incredibly vast regions of blue and brown and white. But in order to capture a view of this entire ocean of life, we have sacrificed all its details and the animals and minerals and plant life that add up to the liquid beauty of our world.

Is it by chance that the sea is so complex and immense; it certainly is described that way. All life is said to come from the sea, and certainly in whatever order all life arrived in its present state, living things could not survive without the precious element of water. Why weren't we of the ocean instead of the land? With our ability to see all life, all things through our artistic eyes and sentient self-awareness, we could have been the rulers of this watery world, not as warriors to eat and capture the denizens and fragile things of its deep recesses, but to swim in its waters and sound its depths, to create and build and view sunsets and sunrises across the surface of the deep blue as residents instead of as passing voyagers; there only by our own ingenuity and precarious state.

The inevitable question will always come up as to what our true place is in the cycle of life, all life, in the sea and on land, of the desert and mountain and grassland. Why are we at home on the land while so much of the world is remote from us in a world apart from our own; one that is alien to us? The question perhaps, does not have a universal answer; it can be answered by each of us in our own way, or not at all. Those

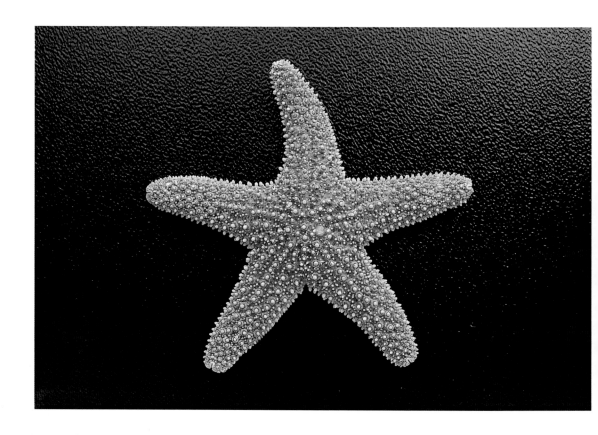

Sea Star or Starfish

questions are the best ones because they permit us to be at least in these small ways unfettered by logic and those who would set our spiritual feet in a heavy wet substance and keep us there.

The sea returns to the sky in quantities that have been calculated and in a form that we know as water vapor, but the real magic and wonder of it is not diminished by the knowledge. The rising of this elixir that is so ever with us happens in plain sight and yet we cannot see it. Storms happen quietly and occasionally with ferocity, the point and counterpoint of energy streaking down from the sky. This power fuses the living body of the ocean and fuels the fury. The action and immensity of it is humbling and brings us, if we can witness with open eyes such moments, to respect and perhaps even to

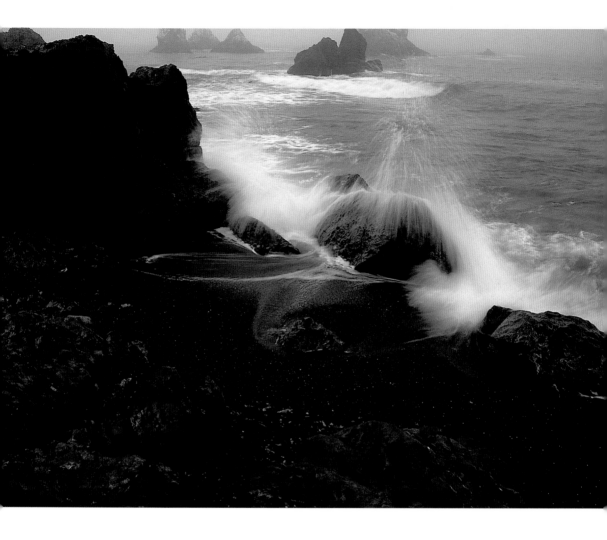

Pacific Coast California

appreciate in our limited way the complexity and innate power of this watery seascape next to our own.

We pick ourselves up from the passing fury and dry ourselves off, as this seawater is alien to us, and if we are lucky, we pause and consider the moment that just passed and what it means to us as wayfarers, afloat on a surface of familiar but mysterious matter, in a world that is ever so complex.

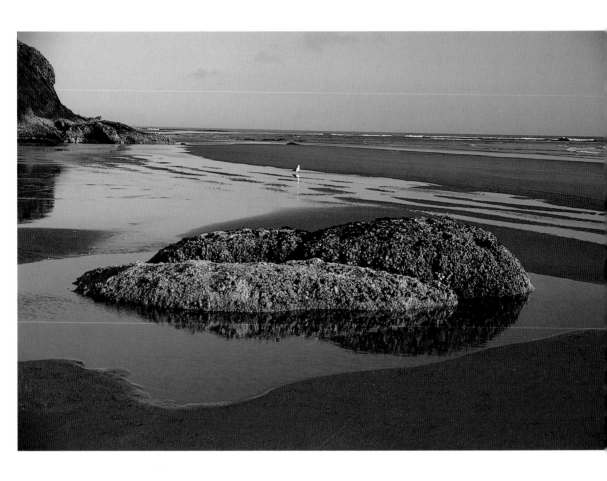

Pacific Coast and Seagull

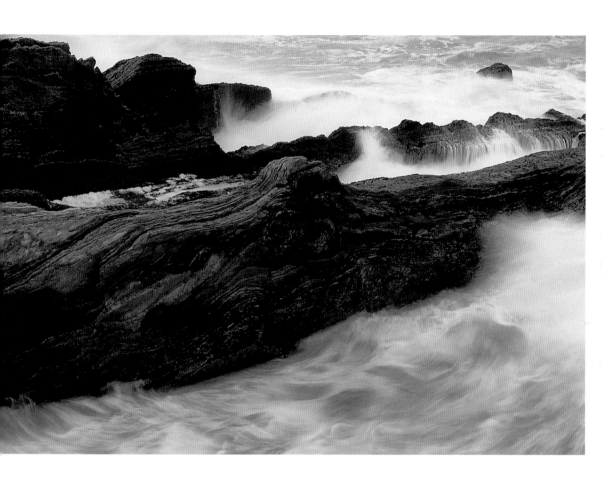

Morro Bay Coast, California

For all its size, for the quantity and almost limitless variety and presence of this fluid world, there is another more familiar realm that has been like the seam of creation throughout the history of this world. It is at this margin, the shoulder of the sea, that we find so much of the beauty and constant change that has drawn us to it as far back in human history as our memory allows. There is a subliminal drive to seek the other side of the lake, the sea, the ocean; to travel to its far reaches, and yet we have been in fear of its very edge. The most dynamic point of this watery surface is its margin, the coast, the surf line that has become our home.

The very rocks and sand and surf at this creative verge react in an almost visible interplay of dominance and passivity that yields a panorama of beauty and texture and pattern found no where else. The sky provides the sunrise and sunset, the moonlight and the full view of the approaching storm. The waves crest and fall and collapse on sand and shells and rock, offering an unceasing, mesmerizing pattern that creates a sort of metronome of peace and soothing reassurance for us. For some it is the crescendo of

Primrose, Capitol Reef, Utah

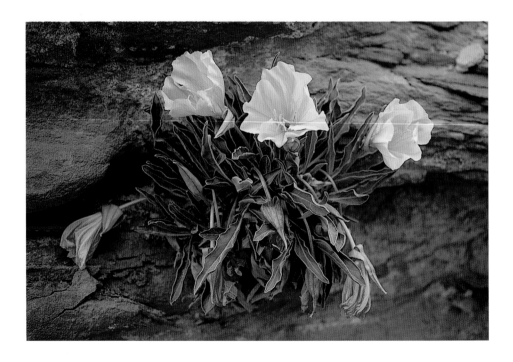

giant waves on craggy rocks at cliff-side that exhilarates and causes us to want more; for the waves to spray higher, to roar again with even greater energy and to lash the rocks.

The sands shift and the rocks shatter the waves into tiny mist, a transition from the largest organism on earth, the sea, into vapor that nurtures all life; this in an instant. The beauty is more diverse more constant and changing than we can absorb. The aesthetic wonder of this nursery of life has always fascinated us and still delivers a vitality and curiosity about our heritage, and our future, as nothing else seems to. It is the colors and the forms, the cycles of the tides and the birth and end of the day that are starkly played out eternally that provide us with such a catalog of sentient feelings and fulfillment. The beauty is there for all to see, to weep over, to view as the beginning of a journey to the horizon, yet this is only the kinetic beauty, the tantalizing first blush of the sea's real gift to us of brilliant colors and shapes and forms, close under its rowdy shores.

In our terrestrial home, we are treated to the delicacy and brilliance of colors and forms that strike our eyes with startling clarity and a sense of extraordinary wonder. The throat of the hummingbird, the wing of the butterfly, the shock of the red cardinal flower, sun tinged in a dark glen, these sights and a life time of others are part of this solid landscape that produces much of what we consider to be the greatest beauty we are ever to see. But these colors and wonders seen in the air and bound by the edicts of gravity are often surpassed by the wonders found just beyond the roiling surf in the filtered sunlight where life can live in near defiance of the pull from the center of the earth. The colors and forms of the quiet and complex world just beyond our sight is one of the most divine creations given to us to see and wonder at.

The life and forms of the reefs and shallows of the oceans and seas of the world are ethereal. The colors, the reds and mauves and pinks, the yellows and purples and shades of colors long past naming or categorizing are here in the shallows, and the sand and rocks of waters tantalizingly close to our sighted eyes. Here it is not just the solid masses of rock and sand but the animals and plants that cling to this wonderful land of

Shell Arrangement II

Alabaster Murex

soft light and constant slow motion that are fed and nourished by the currents of water flowing past. The bounty of this complex and exhilarating haven between the deep blue sea and the starkness of the beach beyond is quite possibly the best indicator of the importance of the tension of this zone of creation. There is so much that is crowded onto the land and into the sea where the two come together that we cannot really ever absorb it.

We see the motion and the give and take of the sea and land, but the wonder is in the starfish and the sea slugs, the fan coral and the lionfish. So many patterns and forms are supported in cold waters and warm that we cannot help but be captivated by the sheer variety. The sustained colors that never fade in the filtered sunlight are so vivid as to be surreal, and the animals that are so nearly water themselves, have been blessed

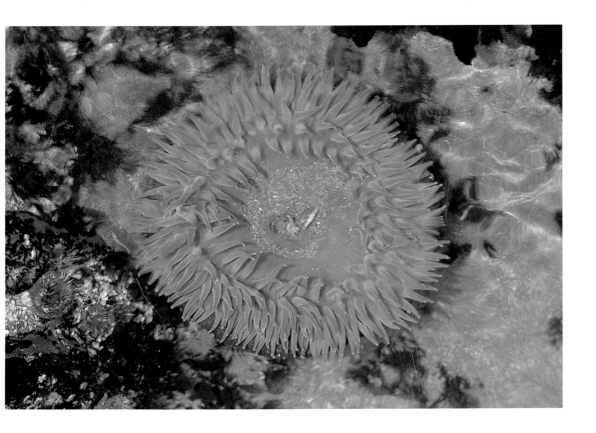

Sea Anemone, Washington Coast

Green Turbo Shell

with a dozen ways of propelling and moving about in this realm that they too seem to become part of the sea itself. But whether they are granted a bit of color or a transparent jellied mass to navigate with, or the pennants and flags of the harlequin, dancing in and out of rocks and coral, they display a unique treasure of grace and color and form that leads us to recognize their beauty and variety in the sea.

To these wonders are added the shells of the creatures that occupy this wonderful world. For eons animals have lived in these sometimes tepid sometimes freezing waters, birthing their offspring and then casting themselves adrift onto the ever-

changing pile of shells and conchs and whelks. But the spirals and loops and claws and fan shapes that they have displayed with ever more colors and tones and textures are the reason for their prominence. If small mussels and snails, often creatures of non-descript tissues were to be housed in some protective case, a simple envelope of chitin would surely have sufficed. But these creatures have fashioned a circus of sizes and varieties that fascinate us, and again, provide no explanation as to the why of their wonderful appearance.

Yes, these myriad displays of Technicolor seem to be adopted as camouflage and even peacock attractiveness, but the very reason for the organized departure from the "one size is sufficient for the fittest" is hard to explain. Here we have all that we can differentiate, all that rainbows can paint and sculptors can fashion arrayed in this shallow liquid elixir and no earthly explanation as to how this menagerie came to be. The sea and the land have ever been the cradle of birth and variation, but the purpose is elusive, and the rationale utterly beyond our grasp.

We can ever see the "snarling" need to consume and procreate as the fashion and necessity of life itself, but the variety of the banquet and the pleasure of savoring our hunt for sustenance and the untold number of other creatures that inhabit this smorgasbord of plants and animals and land sites, is not to be explained away by a hackneyed philosophical dismissal that life's great adventure and unending variety is simply a cosmic roll of the dice – a literal game of chance. As we venture deeper into every realm of life, it becomes ever more difficult to see so much assembled complexity arrayed there as a simple logic tree.

In our moment in the midst of all this, we are at once gladdened by all this intense and immense variation, and confused by its meaning. Perhaps there is little to be understood from the colors and forms and patterns other than that they are a gift. A gift from a benevolent and creative God, a deity, a force greater than our limited capacity to define or comprehend it, but a presence whose capacity to organize this unending and unceasing ever-changing realm that we find ourselves in is truly beyond our understanding.

Leave the explanation to one of logic, of mutations and evolution, the unseen hand of what, a progression that explains the Nautilus shell and the Christmas tree worm? Perhaps this same simplified logic can add color to an ocean reef or explain why since near the beginning of time, seashells have formed by twisting counterclockwise instead of alternating from left and right.

The liquid nature of so much in our world is so infinitely complex and beautiful that it defies even the very logic that is so often used to dismiss the explanation for its existence. It is a gift, and its rarity in our small corner of the universe, this delicate skin of the earth, provides not just clues and curiosity, but promise and comfort in the wonder and fascination we derive as we poke and prod it as it is our nature to do. The gift seems

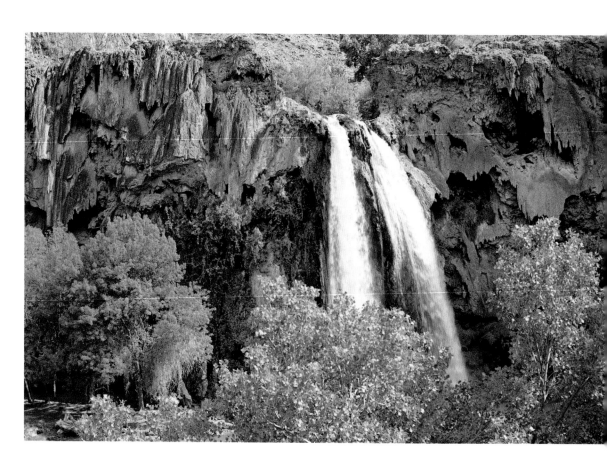

Havasu Falls, Grand Canyon, Arizona

to have no limit as we search in ever-smaller corners of atoms and sub atoms. The beauty of the forms that we discover are carried not by their color or textures, but by their symmetry and miraculous congregations and affinities for one another. This basic nature of matter itself, the building blocks of color and variety become their own fascination, and provide a challenge to randomness and coincidence.

Soon we will find ourselves, in our inevitable way, looking for answers in the gut of the universe itself. The answers, we tell ourselves, must be in the sky, in the cosmos, somewhere out beyond what we think we already know. With our ingenuity and

Firestorm

insatiable need to divine the unexplained and unlabeled, we turn our eyes with ever sharper lenses to the cosmos to see if we can actually see God or what must in fact be the absence of a presence greater than ours. For now, what we proclaim to have discovered is the true universe, and we exclaim in our almost silly self-assurance that it has revealed its very origin, its penultimate beginning, its big bang and the organized alignment of all matter and all things that came after.

And yet, so far, this hypothesis has not diminished our love for the unknown, or led to a final declaration that we must all accept this momentary outburst of supreme simplistic logic, the sticky that holds the whole thing together. For now, we can still see life and wonder in still waters and the bold and beautiful ever changing colors of sunrises that are shared by every common soul.

For all of this we are invited to look deep into the sky and see the cosmic light show that has been there since, well, the beginning of time. We have not been able to see it as we have been crawling on our knees and learning to walk here in this garden of sensual beauty. But the crucible of colors and forms, the nursery of stars was at work long before we were given the vision to witness it. To our surprise and our amazement, while the significance and timeline of all that we survey is debated and proclaimed, we are treated to one of the most incredible light shows that we could ever hope to witness. The beauty of the cosmos is far more incredible than our limited capacity to imagine what we might witness in these galactic spaces.

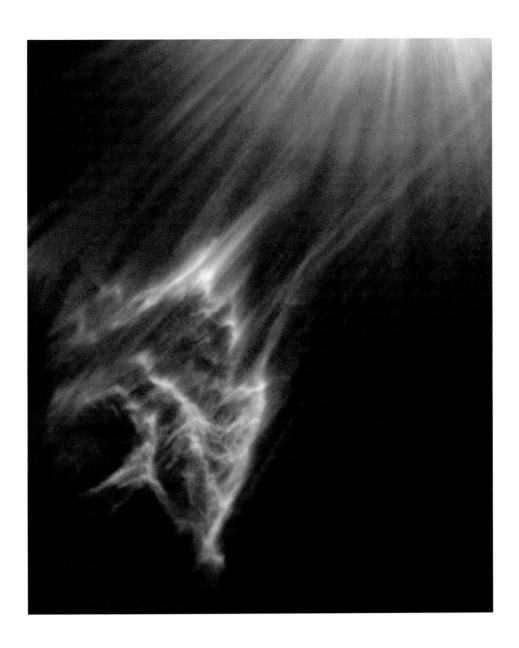

Immense Ghostly Dust Areas in Deep Space

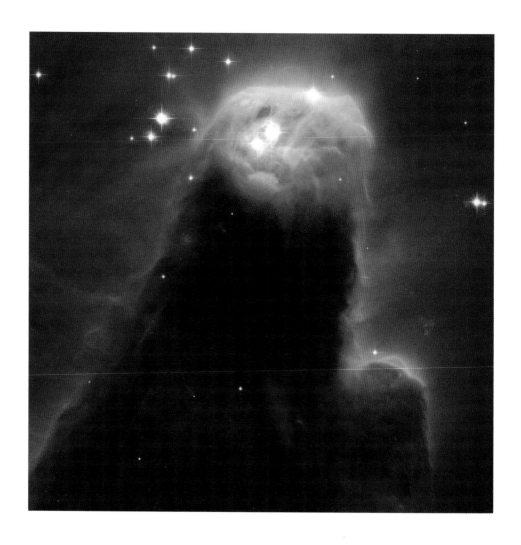

Cone Nebula

Celestial Art

"Drop to your knees beside the wide road,
 And pick up a stone to turn in your hand.
 Now make one like it-seed of the earth-
 Then if you succeed, tell me there is no God.
 Take clay and dust, and fashion a child
 With wistful brown eyes and breath in its lungs;
 Make flesh-warm lips, a brain and red blood-
 Then, if you succeed, tell me there's no God."
 -Carrie Esther Hammill-

At our most defining moment as a differentiated creature on this round world, we looked up and wondered for an instant what was in the heavens. As we paused at the side of a quiet pool that first time and looked inward, discovering ourselves, we began the human journey of revelation and awareness. Little has changed from those moments of truth, of looking farther than our next kill or berry bush. The lenses have grown ever larger and more powerful, the layers of information ever more complex and unmanageable, and yet our explanations have become even more creative in explaining all that we see as, well, evolutionary. We have recently pronounced the moment that universal time began, and even more incredibly, the inevitable end of all matter and the universe itself. In our incredulous way, we have even tentatively postulated the riddle of the structure of all living things, at least on this planet, and pronounced that this same architecture applies to the entire universe. Well it would appear that we have little left to do but tie up a few loose ends and we can sit back in our own self-assurance that we know it all, a phrase that has never had much of a positive connotation.

It is always difficult to win an argument or make a point when the information, nay the beliefs, of the various parties are in great opposition, and here we are arrayed in a vast crowd of heterogeneous perspectives. In the youth of our species, or perhaps

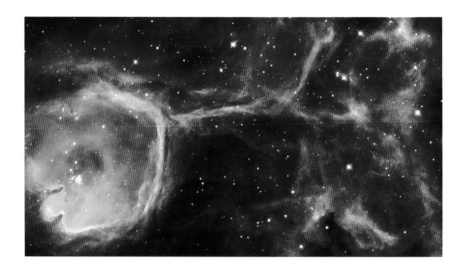

Celestial Geode of Gas and Dust

adolescence, we looked up at the wonder of the night sky and saw a round disc casting its cold bright light on us, and imagined in it gods and heroes, and even the occasional bit of green cheese. These were only the early visions of one of our most constant cosmic neighbors. What did our early great grandparents see when they were given the gift of sight? What curiosity or fears did they experience when they lifted their eyes from the killing field and saw the moon as something to be considered, something far ranging, beyond its existence as a light source in the forests and veldts that the night creatures used to hunt by. What a moment that must have been, curiosity, wonder, and perhaps even a touch of trepidation – should things indeed even have meaning, and now we are it seems, forever on the hunt; the Box has been opened, and we seem to believe that the only way to close it is to empty it first.

So for eternity, we seem determined to turn our eyes, our minds and whatever looking device we can invent, upward and inward to probe the vastness all around us.

For our efforts what have we discovered in the inky blackness: an ever larger, more complex and fascinatingly beautiful cosmos. It is speculative but intriguing to wonder what first caught the eye of the early ones. Was it the cyclic nature of the sun, the moon phases, the panic or curiosity of an eclipse and its sudden darkening of the sky and unanswered meaning that startled the first human to look up and find something more than bovine indifference at the event? Was it the coldness that gradually took the land as the sun settled further and further to the south and went almost out of sight in the far northlands where bands of nomads roamed? Was the association cause and effect, the sun is out of range and the cold winds blow, or was it a creeping, niggling unanswered something that just seemed to need an explanation.

Retina Nebula

Barred Galaxie

The import of the sun and perhaps to a lesser degree the moon, must have loomed as a significant force by association in the minds of early travelers from our species. Poof, one day they are blissfully ignorant of the whole rhyme of things, and then they are eternally snagged into the thinking universe where nothing seems to be able to be ignored. Once the heavens are considered they will never be anonymous again, and this leads to myths, legends and ultimately, the greatest and most respected myth making of all, science.

Wandering upon the land, the night sky too would certainly have offered the wonder of the stars, mere pinpricks of light but varied and changing too. When did the idle curiosity turn to a furrowed brow and the necessity to consider the patterns and cycles of change that were inevitable with this too? The bright band of the home galaxy would blaze in the night sky on moonless nights, and the gradual or sudden need to identify familiar shapes and signs would present itself, and so an interpretation of the patterns and clusters of what could be seen would emerge, and be passed from one to another as we sat or crouched about the kill, or later the fire pit.

Butterfly Star

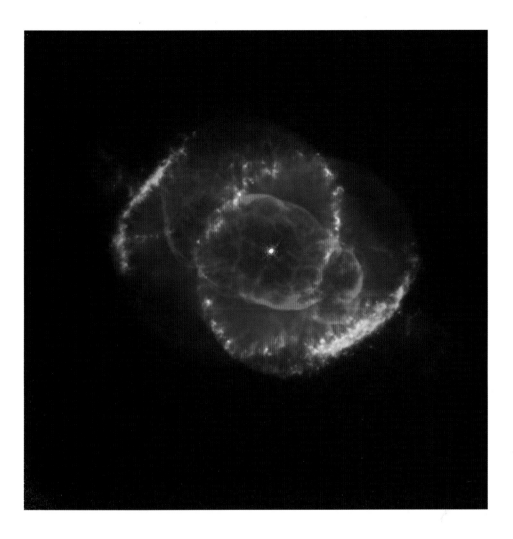

Cat s Eye Star I

It remains tantalizing to us that we will never know, with all the science that we can muster, just what was said or felt or the true order of discovery by these ancient ones, and yet there is pleasure in that incompleteness and wonder from our perspective too. Then too, if the eclipse of the sun was not startling enough, imagine the first appearance of a comet in the night sky. These wonders from our own solar system must have brought many new questions to the huddled hunters and new explanations must

have been tried out to provide form and order and remove the mystery and unsettling fear that might have crept into the budding psyche of these early wanderers. A vast white streak led by the sharp point of the head of a comet's streaking body and trailed by the stark and fading tail; a fleeting but not one day occurrence that left no indelible mark in the sky would not be remembered as the stars that were ever present would be.

A comet would inspire a corruption in the pattern of what was familiar, the valuable, the predictable. Could it be something of intrinsic beauty, or would the notion, the concept of beauty only come later. Was the perception of beauty still distant after the early awakening to self-awareness? These wonders revealed to the naked eye would certainly be offerings from a higher order, yet the ability to see beyond the frightful and threatening may have been delayed in the development of early minds. These beautiful streamers may have even gone unnoticed and unconsidered for eons while the ever-greater issues of sun and moon and starry backgrounds of light came to be prominent in our lives. But the day would come when comets and their glories would intrigue and even fascinate us, probed by the long fingers of our technology, always seeking to find out the how and rarely coming closer to the why of their very existence.

As we wandered the frozen expanses of the north, plunging onward drawn by something or pushed by something else, we wandered so far north that we were caught by the dancing light curtains of the Aurora. These silent and magical curtains that have formed a ring around the poles of earth forever, in our concept of that idea, have changed nothing in this vast landscape. The phenomenon has been described, it too has been probed and measured and considered, but never assigned a value. The greens and reds and yellow lights have danced for us all, the early and wary and the insatiable of our times, as we have looked into these sky-filling displays to find their meaning. There may be no meaning. Perhaps they are simply a byproduct of something else, the discharge of this, the reaction of that, just an off-gassing of the sun and the reaction of the earth standing in the path of the escaping energy. What a sad and empty description of what is and has been, an experience so dramatic and captivating that it has necessitated a whole mythology, a religion to explain its meaning and significance to those who live in its rainbow light.

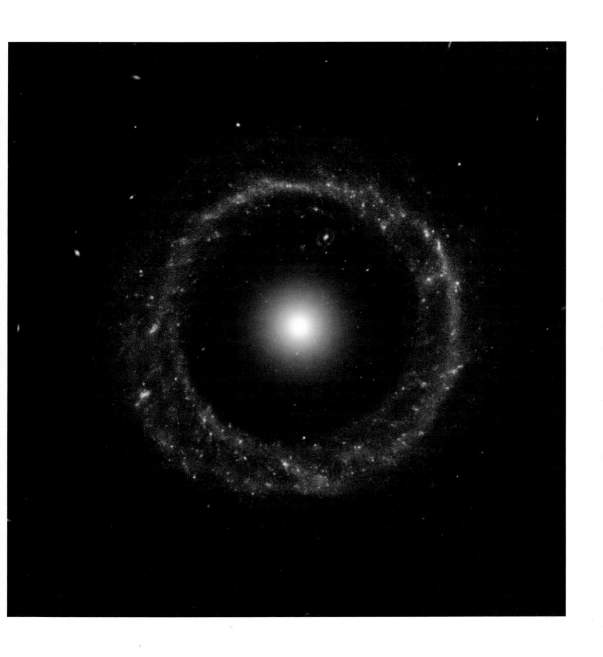

Pin Wheel Galaxy

On nights that are silent and crystalline, the lights appear; the curtain stretches from the horizon through the muskeg and beyond into the tundra grass. The cold is like a presence itself in this region of northern reaches, and makes the light so much more intense. The waves of the white and green lights roll from horizon to horizon, lifting into the zenith and move away and then back again. They reach deep into the top of the sky, and the red and purple bands shade the top of the curtain once again. It is like nothing we see in our lives, unless we live in the light, and embrace the cold lands of the north.

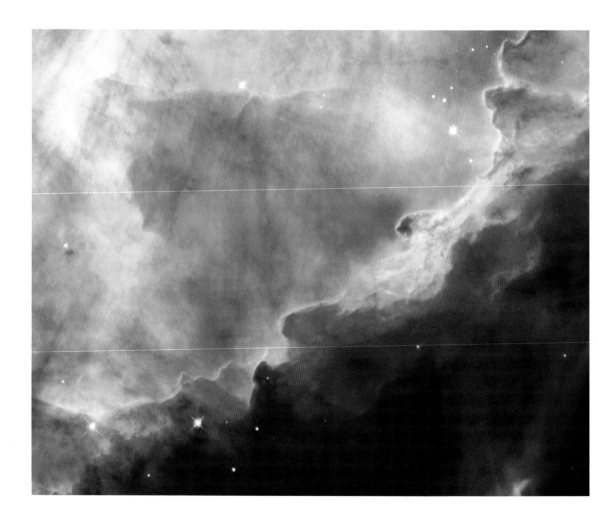

Perfect Storm

Why did we stay in this land of fears and wild prey if we could not see beyond the fear itself, and find, even through spiritual explanation, why the sensations of our world were not the limit of our existence, but in fact a part of something pleasing, soothing, even exciting. These budding awarenesses were part of our lives and needed no explanation. It is a wonder that we ever moved beyond the kill it, eat it or discard it notion of all

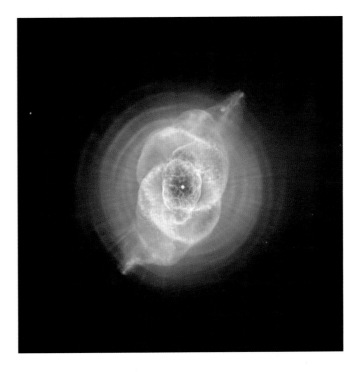

Cat s Eye Star II

of life, to a level of fulfillment; one where we can exist for no other purpose than the satisfaction we receive just by sharing a moment in time perceiving it.

How long did we consider this dancing light before it became part of our religion? However long it was, it is intriguing to think that we did indeed connect it to God through some vehicle of explanation, and that eventually, at least for us as the current residents of this plane of existence, we have even evolved to the point where the explanation of its physical nature does not limit its beauty and restrain our marvel at this rainbow of the night. As it ebbs and flows through the sky, never tipping its hand to its next miracle of self-illumination, it remains not just an anomaly, but a pleasure of frivolous enjoyment to those who live under its cosmic light.

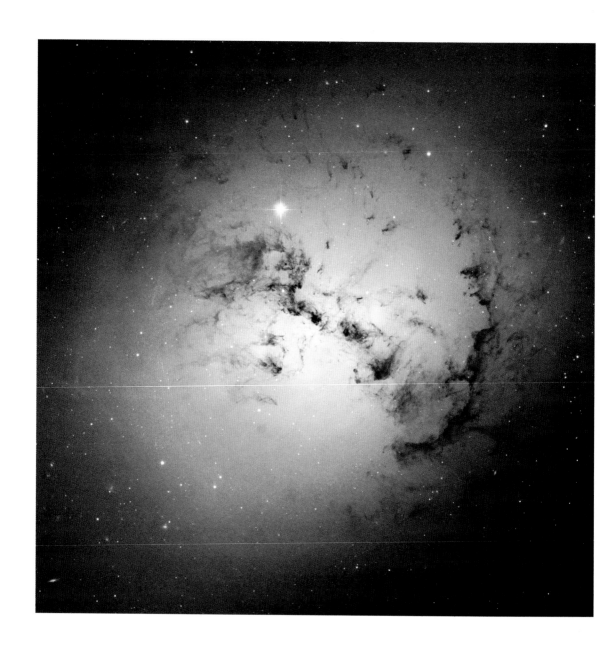

Galactic Dust Bunnies

As we have plodded and then walked and then begun to run along the road to our future, we have become more and more intent on inventing ways to probe deeper, see farther, reveal more of the universe around us, and the results have been an ever faster pace of discovery. Alas, this pace has landed us no closer to the true beginning than we were at the start. Our quests into knowing the secrets and meaning behind the cosmos and universe have led unendingly to new postulates and theories, but an ever increasing number of new unanswered questions and partially contrived answers seem to always be the result of these inquiries.

Along the way to heaven, we discovered in our insatiable inquisitiveness, that a glass lens would magnify the reality in front of us and we could look into ever smaller spaces; while turning it outward, we could begin to see beyond the edges of the night and day. Thoughts about our place in this complex of glowing and sparkling objects were challenged and the preeminence of our world went from the center of all things to a distant and insignificant solitary spot amid an ever enlarging unnumbered many. At first the discoveries were not much more than our near neighbors in this circle of orbiting spheres. But even early on we were treated to a revelation that the very colors and shapes that we had become accustomed to here in our landscape, were repeated out there in revolving shades of red, and orange, blue and yellow. The conjuring and measuring began in earnest, and speculation abounded. People on other planetary bodies in the outer reaches of this tightly knit group of planets would surely yield a glimpse of heaven itself. What could be beyond the beyond?

In more recent times, as the lenses began to grow ever-larger and the distances ever greater, the patterns seemed to be repeating themselves with ever more distant stars and complex galaxies. But new forms of stellar development appeared in the lenses, and we began to perceive that we were witnessing the creation of new stars and even galaxies. The colors and variety were beyond description; time and distance were becoming compressed through this complex of glass discs, so that we could look back to the beginning of time itself. Perhaps if we looked in the right corner of the sky, and squinted, we would be able to look into the eye of God himself. Perhaps we already have, but cannot see Him for the looking.

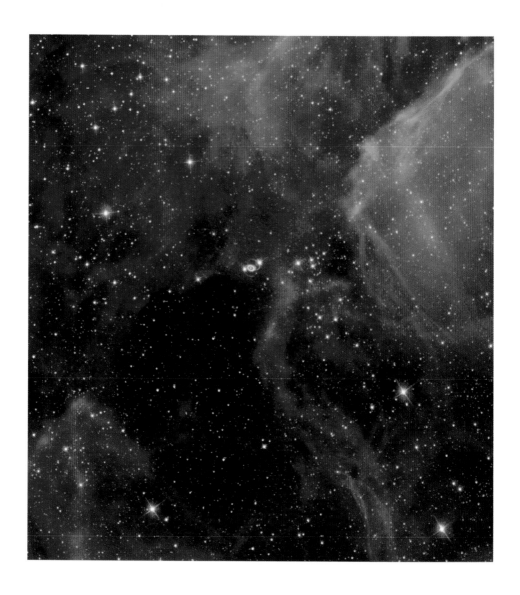

Large Magellanic Cloud

Space has brought us a frontier of sorts, another place to seek to satisfy this restless and often contrary mind of ours, and yet one of the most extraordinary features of all that discovery is that there is an ever-constant element of beauty in it. To some that would simply mean that perhaps we are looking back into our distant past to the very creation of all things, and finding there familiarity and comfort with the assumption that we are an integral and constant part of all things. The context is a good one; the perception of beauty certainly has a constancy, a common thread of mutual appreciation. The question is ever one of the very creation of the context of this beauty and the origin of all things. For us, the search into inner space and outer space has revealed patterns and colors, fascinating forms and textures, truths, well sometimes, but certainly new hypotheses about all things. If, as our inquisitive science tells us, we have actually reached to the outer limits of the very universe we are lost in, and that the estimate of universal time has been set and the clock is accurate, one would be led to believe that all knowledge that we will ever need has been scribed in the book.

In art, that premise is meaningless. Indeed, perhaps in theology it is also a very moot point. In our wildest science-fiction dreams we will never be able to explore beyond our own solar system, the fascinating, the colorful, the incredibly dangerous and powerful elements of the universe that we can already see. Our disappointment at the realization that there are no more superlatives in space and time could indeed overwhelm us, or perhaps take some of the frenetic haste out of our hell-bent-for-leather species. If we have seen the limits of time, and have looked through this tiny insignificant prism of glass to see the limits of the universe, perhaps we can now begin to consider the possibilities of the elements of beauty in those things that we all share as a species here in this little corner of the Milky Way.

We have seen what is unattainable, the vastness of space, the warp of time, the beginning and even the end of the universe according to our best arrays of Greek symbols and Arabic numbers. But what is interesting is that while all this searching and postulating has been going on in the small and elite corners of the earth, there has been a

search for beauty, for expression, for communication that has been going on far longer and involving peoples from all corners of the earth. As we began to try to emulate the elements, the colors, the meaning of beauty of the true aesthetic of the universe, we began to see what was to us a parallel to the universe of science, not the place of numbers and time, but of variety and change.

The world we have witnessed since that glimpse of our reflection in the quiet pool has been one of longing and continual search for others like us, for expressions of beauty and the ultimate aesthetic of all things that we see and touch, hear and feel. What we have done from our earliest days of self-awareness is to try to express our own emotions and understanding for all things in our world through the emulation of God's art. We have striven from the very beginning of our awareness of self, and our tentative perception of a spirit beyond us, to express ourselves in a thousand ways, from cave walls to stick figures to molding a hundred materials into our visions of beauty and

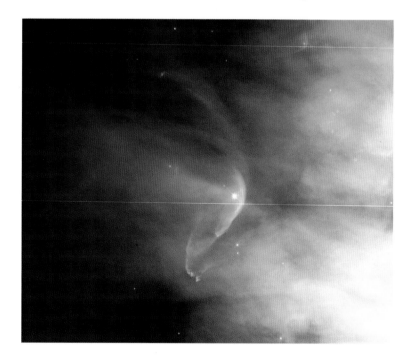

The Bow Cloud

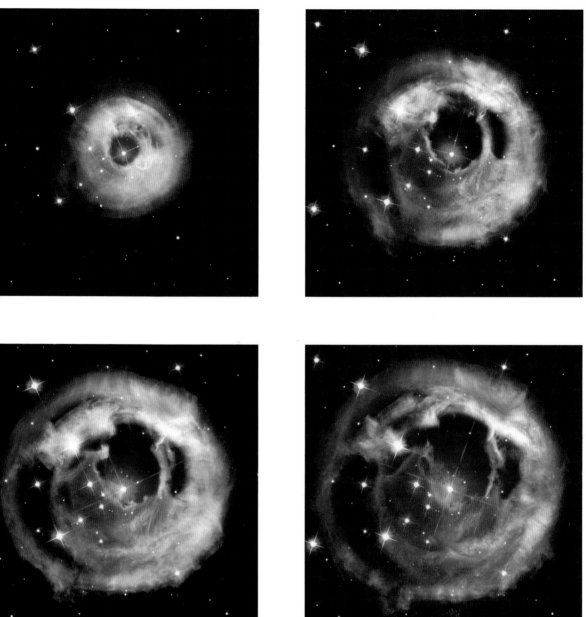

Monocerotis - An exploding star changing dramatically in seven months.

wonder in our world. All this grandeur and subtlety, color, patterns, variety and wonder that has been given to us and the spirit search behind it has led us to create our own art, synthetic art.

Go back, beyond the Big Bang – matter cannot be destroyed or created – before the Big Bang there was a clump of matter/energy with an inherent organization that included the prescription for all creative actions that were to follow. But where did the matter come from? Could the Universe really have been a true void? Real time preceded the Big Bang – the creation of the original matter of the entire Universe, imagine that God-force in the void – the actual creation of all matter that would populate the blackness, the edge of darkness. The edge was only defined by how far the light of the star fire could travel. Was that the edge of the Universe? Is that edge ever-receding as the star fire expands and breaks up as we are told it is now doing? Were the outer limits of this magnificent void set at the time of the Big Bang, or are they limitless, a true infinite realm without measure? How can we measure the inky blackness? If we

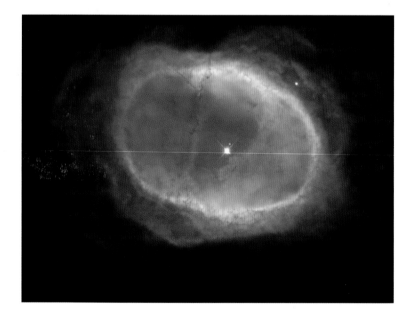

The Glowing Pool

were at ground zero at the time of the Big Bang, what could we have seen if we had looked out into the void? And how far is the true edge of all this?

Was the edge a billion light years from ground zero, or was it just at the edge of the light surging out from this tight beach ball of energy-matter – a mile perhaps, 50,000,000 miles. The expansion of this beach ball begotten universe to its present size is the definition of the furthest extent of the reach of the light emitted from all of the ever-expanding stars. Why doesn't the light reflect back off the "walls" at the edge of the universe? Is the real edge of the universe defined by the reach of all the stars and novae and lighted gas as they shine out into the inkiness? Or perhaps the limit will be defined by the outer extent of the expansion of all of the matter in the universe in another 100 billion years when the outward expansion ceases and all matter returns to particles with no definition. If we accept the limited argument that logic can explain the Big Bang, then we also discount the unfathomable architecture and dimension of the creation of the seed of the entire perceived universe.

Heady stuff. Perhaps it is the beauty, even the sanctity of the force and plan behind it all – God – that is the cosmic generator of all that we can perceive. Even if we accept the grand notion of the nearly inconceivable reverse engineering of the Big Bang, we have only painted ourselves into an intellectual corner with our universal laws of physics, and we indeed become part of a continuum of creation, but obviously not at the beginning. We seem compelled to look even further back to an even more confusing and vague past, before universal time as we have defined it, but not before the creation of all matter. Even then, the speculation will be swallowed up in theory and logical symbology. The good news may be that we will never be able to puzzle it out, and the best we may ever hope for is a comforting postulate of what might have been at a time and in a dimension that means nothing to our frail but beautiful existence in this time and place.

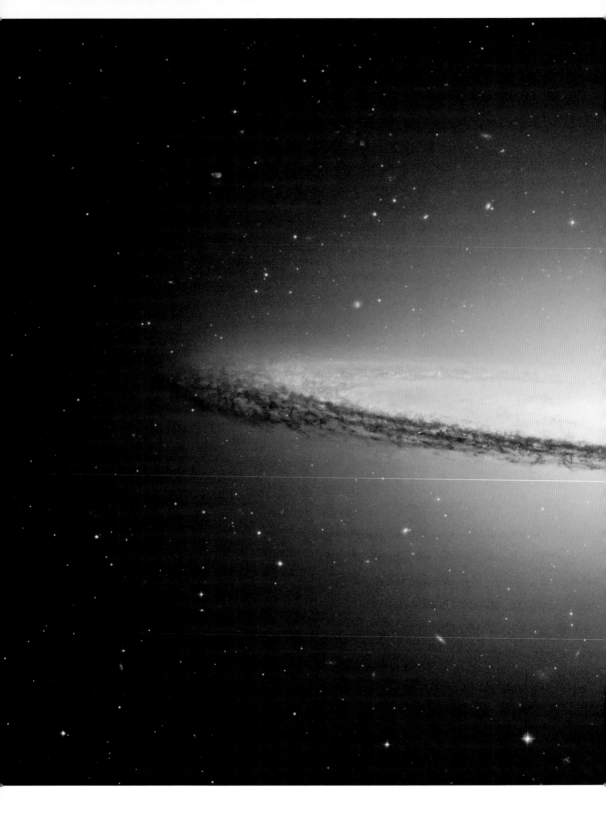

The Sombrero Galaxy

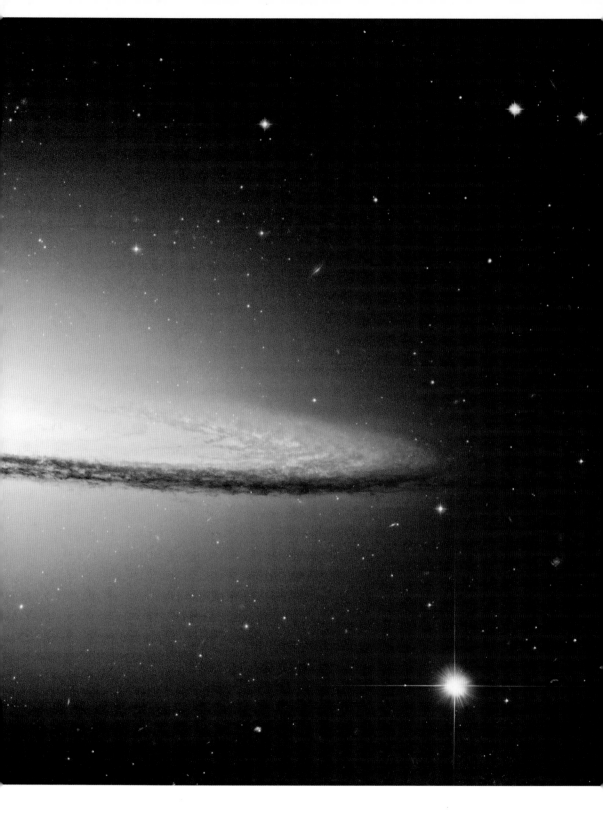

Dodder, A Parasite, Death Valley, California

Sentience

"Faith is the daring of the soul
to go farther than it can see."
-*William Newton Clark*-

Out of all this supposed randomness has come a curious element of beauty, of art really, but who's art is it, and who can see it as art? Does a tree falling in the woods make a noise if no one is there to hear it? Is light sparkling on a pond at night anything but bouncing photons if no one is there to describe it as wondrous, tranquil, and the inspiration for thoughts of romance and creative license? Why are we capable of seeing beauty – what purpose does it serve in the surging, pulsing, leaping competition to evolve and survive with the rest of the creatures of this random universe? That is a question that bothers mankind with annoying regularity and growing intensity.

Beauty is only a perception of creatures that have been granted the capacity to see-taste-smell-hear it. Without the equipment to consider the light beams and sound waves, the odors of the air and the touch and feel of softness and cool-smoothness, existence is pretty much one of utility and necessity, survival and security. Beauty is something that transcends all of this everyday preoccupation and occurs almost in another dimension. Are we the only ones who see beauty, who are self-aware; when we can talk to the birds of the air and the beasts of the field the fish that swim in the sea and perhaps the flowers nodding in the field we may be able to discover the answer, but for now it is enough to contemplate our own gifts in this life.

We can look into the mirror of life and see so much reflected there that we become confused, as much with ourselves as with the universe we have before us. We see color and texture, patterns and fragility, the sands of time sculpted into mountains and a stream of water tucked into a small glen. These scenes bring visions of tranquility

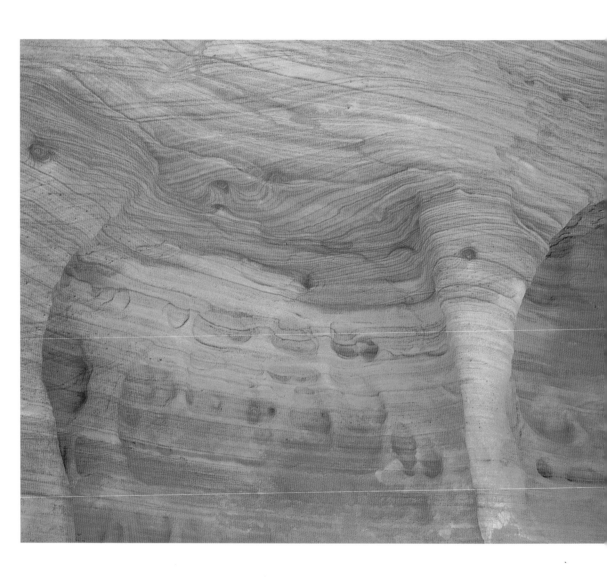

Alcove Ceiling, Upper Reaches, Zion Canyon, Utah

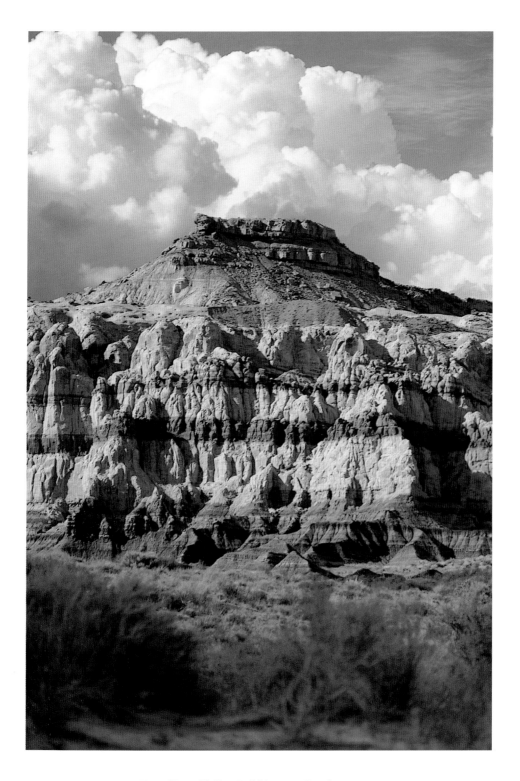

Vermillion Cliffs, Utah/Arizona Border

of majesty of grandeur, and …beauty. We are blessed with the sight to view the entire universe as far as our spyglasses can see into the majesty of space and the fineness of littleness on the head of a pin, not just to determine what might be done for us, but rather for the joy and satisfaction we receive for the looking.

Why not a gray universe? What value is there in all these shades of purple and puce, orange and red and deep vermilion? Does the blue of the ocean or the sky really need to be any other shade than medium dull? The wing of the butterfly the brilliance of the coral reef, the deep hues of flowers in the dark wood, perhaps a shade of British drizzle or Erie afternoon would be acceptable, and every bit as functional. Why spend the time on developing a palette of a thousand colors when the dark of space and the light of the stars could be split into grades of grayness. Just because?

Lost Coast, California

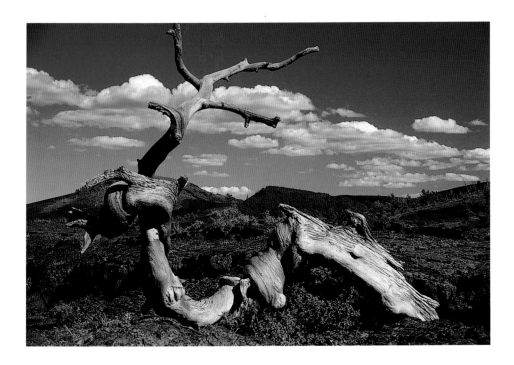

Malpais and Dead Tree, Idaho

Somewhere in this progression of randomness, reason falls apart, and while we are asking questions with no answers, why is the universe so chock full of wonderous things anyway? Wouldn't one star's brightness and size be worthy of emulation by every other star, shouldn't stellar dust be of one basic hue – gray – rather than swirled and shot into incredible shapes and colors and scattered into the corners and edges of all that space that we can see? Why are we privileged to see the designs of space and our world as something that transcends what we can eat or devise into shelter? Why waste all this magnificence on a sightless, senseless universe populated with survivalists who cannot transcend their own hunger and thirst and need to procreate? The gift is sentience and it is ours to use for whatever purpose we choose, whenever we choose to look through those eyes.

Burning Embers, Mogollon Rim, Arizona

One of the oldest and most important companions in our journey through time has been regarded for its utility and even necessity in our survival. It has been part of our evolution from somewhere in the hazy past to here in the hazy present. It has aided us in traveling over vast areas of frozen waste and treeless landscapes. It has been a companion when we have found ourselves utterly alone. It is almost like the presence of God – but it lacks the omnipotence; it is fire. This star-magic that burst from the silent explosion at the beginning of time has been the central catalyst for all creation we are told. Hotness and cauldrons, red glowing rock and metal these are the elements of the forge of creation – of God, we are told. But on our small level, the bleakness and oppression of the darkness that surrounds us in the open is almost magically cut by the presence of this gift.

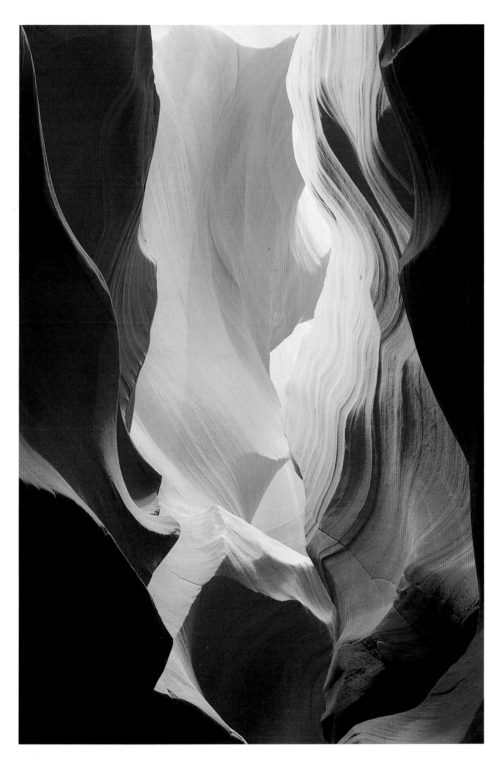

Antelope Canyon, Arizona

Fire. Why do we have this elemental bit of the heavens here in our outpost so far from the beginning of the center of the universe? Why are we permitted to build and banish the flames of this mercurial tool with total abandon, and yet without its dancing presence, many of those that inhabit this whirling object in space would perish. That is fire's utility; but what of the mystical, the religious, the philosophical, and the beautiful? Would we worship this most unique force or presence in our lives if all it did were to keep us alive? Value it of course, but what more is there to this dancing matter that hovers over the log and stick, the fuel that sets it free?

Is there anything in our experience that has no weight, which can be absent one minute and spark to life in thin air the next that morphs and pirouettes creating a different shape at every eye blink? Fire is unique. It is a force, a power in our lives, and yet it is and always has been a fascination for us as we have tried to confine it and tame its dance while we gazed into its heart and thought a thousand thoughts and saw a thousand visions. Is this universal forge a force of random creation? Do we accept that

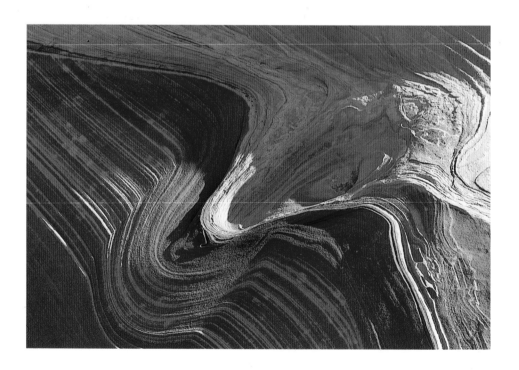

Sandstone Detail, Coyote Buttes Wilderness, Arizona

the very star glow that keeps us hunting in the heavens for answers and the source of all creation is just a happenstance? Somehow that just doesn't seem adequate.

The prairies and the mountains, the islands and the meadows that have found us alone at dark have challenged our resolve to pass that way in darkness and unprotected. As the eons have passed and we have learned to harness this divine gift, we have conquered our fear of this lonely planet and the darkness that so often surrounds us by bringing the magic out of the twigs and grass and conjuring a welcome unseen companion. As the sparks become a flame and the dance grows before us, we look into this mirage and find thoughts and images that come to mind that would never have entered our thoughts in the dark. Fire is not just the heat that battles the cold or the sear for the meat we have killed. The deep feelings and visions, the apparitions and beauty

Sunrise, Manlius, New York

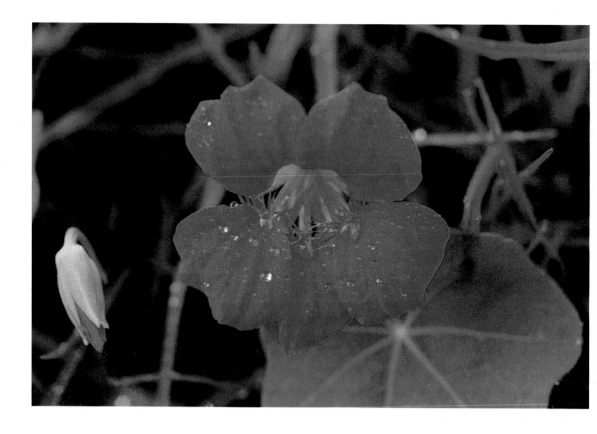

Wild Nasturtiums, Near Petropolis, Brazil

that flare before us are far more than the consumption of fuel. Indeed, is it not possible that those flames give off heat only as a byproduct of the primary purpose of generating possibilities in our minds?

There will be explanations about the how of fire and the composition of the spirit of flames, but even light itself eludes our frail minds when we search for a definition of it. Flames will dance and will always reach places in our souls and in our sight that cannot be described or measured on scales. This most magical gift will inspire and help us to conjure images and thoughts, visions and mysteries as long as we gaze into its ever-changing depths, and open the gateways to our most inner selves allowing the magic to catalyze our dreams.

Winter Scene, Prescott, Arizona

All things that occur in our lives, that reach beyond necessity are experienced through our senses, and are sensed by our minds. The beauty, the art, those aspects of our existence that add a dimension to our very lives are part of this gift – the reach beyond random necessity.

Of all the light in the universe, why are we able to see this most expressive and complex band. Why are we not blessed with the imaging to see wild game at night, or to see the structure of bones and tissue in the shadows of rays and wavelengths that are denied to us as creatures? Our minds would glow from the images of heat given off from running antelope and the sight of caves heated by fire, but we would miss the falling rain and the sight of colored leaves, the tranquil soft colors of an evening sky, the

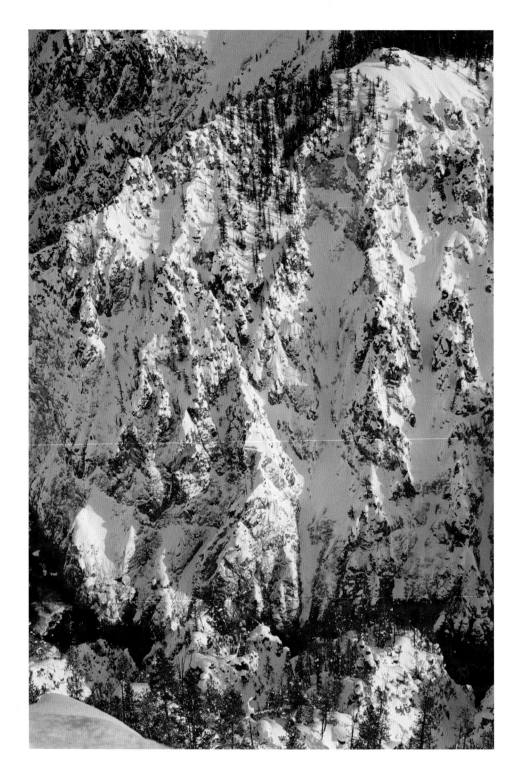

Yellowstone River Canyon in Winter, Wyoming

rainbow's mystery and the brilliance of sunlit colors. What would be lost to us would be monumental and universal in its magnitude, as we would not be able to see the far reaches of the universe and all its magic either. But the process of elimination in arriving at this gift of colored sight was random we are told.

The quiet wonder of rainbows; they have no purpose that we can discern. Why should we be treated to this wonder of the sunny sky misted with rain? Other creatures with eyes can detect rainbows, but they too are probably as stumped as we are as to why they are there. We have the what, we know how a rainbow forms as we understand so many of the visual blessings of this world, but who has even considered the why? Can we not accept that many of the beauties of life are there only as expressions of God's art, to entertain, to inspire to add a dimension to life that is unique to all creatures who are fortunate enough to be able to appreciate life beyond the kill or becoming another's dinner. This is surely the meaning of beauty and aesthetics.

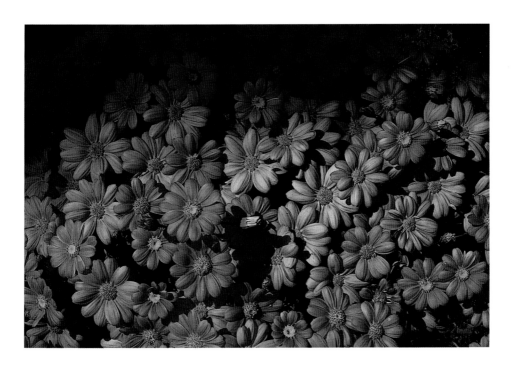

Near Victoria, Vancouver Island, Canada

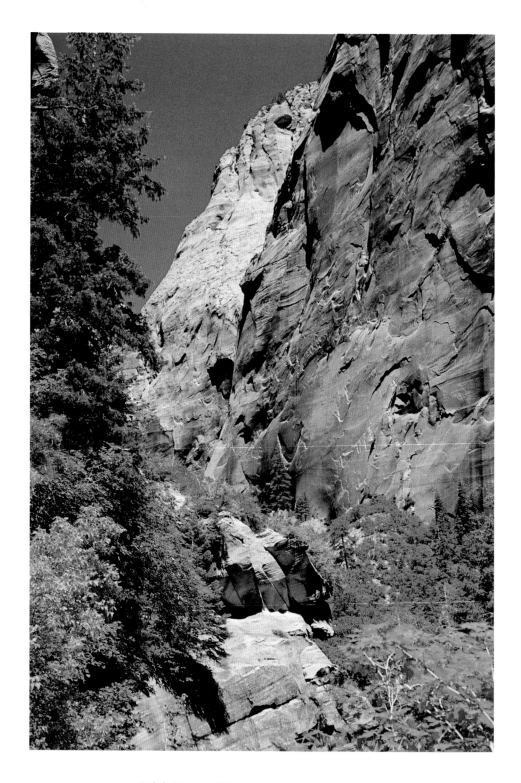

Kolob Canyon, Utah

With the discovery of the beauty in our lives, that self-aware leap into a genus never known before, we captured a view of our universe never known to this small outpost in space. We now have the clairvoyance to see our own salvation from the knowing compulsion to survive. Survival has no future. In its rawest form it is locust like: consume and move on, hunt to extinction and die, or change the menu. When the glen or plain, the marsh or the mountains begin to be seen as something transcendent, a new dimension to the creature that can see with this vision is realized.

There is after-all a limitation to survival, a tomorrow emerges, an awareness of measured consumption, of limits to cancerous runaway procreation. From God comes beauty – and the capacity to view this universal dimension. The pace of abandoned, headlong motion is slowed. Questions emerge. With the sight of this new dimension of seemingly purposeless aesthetic reality comes a hesitancy to continue the survival imperative and contemplate the value of all that surrounds us. The dimension of beauty tantalizes us with the imperative to sustain and even cherish the thin skin of the living universe we inhabit to ensure a tomorrow. We begin to see the value of persevering and conserving the life that, until now, we have only viewed as a vast banquet table, as we look through these new eyes of wonder. God's gift to us – this sentient burst of colors and shapes and textures – may be the element that stays our hand from cannibalizing our very existence. Can we stop or slow this headlong rush to Armageddon once we have been given the opportunity to consider all of life through another frame of reference?

Our perception of this world has changed over time. This wondrous and perhaps unique gift of seeing beauty in life has been extended from the initial preoccupation with the qualities of the infinite landscape, to our own qualities of attractiveness and aesthetic essence, and then to our own built universe; the ordered adobe and daub/wattle house, the temple and pyramid. Then the advanced age of castles and cathedrals and planned cities dawned. All of this "created" world has grown out of necessity and self-indulgence, self-preoccupation, not survival. Only in this era of our existence have we been able to pierce the depths of our gifts and see beauty as a limiting factor. We are able to witness the frailty of the moment of natural, God inspired beauty, before we alter and consume it.

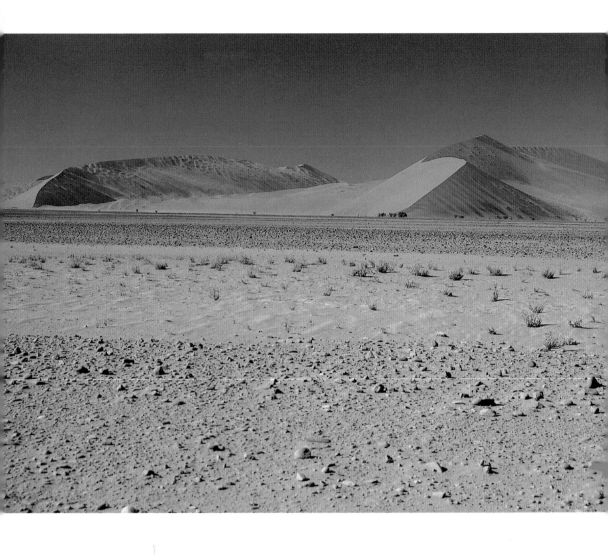

Namib Desert, Southwestern Africa

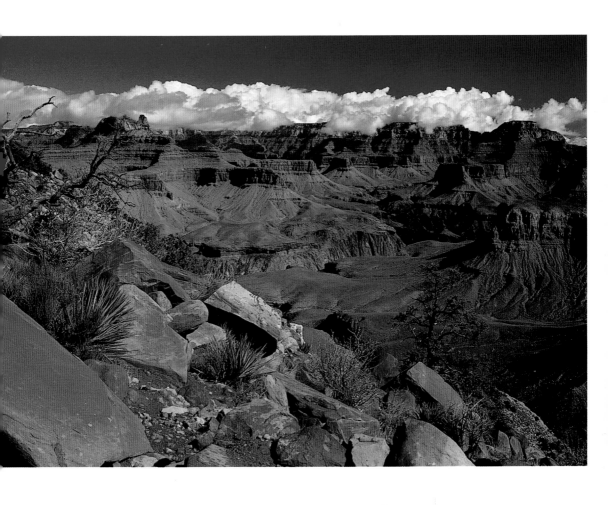

Grand Canyon of the Colorado, Arizona

God's beauty is often fleeting and ever changing. The surface of this lonesome globe changes more rapidly than we ever suspected. Our hunger for growth and survival could overtake the entire realm, but beauty limits the hormones we apply to this endeavor, and offers us not only a refuge, but also a dimension to our existence that was never recognized before. We can now discern patterns and cycles and forms in the natural environment that we never noticed before, not through scientific enquiry, but as pure art.

With this gift of sentience, and the saving grace of being able to view the universe through the eyes of salvation, what do we begin to recognize in this new perspective of witnessing our universe? Patterns and lines emerge from the ever-present light that define all visual beauty, and the next age of constructed, synthetic beauty, reflecting God's divinely inspired universe, has emerged.

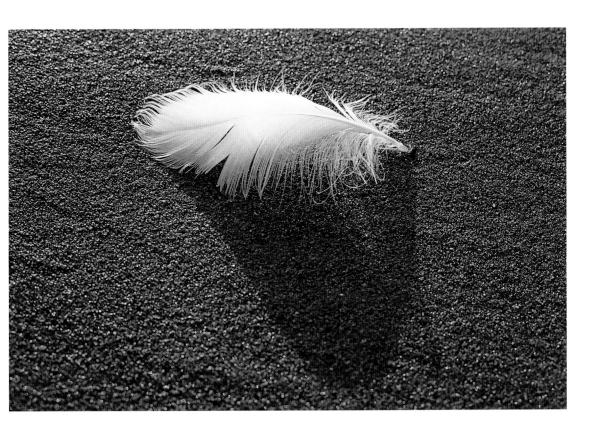

Seagull Feather

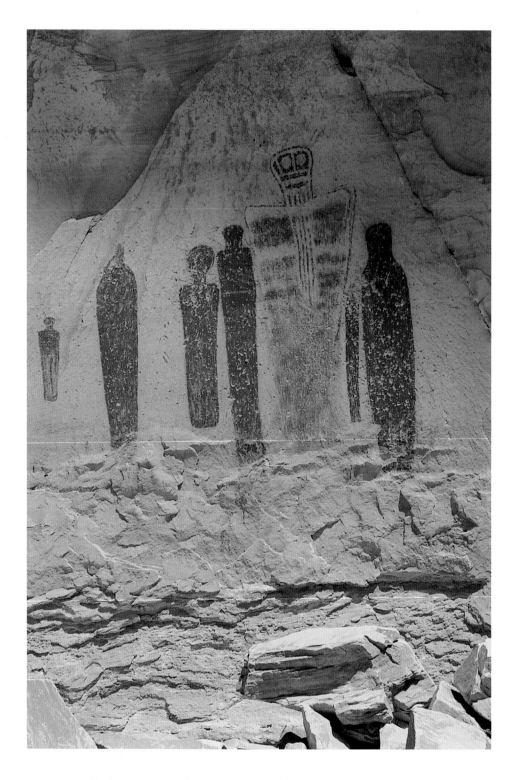

Early Art, Canyonlands Region, Utah

Synthetic Art

"Faith and love are apt to be spasmodic in the best minds.

Men live on the brink of mysteries and harmonies into which

they never enter, and with their hand on the door-latch,

they die outside."

-Ralph Waldo Emerson-

The questions that arise for all of us about ancestral beginnings survive in our minds in part because they can never really be answered. They drift away from the chain of logic and arithmetical proofs; they are sustained for the very reason that we can't declare findings or put them to rest as decisive revelations, and we are richer for it. The pursuit of a definition for beauty or aesthetics in our tribe of animal life is the same.

The evidence of human attempts to express feelings, thoughts, life and perhaps even an appreciation for the perceived beauty of landscapes exists at rare sites in a few consistent forms in the world. The paintings in caves, the etchings on rock faces, and even the rare find of twisted twigs and other fragile natural materials formed into human reflections of the world, provide tantalizing evidence that ancient tribes around the world were the first to draw scenes from human lives, or fashion totems from vegetation. The study of all these early expressions of life as seen and perceived by us early on, is vast and intriguing. Yet this explanation may always fall short in its finality in integrating the meaning of so much. Did we mark the insides of caves to try to capture the essence of the things we ate? Was it perhaps to pay our respects for the presence of the bounty in the landscape? At some point, these expressions became magical and religious we are told, and a conflict of interpretations arises between answering the riddles of life through concrete expression, and paying homage to a strongly held belief in a real power in our ancient lives. At some point, early or late, we seem to have begun to perceive this vast, often frightful world as a place of beauty.

Perhaps with the earliest presentations on cave walls, we had an urge to express the grandeur, the grace, the beautiful and awesome in our lives. The shapes of animals and the stars, the human form, the hunt, the many moments in our early existence, all these and more were chosen to adorn our sheltering walls, and inspired the figurines we strew on our cave floors. These impressions still remain with us, preserved and often remaining untouched for thousands of years. The dryness and loneliness assured their eventual discovery by the ever more prolific race that created them so far in the past, and yet what we have discovered seems to lead us ever more tantalizingly to two more significant issues – what has been lost over the ages to the ravages of rot and the elements, and what part did divine inspiration play in these tangible expressions of our thoughts and feelings?

Our notion of beauty, that appreciation for the intangible value of things with no utility or nutritional sustenance, has become an inescapable part of our lexicon and our perception of all life and its settings. Somewhere along this path of personal and unique development we discovered the urge to represent what we saw in specific niches of our lives. On every continent in every kind of climate and weather, we moved, perhaps slowly, perhaps at breakneck speed, to use our hands to reproduce outlines and functions of so much that we interacted with as part of our very existence.

The urge to copy the lines of animals, to reproduce the hunt, to show stars in a sky and even to draw self-portraits of our bodies and anatomical functions began not all at once, but in every corner of the world independent of our far flung brothers and sisters it would appear. This art, this chipping and painting and laying out of immense landscapes of stones was almost like a fever. Pick a date far enough removed from today, and no band, tribe, family or group of hairless apes created anything. What intrigues us in part is the switch, the fuse, the catalyst that set us off on the road to mimicking or reproducing forces and elements, causes and effects that we experienced in life. Were they just attempts perhaps, at marking trails in desertscapes, or posting information in central locations? Were they intended to mark the passing of beasts and memorializing the hunt, or were they indeed attempts at reflecting the essence of things

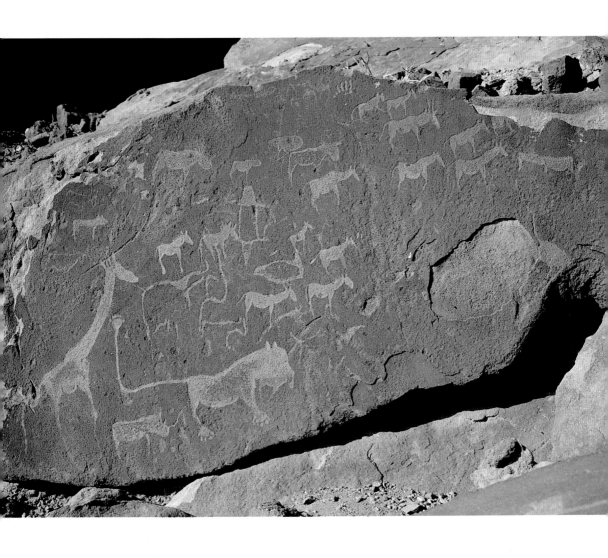

Early Art, Near Twyflefontain, Namibia, Southern Africa

that held "magic" or power over all that was done and viewed by these ancient ancestors?

Where does magic intertwine with beauty, with the intangibles of life? Did the concept of beauty affect us in our early inspirations and thoughts about life, or did it come with a thud much later on? Whatever the timing of all this, the outcome was that each chink in a rock or twist of a bundle of grass, every pigment applied to a cave wall or landscape geoglyph was an expression of our feelings, perceptions, and somewhere in the mix, the beginnings of our reach beyond the tangible and visible to the ethereal. That urge has never ceased, and the expression of it goes on.

The symbols of our lives and their reflections provide us with a glimpse of our early selves, but what led us into the caves during our early self-discovery? Questions abound about the meaning of the hour glass figures in our early glyphs and paintings, the squiggles and the antelope-like creatures and giraffes on cave walls and in sandy vastnesses in utterly uninhabited spaces, but what led us a mile into a cave with only a burning branch to light the way? Why venture so far into the dark wastes to make these sacred or profain images? What drove us or led us on this quest to seek ever deeper, the recesses of caves? It may well have been only the curiosity of a certain tribe that followed a tangent that led ever inward toward the darkness of the earth. Did these early cave chippers and painters have a need to seek the darkness and discover something more?

It is hard to imagine a concrete scenario that explains their actions, but what is boldly evident is that we crossed over a line of self-awareness and migratory behavior to one of tactile expression at a very early stage, and in all of this, what we did was to describe our own form of God's art. That was a defining moment for us as a unique species perhaps in the entire universe.

We were then as we are now, part of a vast, intertwined complex of sensations and systems and cycles that, together, described our small section of the universal one. It is and perhaps was, our instinctive curiosity to find answers, solve problems, clarify riddles and explain our existence in order to… find peace, eliminate threats, satisfy our insatiable and, as we have discovered, never ending curiosity. Is it after all, conceivable

that we can ever reach an end point in quantifying and resolving the universe and our part in it, or is it almost self-satisfying to believe that no matter how many hills we cross, there will always be one more to explore.

In our early quest for self-expression, were we compelled by necessity, curiosity, a nagging religious-spiritual-out-of-body urge to explain and perhaps even communicate our needs, our wonder and even our fear of all that we didn't understand? Was this directed at posterity, our young ones, the neighbors or the spirit of what we could not define? When did we first realize or experience the fearful wonder, not of being eaten by a hairy cat, but of something unrelated to our physical safety? When did we begin to realize that our existence was not limited to food, clothing and a protective cave, but was indeed vulnerable to hazards of the spirit both real and spiritual, that were perceived as central to our very survival?

The timing of this passage to self-expression for our newly enlightened species may well have been at the moment of self-awareness, the true beginning of our distinction as mankind. For how long could we live seeing our image in the quiet pool as a reflection of ourselves instead of a menacing creature lurking there in the water staring back. There was perhaps a bit of irony that as we began to see with new vision the deep well of self, we also began to perceive the vastness and complexity of life around us. Sheer instinct was subdued by introspection and a pantheon of newly ascribed thoughts and emotions, capacities that were unknown and untried before emerged.

This was a moment in time like no other. Is it surprising that in our retrospective we describe it as the birth of mankind, the creation of a new species, a thinking, emotional biped that was granted the keys to the door of the universe? In an instant we were able to consider our lives in a form and sense that would fill us with apprehension and an as yet unexperienced fear of the future, of the untouchable, indefinable depths of the dark and uncharted recesses of our minds. What we would eventually refer to as our soul was a central feature of this divine gift, for as we discovered with the gift of vision and beauty, goes the capacity to choose a dark path, a mistaken route fraught with loss and blindness and missteps.

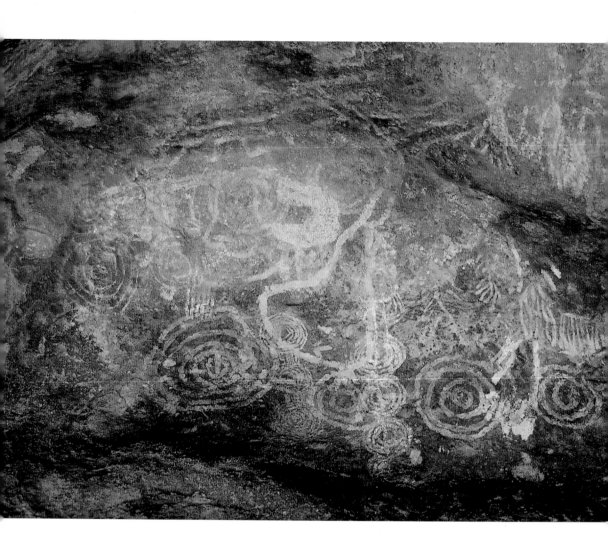

Cave Art, Uluru Monolith, Central Australia

What was already there, the uncountable and as yet unexpressed marvels of the landscape that we had awakened into, was now our seen-for-the-first-time world. We were given the gifts of true vision and all the complexity that accompanies this unique capacity. And as we took our first steps in the body of the most powerful and eventually, most feared of all creatures, we began to see something of life as more than a physical need.

We began to think of the influences, the events, the elements that affected us, and in an ever-increasing way, the way we responded to the landscape, a chain of events, a growth phase began that took us down a road that may have no end. Questions that only seemed to have choices for responses and no clear answers began to offer themselves. From our first glimpse of self, we achieved awareness, self-awareness, a never to be forgotten inquisitiveness that set off a chain of questions and obvious-contrived-essential-unfounded answers that would permit us to continue to move forward.

Then somewhere on the dusty path, we began to feel compelled to communicate these questions and seek answers. Grunts and hand signals were not sufficient to express wonder and fear and doubt about the landscape, the heavens and each other. "Do you see the splendor in the sunrise?" and, "What caused the family to perish?" would eventually come up as questions of mutual awareness, and the responses would need to be articulated with the same degree of detail and information as the questions. Yet the questions, "Where did the herd of antelope go?" and, "How do you describe the color of her hair?" require different degrees of thought and expression in the best of us.

At some point we looked up and began to see the night sky and the detailed variety of it. The variation of the moon's phases, a gazelle's elegant leap became the focus of our new found curiosity, for hunting and utility as well as a certain kind of magic and awe.

From here we progressed to the need to understand, and eventually to explain the little and the large, the elements of survival and the nagging notion of things that appeal to us for no reason. Did beauty emerge after a systematic review of all things and the assignment of their utility in our lives? Was the compulsion to survive and procreate

still so prominent and resident in our newly formed psyches that we could not see the non-survival elements in our world until much later? Possibly; perhaps even probably.

Somewhere in the stumbling, trotting, crawling shamble into the future we accomplished in a hundred ways in a hundred places the ability to understand, to explain and eventually to express through our hands, what we saw and felt and perceived. When we arrived at the need to express, we had reached a new plateau of action, a record of our thoughts, experiences, and milestones on our trails. Could it have been that when our ancient or prehistoric forebears etched a gazelle on a boulder or cave wall, they made a mistake, a slip of the stone hammer – and a stylized baboon or human form became as one? Certainly the prospect is there to imagine the morphed creatures in so many early petroglyphs could simply be the progression of possibilities formed from mistakes. It happens even in our time. The fortuitous mistake in mixing paints, in drawing a horse, in spilling the ink across the page. With our ancient relations, could this have been a catalyst to seeing the world that they viewed every day in the same old way, as something fresh and different. The actual dawn of awareness, of beauty may well have been the slip of the sculptor's chisel. A mistake that lead to viewing all of life as potential, the shapes and colors as possibilities; and so it continues.

From all this, the curious possibilities, the notion of spiritual expression and release, would not be far behind. The ever questioning, curious, self-expressive us, would certainly be driven to look for answers in the shape of the landscape.

And where in the vastness of the world did we chip and paint and twist the twigs that created our artistic and cognitive legacy – everywhere. In the hot deserts and cold wastes of the world. In the caves and ledges of mountains and mesas, and around countless fire pits, and with care, and occasionally, abandon. We had to follow our inevitable curiosity, a need for more danger and fulfillment, the haunting and progressive that defines us from all others. Logic and survival found a counter-point in self-expression and aesthetic expression.

In this continual search of the next horizon, we began to see beyond the next bison and mastodon and large-toothed feline. The hair of the musk ox and the pattern of the leopard's skin were now being viewed as attributes greater than just the sustenance

of the flesh and the protection of their bodies. Somewhere along this trail of restlessness and discovery we determined that there was something intangible, fleeting, even dominating in our lives. Was it a presence, an invisible man-thing, or was it a force, the life of the volcano, the life of the beast we killed for survival? Certainly the massiveness of the elephant and mastodon could have led us to dream of a life force beyond our own. The magic of the place, the aurora, the hot springs and fuming mountains, the stealth of the silent cats and the savagery of the giant bear, even the presence of the shark and whale in the limitless sea for those compelled to venture there. These forces, animated and awful, could most certainly yield caution and respect, and even adulation and admiration from us.

At some synaptic moment we crossed over from the purely cognitive, logical, process orientation in our lives, to a higher order of thought – the realization of beauty and our ability to reproduce it. In this same moment, perhaps we defined God.

*Early Art,
Canyon
Wall,
Canyonlands
Region,
Utah*

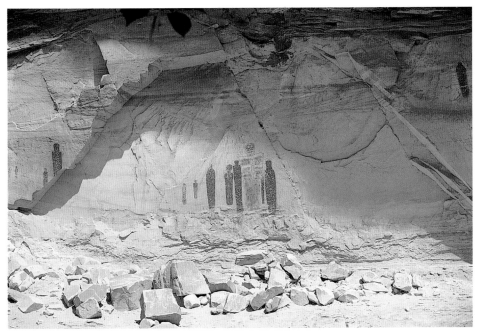

Notes on Photography

The photographs in this book were taken over a period of some thirty years in many countries all over the world.

The camera equipment was primarily 35 mm, which included a Pentax Spotmatic and several Canon AE1 Program bodies.

The cover photograph was taken in Antelope Canyon in northern Arizona with a Mamiya RB 67, and is the only medium format photograph in the book.

The first 25 years of photographs were all developed using Kodak film, primarily Kodachrome 64 or 25. The more recent images were taken using Kodak professional color print film, and Fuji Velvia 50.

There are no digital images, and no computer manipulation of any compositions or photographs in the book. The only filter used in any of these photographs was a polarizer, which was used extensively for landscape shots.

The images from the Hubble Space Telescope were composed and processed independent of this book.

All snowflake photographs were taken by William A. Bentley of Jericho, Vermont.

Ordering Information

We welcome inquiries, responses and orders by our readers and invite you to visit our web site at:

www.gregsmithbooks.com

The discussion about the very beginnings of life and the relationship of religion and science is a robust and important one, and we welcome comments and perspectives on this relationship and the significance of divine art in this ongoing debate.

If you wish to write a letter, place an order or communicate with us, please send all correspondence to:

Grand Canyon Publishing
P.O. Box 8550
Mesa, Arizona 85214-8550

Thank you for your continuing support of our books.